COMPLETE GUIDE TO
MOSAIC TECHNIQUES

COMPLETE GUIDE TO
MOSAIC TECHNIQUES

BONNIE FITZGERALD

Search Press

contents

A QUARTO BOOK

Published in 2015 by Search Press Ltd
Wellwood
North Farm Road
Tunbridge Wells
Kent TN2 3DR

ISBN: 978-1-78221-185-3

Conceived, designed and produced by
Quarto Publishing plc
The Old Brewery
6 Blundell Street
London N7 9BH

QUAR.WEMA

Senior editor: Victoria Lyle
Senior art editor: Emma Clayton
Copy editor: Sorrel Wood
Proofreader: Corinne Masciocchi
Indexer: Helen Snaith
Designer: Julie Francis
Design assistant: Martina Calvio
Illustrator: Kuo Kang Chen
Art director: Caroline Guest
Creative director: Moira Clinch
Publisher: Paul Carslake

Colour separation by PICA Digital
Pte Ltd, Singapore

Printed by Hung Hing
Printing Group Ltd, China

Ideas, Inspiration & Design 44

Mosaic Techniques 84

Projects 120

about this book

Welcome!

Mosaics are an art form with a balance of artistic sensibility and fine craftsmanship. Mosaic art has graced walls, floors, public spaces and private places since the 8th century BC as decorative enhancements and to share stories of the particular cultural and religious era. And, given its durability, the art form has stood the test of time. Today, fine-art mosaics are making their way into international galleries, museum collections and public art installations. For many mosaic artists, classical methods and traditional materials are used to create both breathtaking reproductions and mind-blowing contemporary abstracts. Some artists are using unconventional materials and new techniques to take the art of mosaic in exciting and bold directions. Many of us find a joy somewhere in between.

This book is for anyone with an interest in mosaic making. Whether you are a novice or professional, it offers information and resources for you to explore. Different mosaic materials and their applications are described in detail. You are guided through the assortment and use of traditional and modern tools, material preparation and creating your studio workspace set-up. The design process, plus the various different mosaic-making techniques and the reasons to choose each one are explained. The projects in chapter 5 are offered to instruct technique and inspire your own creativity.

Many professional artists contributed to this book with expert tips, tidbits to deepen the reader's understanding of a concept, and examples of their breathtaking mosaic artwork. To all my artist colleagues I offer a heartfelt thank you. Your extraordinary handiworks make this book both a rich resource and a beautiful book to display and share.

It's an exciting time to be a part of the world of mosaic. Enjoy your journey and keep creating.

Bonnie Fitzgerald

1 Mosaic Materials

There is a vast array of mosaic materials to work with, from traditional materials, such as stone, marble and smalti, to stained glass, found objects and handmade tesserae. This chapter guides you through the most popular materials on the market today.

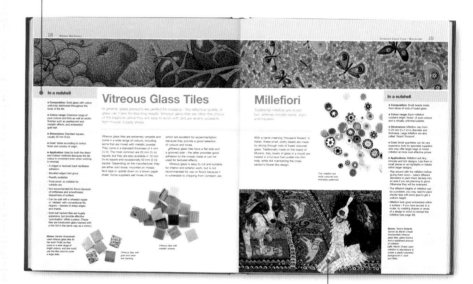

In a nutshell panels summarise key information.

Gallery art by internationally recognised mosaic artists.

2 Tools & Workspace

The tools you need to make mosaics will depend on the materials you choose to work with. Learn about the properties of materials that interest you and what it will take to cut and shape them to fit your designs. Power tools, hand tools and tips to work safely will help you master mosaic making.

3 Ideas, Inspiration & Design

Mosaic art is a journey in which you are constantly discovering new things; as you work on one project you will discover new ideas for the next. Classical mosaic art has taught us a great deal and there is much to be learnt from these traditions. Understanding design principles as applied to the art of mosaic will take your work to a new level.

4 Mosaic Techniques

Technical expertise will enable you to make mosaic art that meets and then exceeds your expectations. There are traditional techniques of mosaic making that have stood the test of time; learn these skills and you will quickly find ways to make your work more pleasing. This chapter also explores new practices and techniques to help you develop your work in fresh and exciting ways.

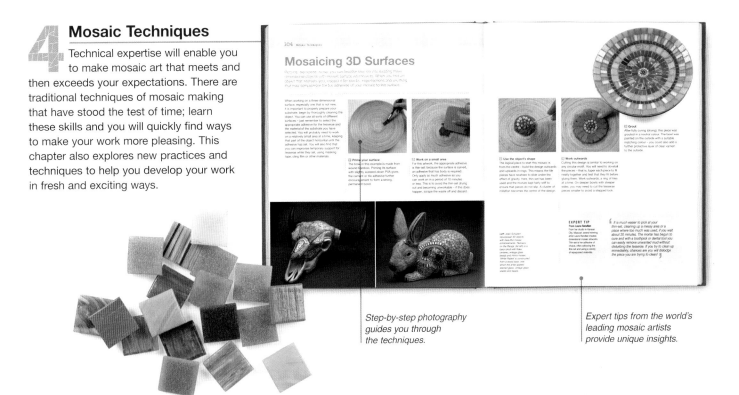

Step-by-step photography guides you through the techniques.

Expert tips from the world's leading mosaic artists provide unique insights.

Ten projects put together all the principles learnt in the previous chapters.

5 Projects

Ten projects have been illustrated and explained in detail for your use as inspiration and to adapt to your own style. The projects have been selected for their versatility of materials, techniques and applications. Whether you choose to follow every step exactly or use as a jumping-off place for your own interpretation, you will find nuggets of valuable information and learning within each step.

Mosaic Materials

There is a vast array of mosaic materials to work with, from traditional materials, such as stone, marble and smalti, to stained glass, found objects and handmade tesserae. This chapter guides you through the most popular materials on the market today.

Stone and Marble

Stone and marble have been used throughout history as mosaic materials because of their durability and accessibility. The earliest known mosaics were made from pebbles as early as the eighth century BC, and the designs ranged from naïve to highly sophisticated works. Today, a range of different stones and marble are quarried for architectural use and for flooring; these vary from soft limestone to hard granite and marble. Of course, you can also choose to sift through the earth yourself, collecting rocks and pebbles from your own garden.

Processing pieces of stone and marble to make usable tesserae will take some time, and special tools may be required, but the beauty of these materials is often on the inside, where crystals and natural imperfections have formed, providing unexpected light reflectors and amazing visual texture. This rough inner face is called the riven edge. Every stone has its own unique quality.

Stone is great for outdoor applications, or inside where its durability is put to use on worktops, fire-surrounds or floors. It is often easier to work on geometric designs that utilise pre-cut squares.

Stone and marble are enjoying a renaissance with contemporary mosaic artists and the materials are finding their way into many fine artworks. These materials are also used for reproductions of ancient mosaics. Fine artists make use of the techniques of master mosaicists, cutting down the materials, properly setting each tessera, and committing to the time necessary to use these materials.

A hammer and hardie can make quick work of most stone and marble cutting. Pre-cut stone and marble are available from speciality mosaic supply shops, although you may wish to cut these pieces down into specific shapes. You can also use large marble or stone 'tiles' by cutting them into rods using a professional wet saw, then processing these rods to exactly the size and shape needed.

The porous nature of stone and marble means that typically these mosaics are not grouted, as they will be stained by grout. A better idea is to work in the direct method, working into a setting bed (see pages 86–89). This technique effectively grouts the gaps between the tesserae from behind, keeping the front side clean. It also allows you to make adjustments for the varying thickness of the tesserae by pressing the thicker pieces in more deeply to make a uniform surface.

Source marble and stone from hardware shops or distributors that sell stone and marble for home installations. Often they will have broken pieces or leftovers from an installation that they are happy to give away.

Stone pebbles are also available to purchase; these tend to have a flat aspect and are uniform in thickness, though randomly shaped, allowing you to produce crackle-effect areas. These are available from a wide variety of sources, including garden centres, quarries and craft shops.

Left: In 'As Night Approaches', Carol Talkov has used split stones to find the magic qualities of the material inside.
Right: This classical reproduction, 'Triton', by Michael Kruzich, is a beautiful example of stone mosaic.

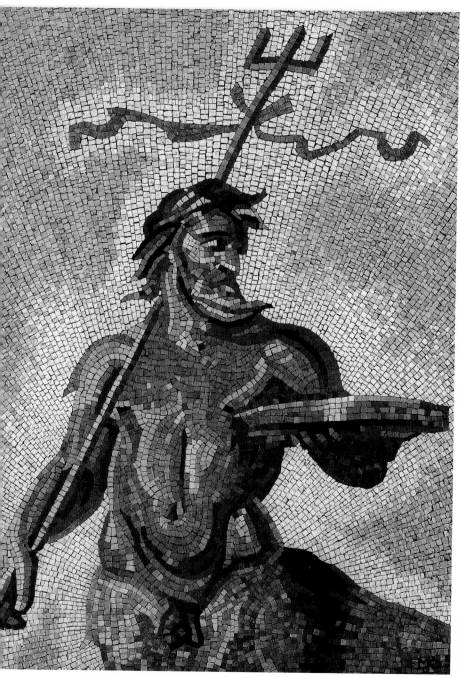

In a nutshell

Mosaic material	Stone	Marble
Composition	A range of different stones are quarried for architectural use and for flooring; these vary from soft limestone to hard granite and marble.	Strictly, marble is a type of stone although it is often highly polished, which gives it a very different, veined appearance.
Colour range	Stones offer a surprising range of colours from cool greens to bright reds and ochres.	Colours range from chalky white to pinks, rose and ochres, through to greens, blues, greys and blacks.
Dimensions	From small mosaic-sized pieces up to very large slabs. Several mosaic suppliers now stock stone pre-cut to reasonable sizes, making the process of creating smaller pieces much easier.	Some mosaic suppliers provide marble as rods, small tiles – about 25 mm (1 in) square, right up to large slabs for worktops and architectural applications.
Applications	Stone is a good choice for outdoor applications, or indoors where durability is important. If you begin with a large piece of stone, you may need a diamond-coated circular wet saw to cut it into rods. Pebbles can be purchased in uniform sizes. You can also purchase randomly shaped pieces of stone.	Marble rods are cut with a hammer and hardie to create individual tesserae, which can be used to create mosaic pictures. For floors, worktops and large areas, pre-cut marble tiles are used in geometric designs.

EXPERT TIP

From Carol Talkov, mosaic artist

Carol Talkov is a mosaicist working primarily in stone, smalti glass, minerals and gems. Her works focus on the abstract, with subjects typically inspired by nature or travel.

I am in a constant state of wonder every time I crack open a piece of stone – the unique quality of each piece intrigues artists and viewers alike. Look to the simple beauty of nature and organic materials. Other natural elements such as gems and minerals provide additional variation in reflection and colours.

Ceramic Tiles

Ceramic tiles can be split into two main categories: porcelain and non-porcelain. By definition, porcelain is a completely vitrified hard and impermeable glass-like ceramic material made by kiln firing between 1200°C (2192°F) and 1400°C (2552°F). Non-porcelain or low-fire clay bodies are reserved for more decorative applications. Ceramic must be high-fired if it is to withstand freeze/thaw cycles.

Above: Detail of 'Labyrinth' by Jolino Bessera, which incorporates a colourful variety of ceramic tiles cut in geometric shapes. Right: 'First Light' by Dianne Crosby displays the subtle yet beautiful palette available in unglazed porcelain.

Small format glazed

Perfect for small projects, these craft tiles are easy to work with and versatile. They come in 20-mm (¾-in) and 5-mm (¼-in) sizes. These colourful ceramic tiles are fully vitrified and can be used for outdoor and underwater projects. You can purchase loose tiles or tiles sheeted on net, in mixed or individual colours. They are water-, weather- and frost-proof, and are very easy to grout. Because of their high glaze they will polish beautifully.

Unglazed porcelain

Most often these tiles are manufactured in two sizes: 25-mm (1-in) squares and 20-mm (¾-in) squares. They are identical on the back and front, making them ideal to work with, regardless of the fabrication technique you are using. They can be cut easily into smaller shapes with tile nippers. To cover large areas, the tiles are available on paper-faced or mesh sheets. They are an excellent choice for floor mosaics because of their durability. Unglazed tiles are porous and should be grouted with care. A sealant is recommended prior to grouting to prevent staining.

Large format glazed

These high-fired (vitrified) tiles have a hard, glazed surface and a broad colour range. They are sold in a variety of ways: sheeted, loose, by the box – even individually. Generally, these tiles are cost-effective in terms of the area the tiles will cover, especially when purchased in bulk. To build up a colour palette, use mosaic suppliers that sell individual tiles. The dimensions vary per manufacturer from 5–30 cm (2–12 in). The thickness varies by place of origin, so mix with care if you wish to avoid an uneven surface on the finished mosaic.

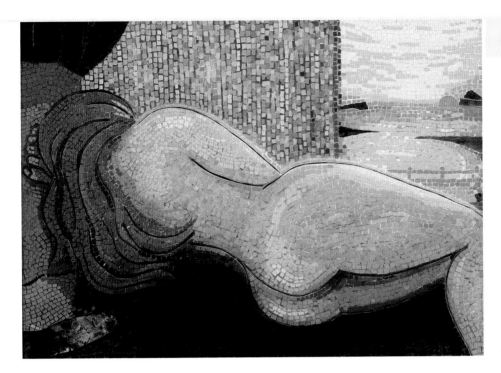

In a nutshell

■ **Composition:** There are two main categories: porcelain and non-porcelain. Porcelain is a high-fired ceramic clay body that has been vitrified. Non-porcelain is a low-fired ceramic body.

■ **Colour range:** Unglazed ceramic has a limited yet rich natural colour selection. Glazed ceramic tiles range in colour from white to black and everything in-between. Speciality tiles are available with unique glazes in a virtually unlimited selection.

■ **Dimensions:** Mass-produced standard-size tiles range in size from 2 x 2 cm (¾ x ¾ in) to 60 x 60 cm (24 x 24 in); however, the most common size available from most mosaic supply vendors is 10 x 10 cm (4 x 4 in) and the largest 10 x 20 cm (4 x 8 in).

■ **Cost:** Varies depending on country of origin, glaze or finish, clay body and whether it is high or low fired. Unglazed porcelain is a very cost-effective mosaic material. Speciality colours such as deep reds and cobalt blue are more expensive because of the pigment needed to obtain such rich colours.

■ **Application:** Low-fire (household) tiles are typically not cold-weather resistant so avoid in freeze zones. The relative softness of the clay tile body makes them easy to shape with nippers. Low-fire tiles are not a good choice for floor mosaics as they may crack under weight. High-fire porcelain and glazed tiles are more challenging to cut, but the colours and finishes may be exactly what your mosaic needs! They are strong and durable.

■ **Best adhesive:** Thin-set mortar is the adhesive of choice for ceramic tiles, although for small, interior-only artworks a good-quality PVA glue can be used. Ceramic is most often grouted.

Below: An important consideration for Jolino Bessera's 'Labyrinth' was that the tiles could take the body weight of those who walk the labyrinth.

Household and patterned	Handmade

Often these are low-fire ceramic and only suitable for interior and decorative work. You can ask the artist or manufacturer, or test the clay body by spraying water on the back of the tile; if it soaks in, the tile is low fire. Sometimes these tiles are hand-painted or detailed with a transfer design under the glazed surface. Generally, they are standard sizes and come in a wide range of patterns and prices. Patterned tiles can be used to provide details and discrete moments of interest within a design.

These tiles can provide unique details and points of interest within a design or be used to make an interesting border. Multiples of handmade tiles are usually made using a plaster mould. There is a huge selection of handmade 'art-tiles' available from potters and ceramic tile artists. If you have access to a clay or pottery studio, you can create other ceramic elements to incorporate in your mosaics in interesting and unconventional ways.

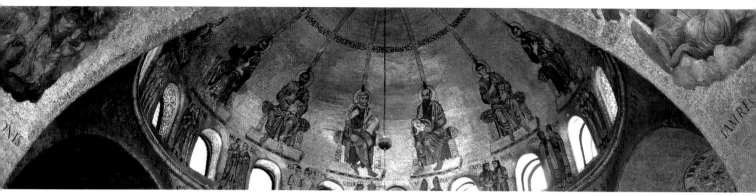

Smalti

Smalti is an enamelled glass formed from molten glass poured into patties, cooled and cut into individual pieces. Most smalti is extremely reflective and is available in a wide range of colours.

The gold smalti used for repairs to the mosaics in the basilica of St Mark in Venice (shown above).

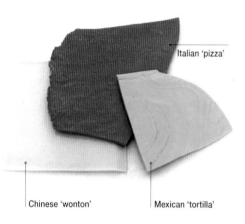

Italian 'pizza'

Chinese 'wonton'

Mexican 'tortilla'

There is evidence that smalti was originally created in Egypt, transferred to Persia, and finally made its way to Greece, where the Romans learned the process of making it. The Venetians imported the technique at the end of the 12th century. Today, smalti is made in several countries including Mexico, China and Russia and manufacturing methods are kept secret to this day. Gold smalti was first manufactured in Italy and used widely in the Byzantine era. Throughout Europe there are many breathtaking examples of smalti in use.

Smalti has different personalities and looks depending on the manufacturer and country of origin:

Mexican smalti: Tiles are relatively inconsistent in colour and size. Interesting texture front and back – each side of the slab is different, so the artist can use the front, the back or the inside since all sides have their own unique beauty.

Italian smalti: Very consistent in colour and size. The inside riven edge of the slab is the most often-used part of the material. Italian smalti is most commonly sold in pre-cut rectangles. Italian smalti is also available in transparent colours (called trasparenti), regular 20-mm (¾-in) square cuts (piastrina) and matt finishes (porosi).

Chinese smalti: Poured into a square rather than rectangular shape. The surface is not as luminous as the Italian and Mexican varieties; nonetheless it has its own beautiful characteristics.

Depending on the country of origin the patties are called 'tortilla' (Mexico), 'pizza' (Italy) or 'wonton' (China). Smalti 'B' cuts refer to uncut or broken parts of the tortilla, pizza or wonton piece. These are finding their way into contemporary mosaics in a variety of ways.

The cleanest and most precise cuts are best done using a carbide hammer and hardie (see pages 29 and 35), the traditional method of cutting this material. However, it can also be cut with a wheeled nipper or glass tile nippers.

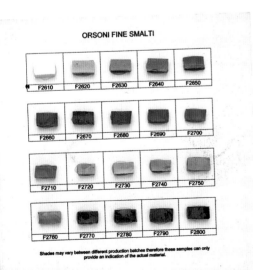

ORSONI FINE SMALTI

F2610	F2620	F2630	F2640	F2650
F2660	F2670	F2680	F2690	F2700
F2710	F2720	F2730	F2740	F2750
F2760	F2770	F2780	F2790	F2800

Shades may vary between different production batches therefore these samples can only provide an indication of the actual material.

Pre-cut smalti tiles are available in a wide range of vivid colours.

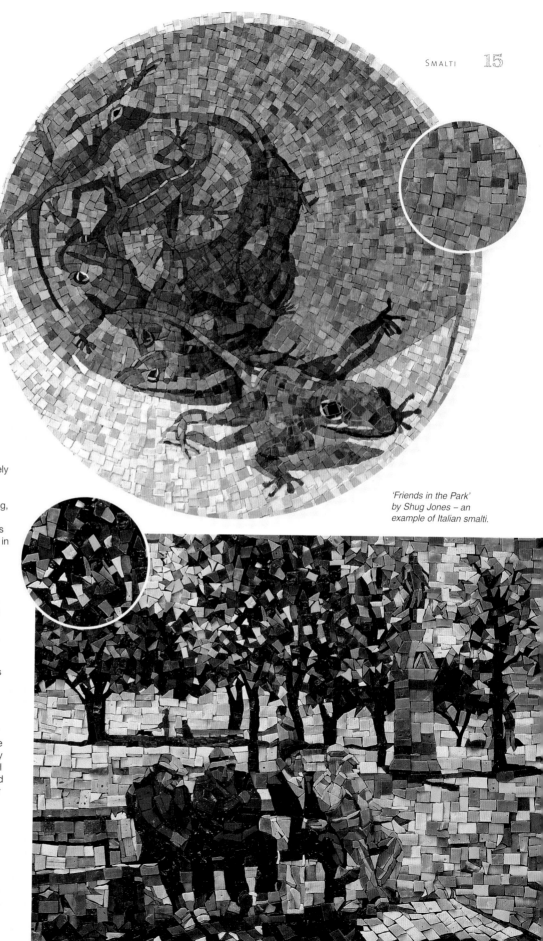

'Coming into the Light' by Shug Jones – an example of Mexican smalti.

'Friends in the Park' by Shug Jones – an example of Italian smalti.

In a nutshell

■ **Composition:** Opaque coloured glass, square or rectangular in section, most commonly available in pre-cut tile-sized pieces, although larger 'B' cut pieces are available through specialist suppliers.

■ **Colour range:** Smalti tiles are made exclusively for mosaic applications so a huge range of colours and finishes is available.

■ **Applications:** This is the classic mosaic material made from molten slabs of intensely coloured glass, which is left to cool before being split and then further cut using a hammer and hardie. Ideal for picture making, these tiles can be used for larger surfaces such as floors, if properly installed. Smalti is freeze proof. Even gold smalti can be used in salt-water pools and floors – there is a thin layer of protective glass covering the gold.

■ **Dimensions:** Depends on country of origin. Italian: Normal/'A' cut – 5 mm (¼ in) thick; Ravenna/'B' cut and pizzas – 10 mm (⅜ in) thick. Mexican smalti is generally 13 mm (½ in) square and 6 mm (¼ in) thick.

■ **Cost:** Expensive – look for a more cost-effective assortment of mixed smalti pieces to begin with. You can always graduate to smalti containing 24-carat gold leaf later!

■ **Best adhesives:** Smalti pieces are traditionally pressed into wet cement (thin-set mortar) or placed using the reverse method (see pages 96–97). Smalti is usually left ungrouted as the surface contains small holes left by bubbles in the glass that would absorb grout. However, when used for floor surfaces, it is often grouted.

Stained Glass

Stained glass, for use in mosaics, is glass that has been coloured by adding metallic salts during its manufacture. We most often think of stained glass in traditional settings, with light passing through the glass: churches, Tiffany lamps and window hangings. Yet throughout history stained glass has proven to be a versatile, durable and beautiful mosaic medium.

Over the past several years, stained glass has become a popular and inexpensive mosaic material. There is a vast selection of colours and textures available, and each manufacturer produces a unique brand. Stained glass varies in opacity: transparent (called cathedral glass), translucent or completely opaque. The opacity makes for lots of creative choices and unique ways to use the material. Textures include smooth, crinkled, seedy and more. Surface finishes are iridised, mottled and stippled.

The most common way to purchase stained glass is in sheets, often called hobby sheets, which measure 30 cm (12 in) square; you can also purchase larger sizes from many speciality shops and online. Sheets of stained glass can be cut to desired shapes with a glass scorer, running plier and wheeled nipper.

The appearance of the glass may be altered by the adhesive and substrate, so beware of how the glass looks in place before permanently adhering in place. Stained glass can withstand freeze/thaw cycles so it can be used for exterior works and architectural installations.

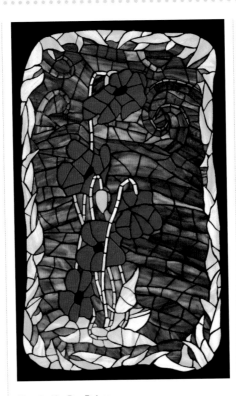

'Poppies' by Bev Delyea combines several different cutting styles and illustrates the wide range of visual texture available in stained glass.

EXPERT TIP

From Christine Brallier, mosaicist and author

Christine Brallier creates stained glass mosaics for the home and public places across the US. Her first children's book, *The Night Before Christmas* (published in 2013), was illustrated with her mosaics.

One sheet of glass can have a large range of values of the one colour, so you don't necessarily have to buy five different sheets of glass to get the darks and lights you want. Cutting from a sheet of glass means you can work with large, complicated shapes or long strips of glass, and then go smaller as you choose from there.

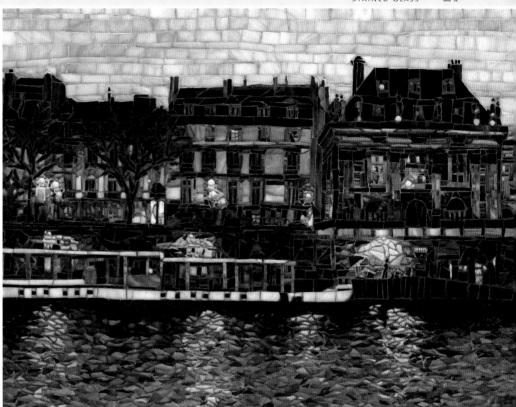

The rich colour palette provided by stained glass and its reflective quality makes for a dramatic and painterly effect in 'Evening Walk on the Seine' by Carl and Sandra Bryant.

In a nutshell

■ **Composition:** Stained glass is made by fusing together some form of silica such as sand, an alkali such as potash or soda, and lime or lead oxide. Colour is produced by adding metallic salts during the manufacturing process. Stained glass is produced as a semi-liquid, poured, rolled and cut into sheets.

■ **Colour range:** Vast, rich and unique colour palettes are available from several manufacturers. Most stained glass is made in America.

■ **Dimensions**: A great advantage to using stained glass is that you completely control the size and shape of your tesserae.

■ **Cost:** Reasonable and competitive with other materials for mosaic artwork. The beauty of mosaics is that even the smallest scrap of stained glass may find its way into your work – waste can be kept to a minimum.

■ **Applications:** Stained glass has countless applications in mosaic art. For interior artwork use your favourite glue on an appropriate substrate and grout (more below). Stained glass can be exposed to exterior elements – it is rated for freeze/thaw. Although not good for floors or table tops, stained glass can be used for water features, outside wall murals and paving stones.

■ **Best adhesives:** Use white thin-set for exterior applications – light will pass through the glass and bounce off the white surface, giving a special brilliance. For interior work, white PVA glue works well.

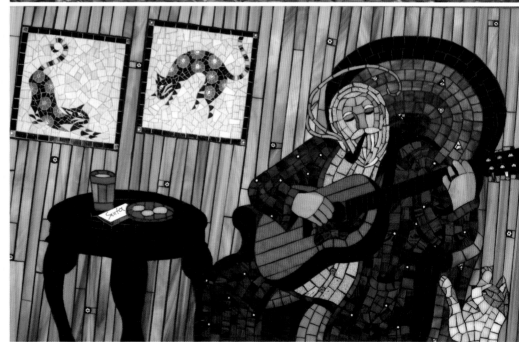

In 'Like a Wreath', Christine Brallier has cut stained glass in traditional mosaic shapes to create a contemporary image of a classical subject.

Vitreous Glass Tiles

In general, glass products are perfect for mosaics – the reflective quality of glass can make for stunning results. Vitreous glass tiles are often the choice of the beginner since they are easy to work with and are widely available from mosaic supply shops.

In a nutshell

■ **Composition:** Solid glass with colour uniformly distributed throughout the body of the tile.

■ **Colour range:** Extensive range of pure colours and tints as well as exotic finishes such as pearlescent and metallic effects, and embedded gold leaf.

■ **Dimensions:** Standard square, usually 20 mm (¾ in).

■ **Cost:** Varies according to colour, finish and country of origin.

■ **Application:** Ideal for both the direct and indirect methods (because the tile colour is consistent even when working in reverse).
- A ridged or textured back facilitates adhesion.
- Bevelled edges hold grout.
- Readily available.
- Frost-proof, so suitable for outside use.
- Not recommended for floors because of brittleness and smoothness/slipperiness of surface.
- Can be spilt with a wheeled nipper or 'nibbled' with conventional tile nippers – beware of sharp edges and shards.
- Gold leaf backed tiles are hugely expensive, but provide effective 'punctuation' within a piece. (These tiles are translucent glass backed with a thin foil in the same way as a mirror.)

Above: Sandra Groeneveld used vitreous glass tiles for her work 'Fruits' as they come in a wide range of bright colours, and she could use the tiles uncut to cover a large area.

Vitreous glass tiles are extremely versatile and come in a wide range of colours, including some that are mixed with metallic powder. They come in a standard thickness of 4 mm (⅙ in). The most common are 20 mm (¾ in) square, but they are also available in 10 mm (⅜ in) square and occasionally 50 mm (2 in) square. Depending on the manufacturer, they are either sold loose, mounted on mosaic face tape or upside down on a brown paper sheet. Some suppliers sell mixes of tiles, which are excellent for experimentation because they provide a good selection of colours and tones.

Vitreous glass tiles have a flat side and a grooved side – the latter provides good adhesion to the mosaic base or can be used for textured effects.

Vitreous glass is easy to cut and suitable for interior and exterior work, but is not recommended for use on floors because it is vulnerable to chipping from constant use.

Vitreous tiles with gold and silver leaf backing.

Vitreous tiles with metallic streaks.

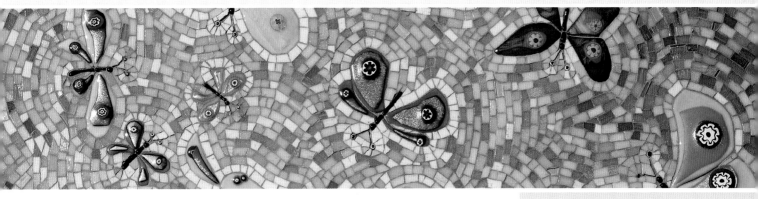

Millefiori

Traditional millefiori are round but varieties include swirls, stars and squares.

With a name meaning 'thousand flowers' in Italian, these small, pretty beads are made by slicing through rods of fused coloured glass. Traditionally made on the island of Murano, Italy, layers of glass in a mould are heated in a furnace then pulled into thin rods, while still maintaining the cross section's flower-like design.

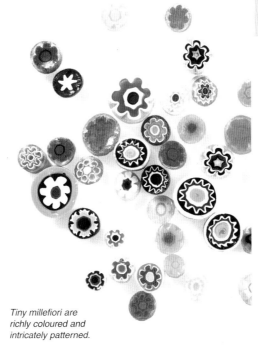

Tiny millefiori are richly coloured and intricately patterned.

In a nutshell

- ■ **Composition:** Small beads made from slices of rods of fused glass.

- ■ **Colour range:** Each millefiori contains bright 'blobs' of pure colours and a virtually unlimited palette.

- ■ **Dimensions:** Millefiori vary from 2–25 mm (⅛–1 in) in diameter and thickness. Large millefiori are also called 'Grand Tronconi'.

- ■ **Cost:** Small quantities can be very expensive; look for specialist suppliers who may offer larger bags of mixed millefiori at more cost-effective prices.

- ■ **Applications:** Millefiori suit tiny, intricate and rich designs. Use them in small pieces or as highlights or details within larger designs.

- - Play around with the millefiori before gluing them down – select different diameters to pack them densely into an area if you are planning to grout. Otherwise they will be swamped.

- - The different heights of millefiori can be a problem; you may need to pack shorter tiles with extra glue to get a uniform height.

- - Millefiori look good embedded within a surface – if you have access to a router, try creating shapes or areas of a design in which to embed the millefiori (see page 39).

Above: 'Sara's Butterfly Dance' by Martin Cheek incorporates vitreous glass tiles, glass fusions and a restrained amount of millefiori.
Left: Martin Cheek used millefiori in abundance to create a playful carpeted background in 'Josh and Mika'.

In a nutshell

■ **Colour range:** Most commonly, 'silvered' mirror, although coloured mirror glass is available.

■ **Composition:** Clear or tinted glass with a reflective metal foil coating on the 'back' of the glass.

■ **Dimensions:** Available in large sheets from glaziers to cut yourself or as small tile-sized pieces – 25 mm (1 in) square – often on a mesh backing.

■ **Cost:** Offcuts from sheets of mirror glass from a glazier are the cheapest option, although you will need to master cutting these to the size you require. You can often purchase 30 cm (12 in) square mirror tiles from home improvement shops that are very easy to cut down for mosaics.

■ **Applications:** Mirror glass has a very retro 'disco ball' look so it is not suitable for every situation! It is certainly not suitable for floors due to its brittleness and sharp edges.

- Always wear gloves and goggles when working with glass; it shatters unpredictably and the shards are particularly nasty.

- Cut mirror just like you would stained glass, using a scoring tool and running plier. Then you can cut the mirror into smaller mosaic pieces with a wheeled nipper.

Mirror

Mirror can have a dazzling effect when used for mosaic. Mirror glass has a retro, 'disco ball' look. The reflection of the surrounding environment becomes an important part of the mosaic design.

Mirror glass is available in large sheets that can be cut down into tile-size pieces. Mirror is made by applying silver nitrate to clear glass, then a coating of copper sulphate and paint are applied for protection. Mirror most commonly appears silver, although coloured mirror glass is also available. Spots that appear on mirror, called 'patina', are due to contaminants or moisture getting through the protective coatings and oxidising the silver nitrate layer. To help avoid patina, seal the back of each tessera with mirror sealant or a coat of shellac, and use an adhesive that will not react with the mirror backing.

Below left: 'Milagro Corazon' by Andrea Shreve Taylor is covered in coloured mirror.

Below right: Adorned with gold-coloured mirror, Andrea Shreve Taylor created a golden retriever figuratively and literally!

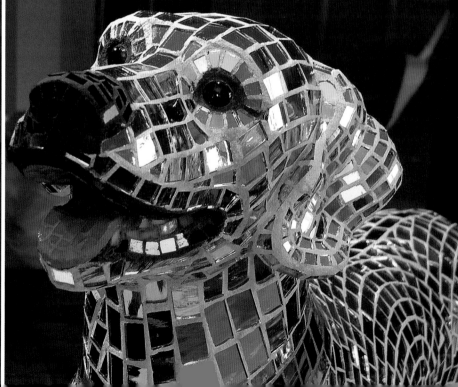

Tempered Glass

Tempered glass is a type of safety glass processed to increase its strength compared with conventional glass and used in applications in which regular glass could pose a potential danger.

Tempering puts the outer surfaces into compression and the inner surfaces into tension. Such stresses cause the glass, when broken, to crumble into small granular chunks instead of splintering into jagged shards. The granular chunks can be used as mosaic tesserae.

Breaking tempered glass for use in mosaics can be intimidating. You must wear safety glasses. To break the glass, wrap it in a towel or heavy plastic. To break the surface tension you must hit the sheet with a hammer on one edge. You will know immediately when it breaks: there will be a 'pop' and the glass will sag. Carefully open the towel or covering and you will see and hear the glass fracturing. Islands of glass are larger pieces of the shattered material that you can use whole or break down further.

Adhesives for tempered glass are the same used for other kinds of glass techniques: white PVA glue, MAC glue, or UV glue. Choose an adhesive that complements your final application: for interior works a clear-drying PVA glue works well. Because tempered glass provides a clear overlay, the artwork under the glass is an important consideration. Paper collages, photographs and speciality paints are all good choices of background art. Your mosaic will glimmer as light is refracted, providing a glimpse of the veiled collage underneath. Grouting is a personal choice. Many artists working in tempered glass use coloured grout, further enhancing the underlying background.

In a nutshell

■ **Composition:** Tempered glass is four to five times stronger than standard glass and does not break into sharp shards when broken.

■ **Colour range:** Most tempered glass is clear, green, bronze or grey. Some mosaic shops carry tempered glass with coloured backings.

■ **Dimensions:** Tempered glass comes in several thicknesses, and mixing thicknesses can be troublesome if you plan to grout your finished work. We recommend staying with one thickness; a common thickness is 2 mm (3/16 in). Most stained glass is 3 mm (1/8 in) thick.

■ **Cost:** Tempered glass shelves can often be purchased from office supply shops or online – you may have to purchase a minimum number of shelves. If a neighbour is remodelling and getting rid of sliding glass doors, they are almost always tempered glass. If you happen to see the unfortunate sight of a smashed passenger side car window, get a bucket – free tempered glass! Frameless shower doors are another economical option.

■ **Application:** When used as an overlay tempered glass makes for exciting, shimmery mosaic artwork. It can also be used in architectural work.

■ **Best adhesive:** Any glue that dries clear works with tempered glass: PVA, silicone and MAC. Be sure your underlay artwork adhesive is dry before applying the tempered glass, otherwise you risk having your adhesives over-soak your underlay and the additional moisture may adversely affect your underlay artwork.

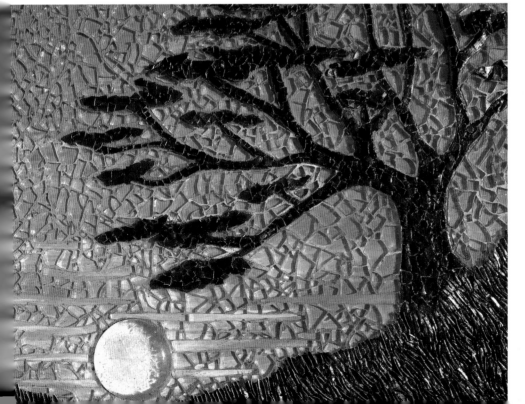

Linda Biggers' 'Silhouette at Sunset' is a vibrant example of a tempered glass overlay. The orange sky is created using acrylic paints and contrasts with the deep black of the tree and grasses.

Handmade Materials

There are countless products on the market that allow you to make one-of-a-kind materials for inclusion in your mosaics. By creating signature tesserae you are adding a personal dimension to your work, making it special and unique.

Above: 'Clone Sacred Shrine' by Bonnie Fitzgerald has a bisque-fired terracotta sculpture at its centre, surrounded by tesserae made from polymer clay. Below: 'Virgin Cuzco' by Laurie Mika is a breathtaking mix of handmade polymer clay elements, vintage jewellery and found objects.

Making ceramic tiles

If you have the opportunity to take a hand-building ceramic class or if you have access to a pottery studio you can make your own tesserae, be they bisque-fired or glazed, hand-sculpted or press-moulded. These elements will be durable and have the added benefit of being your own handiwork.

Making ceramic tiles without a kiln

Air-dry clay comes in terracotta and white colours that you can use for moulds or hand-building techniques. There are also non-toxic epoxy-based sculpting mediums available that will add a new dimension to your mosaic or substrate. You can use these to create signature materials using embossing methods, gold leaf and image transfer techniques. Try sculpting, adorning, glazing, painting and creating batik-effect tiles with inks. The sky is the limit!

Polymer clay

Polymer clay is a type of modelling clay that cures at low temperatures and can be baked in your home oven or a microwave. Although an art form in its own right, polymer clay techniques have found their way to mosaics in many fun and exciting ways. Polymer clay comes in many colours and can be rolled, stamped and treated with mica powders. It is a versatile medium and widely available.

EXPERT TIP

From Laurie Mika, mosaicist and author
Artist Laurie Mika is the best-selling author of *Mixed Media Mosaics*, a handbook for making polymer clay mosaic materials.

❝ A food processor is a great way to condition polymer clay. Use the metal blade in the bottom, throw in a few packs of clay and turn it on. The clay will break into a million little pieces and, as it conditions and softens, the clay will come together into a large, soft ball. ❞

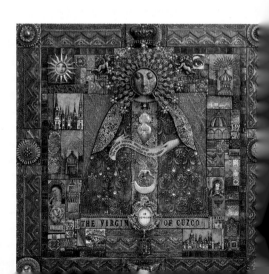

Above: Raymond Isidore's 'La Maison Picassiette' is set back from a modern urban street not far from the centre of Chartres, France. The scale and richness of his project are awe-inspiring.
Below: Melissa Miller's violin is made from old and damaged china collected from antique shops and junk shops.

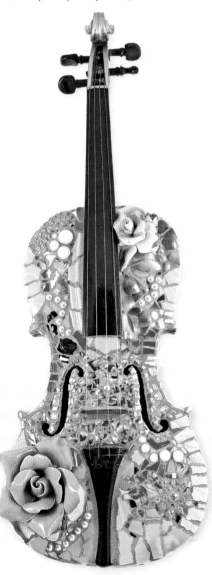

Pique Assiette

Recycle, re-purpose: make green art! Old cups and saucers or plates can provide a rich decorative element to your work. You can usually find suitable old china in charity shops or flea markets. This is also a great way to recycle any accidentally broken, treasured piece of china.

The name comes from the French pique-assiette, meaning 'one who eats from others' plates'. Raymond Isidore is credited as the founder of the art form. From 1938 to 1964 he covered his small house and garden in broken-dish mosaic.

Break the crockery into smaller fragments by placing the pieces inside two plastic bags and hitting them with a hammer. Wearing protective gloves, sort through the pieces and clean up and shape the fragments with tile nippers if necessary. Watch out for shards of glaze left on the edges, as these can be razor sharp.

Flat surfaces from plates are the easiest to work with – the curves found in cups and bowls will make it more difficult to keep the surface of the mosaic flat, requiring you to break these items into smaller pieces.

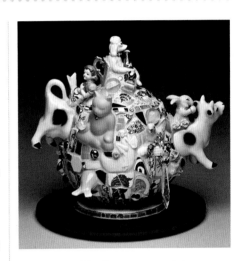

This teapot by Jolino Beserra was created using trinkets and ceramic owned by the client's daughter, creating a uniquely personal montage of her life and a treasured family heirloom.

EXPERT TIP

From Melissa Miller, mosaicist and teacher
Melissa Miller teaches pique assiette through webinars. Her business model is to create art from treasures in your world.

Search flea markets, antique shops, eBay, charity shops and other sources of damaged collectibles to find broken antique china, pottery and more. You should steer clear of new china because the glazes are often unstable.

Found Objects

You are not confined to using manufactured glass or ceramic tiles in your mosaics. 'Found' objects – natural materials, trinkets and vintage jewellery – provide a rich source of alternatives for creating complete mosaics, or elements that you can combine with more conventional materials to give variation and interest to your designs.

Above: *'Earth and Sky' by Bonnie Fitzgerald is a study in using handmade ceramic materials, including pebbles, shells, beads and glass.*

Pebbles

Most pebbles, whether found in a natural environment or a craft shop, are polychrome, black or white. Sort and grade pebbles by colour, shape and size; this will be of great help when using them. Many pebbles are porous, so grouting is not recommended. A better idea is to work using the direct method (see pages 86–89), setting the pebbles directly into the setting bed. This technique effectively grouts the gaps between the pebbles from behind. It also allows you to make adjustments for the varying thickness of the pebbles by pressing the thicker ones in more deeply.

The creation of pebble mosaics is an artform in itself. Working with large stones and pebbles is a skill that requires specific techniques, whether you are working directly on a design in situ or using pre-cast techniques to create slabs for later assemblage. It is essential that the design is built on strong foundations with sufficient concrete or hardcore underneath to prevent subsidence and cracking.

It is better to source larger pebbles and stones from garden or building suppliers, who sell uniformly sized stones. Helping yourself to large quantities from a beach is frowned upon, and may be illegal in many areas.

Beach-combed glass

It will take you a long time to collect sufficient pieces of beach-combed sea glass to complete a mosaic. Bottle fragments tend to be thin and relatively light, and are therefore quite manageable to work with. Many mosaic suppliers stock tumbled glass, made to resemble beach glass, often conveniently sold by colour (also called sea glass). Warning: beach glass is very porous and is best left ungrouted. Because the pieces are translucent, use a white adhesive and white background.

Shells

Shells are commonly used in contemporary mosaics. You can collect suitably sized small shells yourself – give consideration to the environmental impact of this – or you can safely buy them from craft suppliers. You can partially reinforce shells by packing them with the cement or adhesive you are using before placing them in the mosaic. The porosity of shells means that you can't grout them so, as with pebbles, it is best to work in the direct method, pressing them into a setting bed so that they self-grout (see pages 86–89).

Right: 'White Study' by Kelley Knickerbocker mixes shards of broken dishes, glass gems, millefiori, glass rods and stained glass.

Everyday materials

Look at your materials stash – how can you transform or change something? Or can you take something standard and use it in a new way? Try cutting glass gems in half. How about using unexpected items such as nuts and bolts, ball chain, hardware, nails, gems or things from nature processed in a new way? Take a leap and stretch your imagination.

EXPERT TIP

From Kelley Knickerbocker, owner of Rivenworks Mosaics

Visual artist Kelley Knickerbocker's ruggedly dimensional mosaics are a textural distillation of her fascination with contrast, material properties and the technical challenges of mosaic construction.

‘ *Burnishing shiny materials changes the way they handle light and makes them appear softer, more luminous. Deglaze the surface of stained glass, glass gems or glazed ceramic with an acid etching cream (dip for 5 minutes, then rinse/wipe off excess) to give them a beach glass surface that absorbs and diffuses light rather than reflecting it. Voilà, a host of new materials!* ’

Tools & Workspace

The tools you need to make mosaics will depend on the materials you choose to work with. Learn about the properties of materials that interest you and what it will take to cut and shape them to fit your designs. Power tools, hand tools and tips to work safely will help you master mosaic making.

Wheeled nippers

Hand Tools

You only need a few basic tools to create mosaics, but different materials require different tools. Always buy the best you can afford and clean them after each session to remove any glue or tile waste. Good quality tools will last a lifetime if well cared for. There are many different manufacturers to choose from, and your best bet is to look to expert vendors who supply tools for mosaic and glass artists.

Preparing a selection of materials in advance will allow the magic of mosaic making to happen. It is this processing of materials that makes for a good selection of tesserae to puzzle your mosaics with. It is good practice to create a pool of materials to work from: this way you can ensure you have enough tiles and other supplies on hand before you start.

Wheeled nippers
The wheeled nipper, sometimes called a wheeled cutter, is the 'tool of the trade' for most beginner mosaic artists. Wheeled nippers have carbide cutting disks that can be rotated as the edges wear. They are very useful for splitting vitreous tiles consistently into halves and quarters. They also work well for cutting down stained glass strips. There are several models and price points to choose from.

Montolit is a professional-grade wheeled nipper. The tungsten steel wheels are coated with titanium to give them extreme durability. They are tough enough for shaping high-fired porcelain and marble, and gentle enough for glass. The smaller angled wheels allow greater access to the material and the cuts are amazingly straight. The handles are a bit longer to allow better leverage when cutting harder materials, and the design is comfortable to work with.

Bohle makes a professional-level wheel nipper called a zigzag glass nipper. It is ultra lightweight and ergonomic, and makes quick work of precision nipping. For anyone cutting a lot of glass this tool is well worth the investment.

LePonnitt is the most popular wheeled nipper for beginners. The adjustable cutting plates should be tight and level. There is a small pin by one of the plates that, when pulled, opens the jaws of the tool wider, making it big enough to cut thicker glass such as smalti.

Tile nippers
Tile nippers are used for cutting and shaping ceramic tiles. The spring allows you to work one-handed while you hold the tile in your other hand. Invest in good-quality nippers with tempered, well-aligned jaws. Some artists use the nippers for glass tiles, but unless you invest in a good-quality carbide-tipped version, the nippers will often splinter or shatter the glass.

Compound tile nippers
Compound tile nippers have twice the power of conventional carbide-tipped nippers, but require less effort. The compound mechanism is designed for fast cutting, with much less effort than traditional nippers. Many are designed to be non-slip and ergonomic. Designed for use on ceramic tile and stone.

Tile snapper
This tool has a scoring wheel and snapping mechanism, and is used to make accurate cuts in vitreous glass and ceramic tesserae.

Tabletop tile cutter
Tabletop tile cutters are used by professional household tilers, but you can also use these to scribe then crack tiles to quickly split larger household tiles or

Tile nippers

Compound tile nippers

porcelain tiles into strips that you can then break with nippers into evenly sized mosaic squares or rectangles. If you place the tile at an angle you can even cut triangles and pyramid shapes. They are obtainable quite inexpensively from most hardware shops.

Carbide scorer

This is a necessary investment if you plan to use stained glass or mirror in your mosaics. The most popular models for the hobby crafter are the pencil-grip cutters or fist-grip cutters. Either works well and the final choice is a matter of personal preference. The carbide tip must have oil lubrication, and better-quality scorers have an oil reservoir. The scorer does not break the glass, rather it breaks the surface tension of the glass. Some artists use the ball on the end of the scorer to run the score and break the glass. Score the glass and turn it over, then tap on the back of the score and the glass should break cleanly.

Running or breaking pliers

This tool actually breaks the glass. Most running pliers are clearly marked on the top with a dark line. In essence, the plier has a 'frown', the glass score is 'run' by the pressure of the squeezed plier down the curved frown and breaks the glass.

Hammer and hardie

The hammer and hardie (see page 35) are traditional mosaic cutting tools, most commonly used for marble, stone and smalti. Mastering the use of the hammer and hardie takes practice, but you will find it is considerably easier on your arms and hands than nippers; much of the work is done by the weight of the hammer.

Hammers and hardies are manufactured in steel, and the tips are made from either steel or carbide. Hammers are sold in three weights and it is a personal choice which weight works best for you. When in doubt, go for a lighter or medium-weight hammer. Combination hammers are available with one tip for stone and the other for glass. Traditionally, the hardie is set into a log or wooden post. There is a tabletop version available in which the hardie is welded to a steel plate.

Before you use the hardie, set the hardie into a wooden post or log. Drill a hole to accommodate the hardie width, with a minimum 2.5-cm (1-in) air pocket under the hardie. This air pocket prevents the wedge shape of the hardie from splitting the wood. The shoulder of the hardie should be exposed with a 3 cm (1¼ in) reveal. Appropriate hardwood logs to use include maple, oak, walnut, cherry and birch. An alternative is a 15-cm (6-in) pressure-treated wooden post, available at home-improvement shops.

Whether you work seated on a high stool, a standard chair, or standing will dictate the height of your log. The top edge of the hardie should be the same height as your bent elbow when working. Remember to calculate the height of your hardie when cutting your log. You may choose to make a tabletop version using a log; just remember the same elbow-measurement rules apply.

Tile snapper

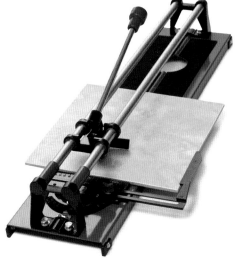

Tabletop tile cutter

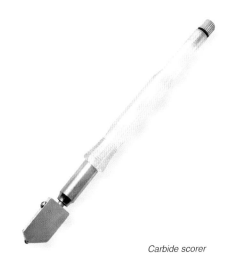

Carbide scorer

Cutting Tiles

Learning to cut tiles accurately is the basic skill that every mosaicist needs. With this basic skill at your fingertips, you will find that your mosaic work really takes off – allowing you to work quickly and creatively. Practice is the key to success.

Which tool?

Use the appropriate tool for the materials you wish to cut.

Glass

The wheeled nipper is specifically designed to cut glass products, including vitreous glass tiles and stained glass. The wheeled nipper can help you trim tempered glass islands to a specific shape. It may also be used for glass rods, millefiori, smalti and other glass products.

Smalti

Many artists like using a wheeled nipper to cut smalti, although the traditional cutting tools are the hammer and hardie. Your wheeled nipper may need to have the jaws opened wider to accommodate the thickness of the smalti, and many models will allow you to make this alteration.

Ceramic

Tile nippers and tabletop cutters will make fast work of these materials, giving clean, straight cuts. The clay body and glaze thickness will dictate whether a simple tile nipper will do the job or if you need to use a compound tile nipper, a tool with more strength. An electric wet saw may be required for very thick, high-fire ceramic tiles.

Stone and marble

Traditionally, stone is cut with the hammer and hardie; however, the compound nipper also works well in many cases. If you are working with large tiles, you may prefer to pre-process them with a wet saw, cutting the tiles into rods from which you can cut smaller tesserae. Large tiles can be cut down using the hammer and hardie, but it will take time to master getting them to manageable sizes.

Dishes and found objects

Many dishes can be cut with one of the tile nippers. If the dish is thin porcelain, wheeled nippers may do the job. There will be times that you need to try a few different tools to figure out what is the best fit for the job. For thicker materials, such as fiesta ware or handmade tiles, try one of the ceramic tile nippers or opt for electric assistance (see pages 38–39).

Smash it

Some artists like breaking tiles and dishes with a hammer. There is an undeniable satisfaction to this approach. Wrap the material in a towel and place it on a sturdy surface – the floor is best. Use a hammer to smash the material. The end result will be more rustic in appearance. When using this technique there will often be undercuts and odd shapes that you will need to trim down using a nipper. This technique is not recommended for stained glass, as it is too fragile.

It takes time and patience to acquire the knack of accurately splitting tiles. It's worth the practice though – once you have mastered the techniques you will be able to consistently produce tile pieces to the shape and size you need. Before you begin making a mosaic you need to prepare your materials. Mosaicists call this 'processing' their materials.

Cutting glass tiles

Vitreous (glass) tiles are hard but brittle, and are likely to shatter unpredictably when you first begin to work with them. Most vitreous glass tiles have a rippled or textured back and bevelled edges. These are designed to aid adhesion and grouting. If you wish to cut very small tesserae you may find that the bevel prevents you from getting a good 'seat' (proper setting of the tesserae in the adhesive). You may find cutting from the centre of the tile, effectively cutting off the bevel, may help with a solid placement. From the outset, it is important to take care and to follow simple safety procedures to avoid cutting yourself. Use appropriate safety wear, particularly eye protection, and keep your work area as free as possible from a build-up of sharp debris and shards.

1 Practise using the wheeled nipper
When working with glass, the mosaicist's primary tool is a wheeled nipper. Take the cutter in your hand, and whether you are right- or left-handed, the wheeled plates should line up with your navel. Hold the tile between the thumb and forefinger of your other hand and line up your cut.

2 Adjust alignment
Squeeze the cutter handles just enough to hold the tile in the jaws, then check and adjust the alignment of the tile. Don't put too much of the tile into the jaws – about one-third of the width of a standard-size tile at most. If you attempt to cut more, the resistance of the tile will be too much, forcing you to grab at the tile handles, which will cause the tile to shatter.

3 Cut with authority
Grip the tile or piece of glass firmly between the thumb and index finger of your hand, and, holding the cutter in your other hand, twist the tool slightly. The idea is to create a fault line that the tile will split along – a line that is a continuation of the tool plates. Once you can see a fault line, squeeze the tool with authority – gentle squeezing will only crack and likely shatter the glass. With practice and patience you will begin to get the results you want.

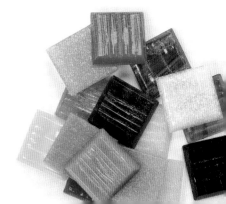

Cutting stained glass

Three simple hand tools are needed for cutting stained glass for use in mosaic: a carbide glass scorer, running pliers and wheeled nippers. First you score the glass with the carbide glass scorer; this breaks the surface tension. Then you 'run' the score with the running pliers to break the glass. From these glass strips you can cut smaller and more precise tesserae with the wheeled nippers.

1 Prepare your materials

Make sure your glass is clean and at room temperature. Decide how you want to cut down your hobby sheet. You will score the glass on the smoothest side. It is helpful to first cut the sheet in half, as this begins to reduce the surface tension and subsequent scores are more likely to break where you wish. If you want to make a straight cut, a ruler with cork on the underside will keep the ruler from slipping.

2 Score the glass

Wear eye protection. It is helpful to stand while you score the glass as it is easier to apply even pressure. Hold your glass scorer as upright (perpendicular) as possible and score the glass from edge to edge with firm and consistent pressure. Start a tiny bit onto the edge of the glass, and finish the score by rolling off the end. It is a personal choice whether you push the scorer away from you or pull towards you. Keep your score firm – enough to see the score, but not so much that you have lots of crunchy glass crumbs along the score. Maintain the same amount of pressure throughout the score. If your scorer starts to go off course, just finish the score. Stopping accomplishes nothing. Do not try to saw the glass with the scorer and do not score exactly over an existing score; all you accomplish is damaging your tool! Use your other hand to hold the glass in place while you score.

3 Run the score

After scoring use your running plier to 'run' the score. The plier jaws are in the shape of a frown; by placing the jaws on the score approximately 1.5 cm (½ in) from the edge and gently squeezing, the glass is bent over the frown and breaks.

4 Process your tesserae

Use your wheeled nippers to process specific shapes of tesserae. If you cut several strips from your hobby sheet you can make quick work of further cutting down the glass with the wheeled nippers. The wheel plates should be tight and the wheels should always face your navel.

EXPERT TIP

From Martin Cheek, an award-winning artist and author
For many years, Cheek worked on animated films and he sees mosaic as a logical progression for him from filmmaking. He teaches worldwide and his home and studio are in Broadstairs, England.

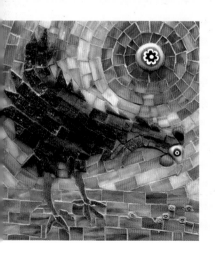

When you want to blend a background – say a sky, to get lighter at the horizon – or an interesting and lively background, prepare a mix of tones you are happy with in a jar and shake it up.

Left: 'Chicken Early Bird' by Martin Cheek uses a mix of stained glass tesserae for the background. The grass is a random mix, all of a similar tone. The sky utilises darker tones radiating out to a random selection of lighter shades.

5 Cutting specific shapes

For larger, specific shapes, draw your pattern directly on the glass with a felt-tip pen. The marker will come off easily with soap and water or nail polish remover. If you use a 'dry erase' marker you can rub off lines with your finger. Follow the same principles as above: score the line you wish to cut, then run the score with the running pliers. If you are cutting around a traced pattern, always cut on the inside of the traced line, or otherwise your piece will be too big. Specific sizes and shapes can be cut quickly and efficiently.

6 Dry lay to check fit

Dry lay your pieces in order as you cut so you do not lose track of how the pieces are meant to fit together.

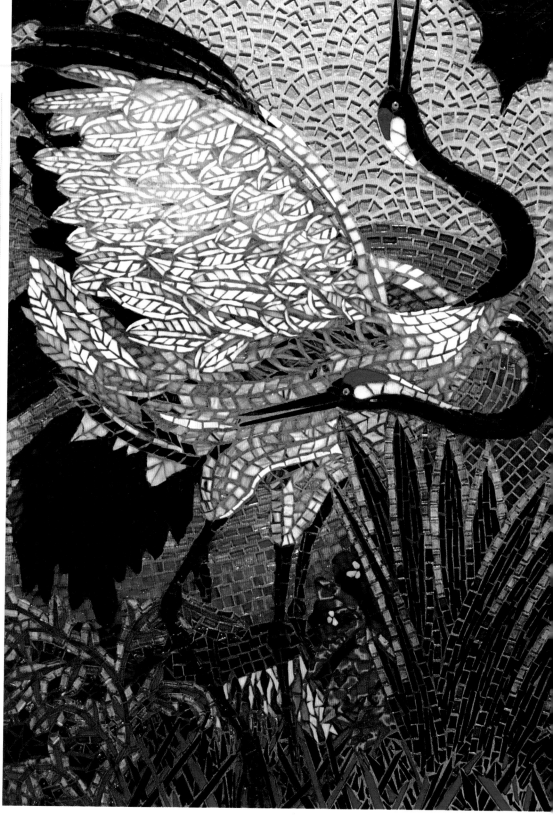

'Manchurian Cranes' by Carl and Sandra Bryant utilises a variety of shapes cut from glass. Brushstroke shapes define the feathers, keystone shapes are used to construct the fan pattern in the background, and the foliage is built from small triangles.

Cutting ceramic tiles

The degree of difficulty in cutting ceramic tiles will depend on whether the tile is high- or low-fired, glazed or unglazed, and on the thickness of the clay body. Whatever the tile composition, you must approach cutting ceramics with care. The higher the ceramic is fired the more difficult it will be to cut. Glazes may crack unpredictably, producing sharp shards in some cases.

1 Using a tabletop tile cutter

A tabletop tile cutter scribes, then cracks the tile. The cutter normally has a moveable arm or wheel with a cutting blade that scores the surface of the tile. Cutters like these are made in large sizes capable of cutting large floor tiles.

2 Cut the tiles into strips

Place a tile into the cutter, pushing it flat onto the stop guard, then move the arm along to score the surface of the tile. Once the tile is scored, bear down on the scored line with the lever. The pressure of the foot over the score will break the score and this should produce a neat strip of tile. You will need to practice a few times to understand how much pressure is needed to score into the surface of the tile, and how much to bear down on the lever to get the tile to break. Work across the tile, breaking it into whatever size strips you desire.

3 Make mosaic pieces

Once you have produced several tile strips using the cutter, you can try positioning these in the cutter and cutting in the other direction, or use the tile nippers to snap each strip into pieces. You can quickly make a stock of evenly sized square, rectangle or triangle tiles that you can cut down further to make appropriately shaped smaller pieces to fit a design as you work on it. Notice how the edges of ceramic tiles are glazed – they look different from the clay exposed by the cut edges.

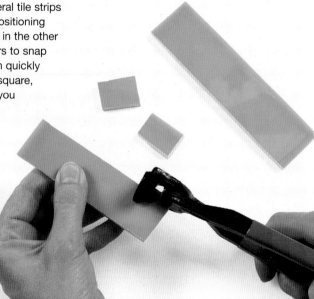

Cutting stone and marble

Place the material you wish to cut on the hardie, holding it between your thumb and fingers. Lift the hammer using your wrist and let it drop onto the material. The weight of the hammer will cut the material – you do not need to add force when striking with the hammer. You can process materials quickly and efficiently into very small tesserae using these tools.

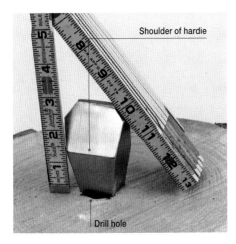

The shoulder of the hardie should sit 3 cm (1¼ in) from the top of the wood block.

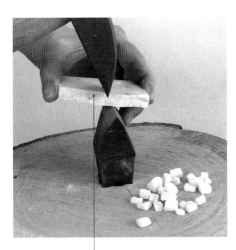

Hold the material between thumb and fingers, before dropping the hammer to cut.

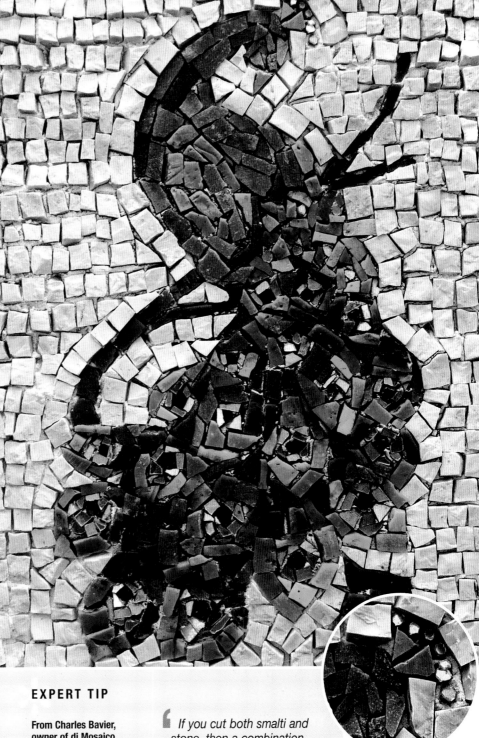

The hammer and hardie were used exclusively to cut the marble and smalti in Jessica Maxson's 'Il Pavone'.

EXPERT TIP

From Charles Bavier, owner of di Mosaico
Located in Tucson, Arizona, di Mosaico is one of the world's premier suppliers of Italian smalti, stone and gold. Charles is also a patron member of the Society of American Mosaic Artists.

❛ If you cut both smalti and stone, then a combination hammer and steel hardie are a good investment. For sharpening your hammer and hardie, you'll need a grinder with the appropriate head. For carbide edges, use a silicon carbide wheel; for steel edges, use an aluminium oxide wheel. Never use a grit lower than 80. ❜

Cutting Shapes

Most mosaic designs can be completed using a fairly small repertoire of basic shapes. It is worth practising cutting triangles, circles and more complex shapes so that you can quickly and accurately cut individual tesserae as you proceed with a design. Here, we use vitreous glass tiles, but the principles for cutting are the same as for other materials.

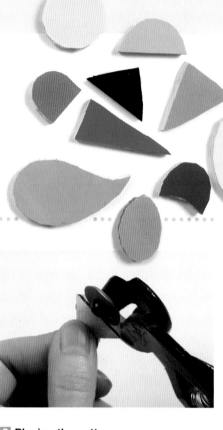

Cutting triangles

Triangles are a simple and useful shape and are the obvious first shape to attempt to cut as they are simply made by bisecting a square tile. Triangles are a staple shape in graphic mosaic designs as they can be easily accommodated within the simplest grid to give variety and movement to flat areas of a design. On the other hand, some mosaicists think triangles, although helpful in graphic and grid designs, can be disturbing to the eye and create a sense of chaos.

1 Marking the tile
If you like precision, use a dry-erase marker or grease pencil and a ruler to draw a diagonal line between opposite corners of a tile. This is your cutting guide.

2 Placing the cutters
Place one of the marked corners of the tile between the wheels of the cutters. The wheels should bear down exactly on the line.

3 Making the cut
Now squeeze the handles of the cutters with increasingly firm pressure – squeeze with authority. The tile should split along the line you have drawn, neatly bisecting the single tile into two identically sized triangles.

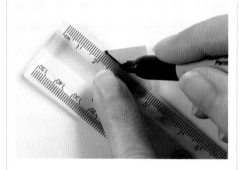

4 Cutting smaller triangles
You can split triangles into smaller shapes by bisecting a tile in half again to give two smaller triangles. If you plan to do this, it is best to draw the necessary additional guidelines in advance – mark both diagonals of the tile (as shown in the photograph). Then, having made the first split, follow the line that runs from the base to the peak of each triangle to split it in two again.

5 Even smaller triangles
For very fine work, you can even split half-size triangles. Again, this is more easily done if you mark up your tile before making the first cut. Draw both diagonals first, then draw vertical and horizontal lines to make a cross which runs through the centre of the tile (as shown).

Cutting circles

The circle is a shape that is often the centre of a key detail, so it is important to get it right. Cutting a circle relies on nibbling techniques: once you have cut a tile to its approximate shape using basic splits, you can use your nippers to gnaw away at the cut edges to create the required final shape.

1 Drawing the outline

The largest circle you can create from a single tile will have a diameter the width of the tile. To draw a circle freehand it may help you to draw a cross to divide the tile into four. Then draw a curve to connect each quarter, turning the tile after each curve. Alternatively, you can use a template.

Tile gauge

If your design is going to require a number of identically sized shapes it is worth cutting batches of these in advance. Create a tile gauge on paper, a correctly sized tile, or another object as a template, then place every tile over this as you cut it to ensure they are all shaped and sized consistently.

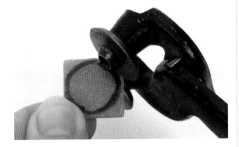

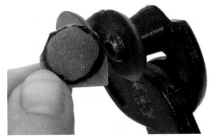

2 Starting to cut

Hold the tile between your thumb and forefinger and put one corner of the tile between the nipper blades so that they are just outside the line of the circle. Squeeze the nippers to cut off the first corner.

3 Nibbling

Rotate the tile a few degrees and follow the line of the circle with a sequence of nibbling cuts. Only try to cut off a tiny amount each time, otherwise the tile is likely to shatter. Continue around the tile until you have a smooth, circular shape. You can tidy up any irregularities by nibbling away any slight protrusions to achieve as near perfect a circle as possible.

Drawing outlines

When cutting circles or other freehand shapes, it is recommended that you draw the outline of the shape to guide the cuts you need to make. This is not cheating – it's a sensible way to ensure that you get accurate and consistently sized shapes, as well as reducing the wastage of expensive materials. A dry-erase marker is ideal for drawing outlines – any residual marks can be easily cleaned off the surface of the tiles before you grout.

EXPERT TIP

From Kim Wozniak, owner of Witsend Mosaic and smalti.com
Based in Pulaski, Wisconsin, Kim Wozniak teaches mosaic across the USA and her art is exhibited internationally.

If using a wheel nipper to cut circles there will be nibble marks left along the edge. If you want the edges to be smooth, use a sanding stone for vitreous glass or an electric glass grinder. For high-fire ceramic you will need a stronger tool – a wet flatbed grinder is my tool of choice.

Electric Tools

Electric tools can make fast work of processing mosaic materials, preparing substrates and helping to finish your work with professional flourish. As with all tools, purchase the best you can afford and then keep them in good working order by cleaning and storing them properly (as recommended by each manufacturer). A power tool is an investment and will serve you for years if well cared for.

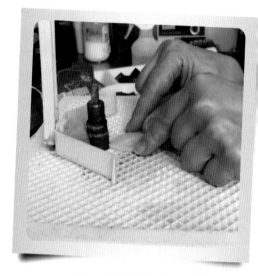

Above: The tabletop glass grinder is a helpful tool when working with vitreous glass tiles or stained glass. Gently push the glass against the grinding head and all nibbles will quickly be sanded down.

Wet saw: professional

Renting a professional wet saw may be well worth the cost for help preparing large amounts of challenging materials in a hurry, especially high-fire ceramic, stone and marble. The wet saw can also be helpful to cut glass figurines, dishes and other oddly shaped ceramic and porcelain materials. Always read the manufacturer's recommendations, and be sure the saw blade is appropriate for the material you are cutting.

Wet saw: craft

These tabletop saws are modestly priced and can be very helpful for cutting as you go when working with ceramic and other materials you cannot cut by hand. The horsepower is substantially less than a professional-grade wet saw and tile glazes may chip as a consequence. Nevertheless, these saws can be very useful for low-fire ceramic and softer materials.

Disk grinder

Also known as a side grinder or angle grinder, this is a handheld power tool used for cutting, polishing and grinding. Different kinds of disks are used for various materials and tasks, such as diamond-blade cut-off disks, abrasive grinding disks, grinding stones, sanding disks, wire brushes, wheels and polishing pads. This is a very useful tool for sharpening your hardie, honing concrete sculptures and cutting through thick surfaces. Use with caution and respect. Follow the manufacturer's directions.

Small rotary tool

This handheld power tool is terrific for many finishing tasks and refinement. By inserting an appropriate bit (or burr) this tool can perform drilling, grinding, sharpening, cutting, cleaning, polishing, sanding, routing, carving and engraving. Both battery-powered and corded models are available. Dremel is the most popular manufacturer of this rotary tool.

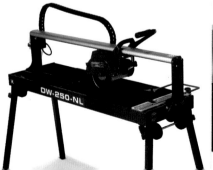
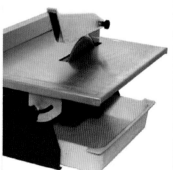

Ring saw

A ring saw is a form of band saw where the band is rigid rather than flexible. Ring saw blades are abrasive. The brittleness of this abrasive coating, and the need to avoid flexure, is why they are made as rings rather than oval bands. As the ring is a circle of constant radius, the blade is not flexed or bent in operation. Ring saws are tools worth owning if you wish to cut glass, dishes or ceramic into special shapes.

EXPERT TIP

From Jolino Beserra, a pique-assiette mosaicist

Jolino Beserra is an artist who creates pique-assiette influenced mosaics as a personal but shared experience. His mosaics are designed with a distinctively graphic point of view to achieve an architectural statement with humour, lasting beauty and permanence. Jolino lives in Los Angeles, California.

When I first started my career as a pique-assiette style mosaic artist, I let the randomness of the broken pieces guide my placement of them. But as I gained experience and wanted to use a specific area of a figurine or piece of ceramic, I became frustrated with the limited tools I had on hand. I discovered a small rotary tool made by Dremel. With a diamond blade, I found that I could mark whatever I wanted to use with a felt-tip pen as a guide and make precise cuts, and shape or carve objects with ease and confidence.

Jigsaw

Modern jigsaws are power tools, made up of an electric motor and a reciprocating saw blade. They have a narrow blade that allows you to cut backing boards into a variety of freeform curves and shapes. Different blades are available; always use the appropriate one for whatever you are cutting.

Router

This is an electric motor-driven spindle tool mostly used in woodworking. For mosaic artists it is used to hollow out shapes from the surface of a board so that tiles can be set flush with the surface. It is also used to rout out spaces where, for example, a mirror would be mounted from behind.

Band saw

A band saw is a power tool that uses a blade consisting of a continuous band of metal with teeth along one edge to cut various materials. The band usually rides on two wheels rotating in the same plane. A band saw produces uniform cutting action as a result of an evenly distributed tooth load. They are particularly useful for cutting irregular or curved shapes and can cut through most mosaic materials.

Glass grinder

Stained glass artists use this to sand rough edges and slight imperfections. These electric grinders have a diamond-surface grinding head. As the motor rotates the head, water from the reservoir below cools the glass as the head grinds. Be sure to wear safety glasses, and keep the grinder's reservoir filled with water and coolant, available from the manufacturer. These tools are readily available online and from stained-glass suppliers.

Other Equipment

Aside from your cutting tools and tessarae, you will need a few other supplies on hand before you start making mosaics. These are generally inexpensive to buy, and most can be found at your local hardware shop.

Containers

Have boxes and plastic containers of different sizes on hand to hold glue and sort tiles as you work. Clear containers are best for tesserae, so you can see what is inside each container without opening every one.

Toothpicks, dental tools and tweezers

For really detailed work you will find your fingers are too big to position the tiniest pieces of mosaic accurately. Position small tiles with tweezers and use a toothpick to align the tesserae. Dental tools are especially helpful for delicate picking.

Cotton swabs

Cotton swabs are ideal for cleaning up small areas of finished mosaics. Use them to remove excess glue and grout and to polish areas of detail.

Sponges

Essential for cleaning down mosaic after grouting – buy sponges cheaply and in bulk from supermarkets, as the tile edges will quickly destroy them.

Squeegees

A variety of plastic or rubber-bladed squeegees are made for grouting. The squeegee simultaneously presses grout into the gaps between tiles while clearing the tile surface of excess grout.

Sanding block

A sanding block is useful for cleaning up baseboard wood substrates after sawing to remove any rough edges.

Rubbing stone or files

The fine-grit side of a rubbing stone or a ceramic or marble file is used to smooth sharp edges. It takes a little practice to

learn how to do this without flaking off pieces of glass, but if you drag the glass at a shallow angle with minimal pressure (instead of pushing it forwards or pressing too hard), you will soon get the hang of it. A rubbing stone or ceramic or marble file can be used on ceramic and stone as well as glass, and can quickly remove any nasty sharp edges.

Graphite or carbon paper

Don't draw it twice: If you like a sketch, rather than trying to redraw it, transfer the image onto your substrate using a transfer tool such as graphite or carbon paper.

Drawing paper and newsprint

It is always a good idea to have large pieces of paper available for sketching, and scrap paper or newsprint for wrapping projects in and helping to confine mess – you can simply throw away a paper worktop after use.

Clean-up brush

A household paintbrush is useful for cleaning your work as you go, clearing away dust and sharp splinters.

Grout colourants and pigments

You can colour your cement products with concrete pigments. Powdered pigments are recommended, although there are many options, including liquid versions. Pigments designed for use with concrete are best and will be UV-resistant. Regular acrylic or craft paint can be used but will fade over time. See pages 114–115, where this is discussed in more detail.

Cork, rubber or felt stickers

Use protective stickers to back finished projects such as coasters and trivets to prevent damage to tabletops and work surfaces.

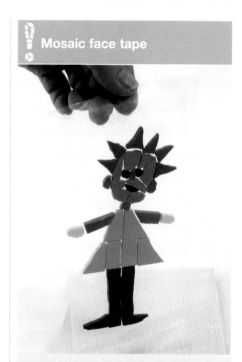

Mosaic face tape

This can save you time and preserve your work in between sessions, or can be used to pick up an arrangement of tiles for installation purposes. To preserve work between sessions, tape the face of your tesserae if you have arranged pieces for use but have not yet applied glue. This will save your work until you are ready to glue it in place.

Palette knives, spreaders and spatulas

There are countless uses for these tools, from mixing grout and thin-set to getting adhesives into small places. Purchase them from the paint and sculpture aisles of your local art-supply shop.

Health and Safety

When working in any art or craft medium, it is important to treat the materials you use with respect, to understand their properties, and to be sensible in how you work with them.

Making mosaics does sometimes require using fairly unpleasant materials such as specialist glues and grouts. Always make sure you read the manufacturer's information about any product you are using, and follow all the recommendations to do with health and safety. You will find you create far fewer problems for yourself if you clean up as you go along, sweeping up tile waste and keeping your workspace clear and organised.

Gloves
Workman's gloves, made from leather or padded cotton, are a sensible precaution when cutting household glass or mirror glass. Strong rubber gloves are essential when applying grout. Latex gloves – the type worn by doctors – are useful when performing detailed work such as painting or cleaning up finished mosaics.

Goggles
You only have one set of eyes; treat them with care! When cutting materials protect your eyes by wearing appropriate goggles or lighter-weight safety glasses. If you do get tile dust or fragments in your eye, rinse thoroughly using an eye bath. Never try to remove foreign matter with your fingers or by rubbing your eyes – the splinters can be very sharp and you risk permanently damaging your eyes. If particles do not wash out, then seek medical help.

Dust masks
When mixing grout or thin-set, or cutting or drilling tiles or baseboards – particularly if you are using power tools such as jigsaws or circular saws – make sure you wear an approved safety mask to prevent breathing in dust. The best masks are rated N95 and have a valve allowing safe airflow.

Ventilated area
When you are working with techniques that produce dust or require the use of chemicals, it is essential that you work in a well-ventilated environment. In most cases, unless you have a workspace with specialist ventilation, this will mean working outside, even if this means waiting for good weather.

Storing materials
Know the physical properties of your art materials (stability) and avoid exposure to excessive heat, humidity and cold. Opened bags of grout and thin-set will be ruined if exposed to humidity or water, and PVA glue will reconstitute in extreme heat. If your storage space is at ground level, store valuables at least 15 cm (6 in) off the floor to prevent damage in the event of flooding.

Disposing of materials
Never dispose of old grout or thin-set (any cementitious material) by washing it down the drain. If you mix grout in a plastic container, any excess can be left to dry completely then emptied into the trash – flexing the container and banging it against the inside of the dustbin or an exterior wall will separate the grout from the sides of the container. Your sink or bucket of cleaning water should also be left to settle so that the cementitious residue sinks to the bottom – decant the water from the top and dispose of this down an outside drain. The remaining sludge should be emptied onto old newspapers that can then be folded and placed in the rubbish.

Protecting your digital files

Many artists have their portfolio, photographs, website backups and countless other important files in an electronic format. Make periodic backups of your hard drive to other storage media.

- Store backup copies off-site or on a digital storage application.

- Store duplicate copies of your CV, contracts, legal papers, contacts, financial and tax records, notes relevant to your creative process and inventories/lists of supplies.

Protecting your workspace

- Be sure to install smoke alarms and have a fire extinguisher on hand for use in an emergency.

- Keep hazardous materials in appropriate containers stored in approved fireproof cabinets away from ignition sources.

- Properly dispose of oily rags and other hazardous waste.

The Studio

Setting up a suitable workspace will allow you to better enjoy the experience of making mosaic art. Even if you need to clear materials away after each use, being comfortable as well as organised in whatever space is available will allow you to work productively and safely. This section introduces some of the important requirements for your studio – whether this is a dedicated room or a tray on your lap.

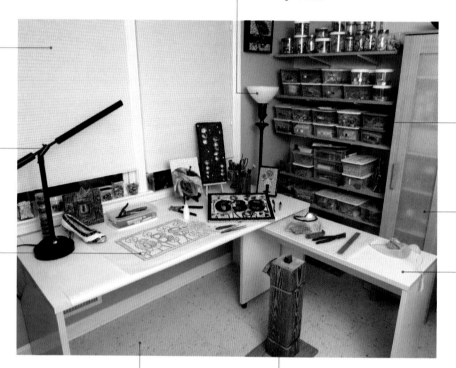

Additional light source

Window for natural light

Directional lamp, which can be positioned over your project

Keep your inspiration nearby, and your cartoons or pattern within easy reach

Materials neatly stored and categorised; have all your materials and tools in your line of sight

Storage space

If available, extra work space is helpful

Lino/tiled floor for easy cleaning

Hammer and hardie

Work surface

It is easiest to work on mosaics at tabletop height. The work surface must be strong and stable. It will inevitably get marked and chipped, so don't use a valued piece of furniture. The work surface will also get wet if you use it for gluing and grouting. An old table or wooden worktop with a sealed or varnished surface is ideal. If you don't have space for an extra table and need to work on your kitchen or dining table, buy an off-cut of board or worktop that you can use as a work surface. Always place a cloth or layers of newsprint between the surfaces to keep the surface underneath from being scratched. As well as being a practical space, your work area should also be somewhere where you can display objects and pictures that provide you with inspiration. Display your supplies and keep your favourite tools within easy reach.

Light

After the work surface, probably the most important requirement for your workspace is good light. Making mosaics requires a lot of close-up work and it is important that you can see what you are doing without straining your eyes. Some artists insist on natural light, because true natural light does not distort the colour of objects in the way that electric light does. However, since the light changes with the time of day and

seasons this may actually work against you. Consider a supplemental light source such as a full-spectrum lamp. This will allow you to see clearly and keeps colours true to life. Most importantly, it helps reduce glare and eyestrain. In any case, the lamp you choose should have a swing-arm, giving a good directional light that you can shine accurately onto your work. If budget and space allow, use more than one light source to reduce shadows cast by your hands and tools as you work.

Floor

Avoid mosaicing on carpet if you can – a tiled or laminate floor is best so that you can easily sweep up tile fragments as you work. Often these fragments are sharp and will work their way into a carpet and damage it, or inflict a nasty cut on anyone walking across it with bare feet. If your workspace is carpeted throughout, buy a heavy-duty plastic worksheet or canvas tarp and lay it down before starting a mosaic session.

A good chair

Find a comfortable chair – an office-style chair with an adjustable back and a variable, supportive seat is a good investment. If you spend long periods mosaicing it is very easy to settle in one position and end up with back and muscle strain. Remember to pause and stretch regularly, and to rub and stretch your hands and fingers. If you are susceptible to back pain, it may help to have a second work surface at a height that you can work at while standing to

Using see-through containers, especially plastic containers and transparent shoeboxes, allows you to see exactly what is inside.

enable you to vary your position more frequently.

Wet area

The luxury of a spare sink in which to mix grouts and clean finished pieces is often the reserve of professional studios. In a home environment, you can use a washbasin for cleaning and a bucket for mixing grouts. It makes sense, if the weather is reasonable, to do any cleaning and mixing outside if possible. If that's not an option, work on a plastic sheet, well away from your artwork, food preparation areas, and anything else you don't want contaminated with grout or dirty water.

Storage

It is worth investing in a set of clear jars or transparent boxes so you can see your materials and find things quickly. If you consolidate different colours or materials in the same container, try taping a few samples on the outside with clear packing tape, to remind you exactly what is in a given box without having to open it. Use separate storage areas for art materials, paints, glues and grouts. Whether you store materials on shelves or in stackable boxes, staying organised will not only make your life easier, it will allow you to spend your time creating and not searching!

First aid kit

A good first aid kit is essential in any workspace, but especially where you are cutting glass, stone and ceramic. Extra Band-Aids are a must!

Keep it clean

■ Try to quarantine your mosaic area from the rest of your living space and sweep up regularly as you work. If you can, wear a dedicated pair of slippers or shoes in your mosaic area, and always wear an apron – this will reduce the amount of tile fragments that you carry into your living areas.

■ Keep an old household paintbrush or dustpan brush on hand to clean tile shards and offcuts as you work. Never brush a fragment or a tile piece clean with your hands; the tile edges can cut you. Make your workspace a no-go area for pets and children – particularly when you are working.

EXPERT TIP

From Laurel Skye, author and teacher
Laurel Skye's signature style is inspired by fabric arts and a fascination with depth of pattern, colour and richness. Laurel teaches worldwide and is the author of *Mosaic Renaissance: Reviving Classic Tile Art with Millefiori*.

Using an easel in the studio for your mosaic work can save your back and neck from unnecessary strain. This arrangement allows you to see your work vertically, as it will be seen when displayed, and will help you view work in progress from a realistic distance.

Ideas, Inspiration
& Design

Mosaic art is a journey in which you are constantly discovering new things; as you work on one project you will discover new ideas for the next. Classical mosaic art has taught us a great deal and there is much to be learned from these traditions. Understanding design principles as applied to the art of mosaic will take your work to a new level.

Inspiration from History

Mosaic is an art form associated more with antiquity than with the modern age, and there is a continuous historical tradition that can be traced from classical Greece to the present day. Perhaps the best place to find inspiration is at the beginning – start your mosaic journey by looking to history and the masters.

Mosaics have a long history that stretches back several centuries BC to when the Ancient Greeks first began to use coloured stones and pebbles to make geometric designs and then pictures. Over hundreds of years these techniques were developed into an art form that also became an industry using manufactured materials. That skill and knowledge was passed to the Romans, who further developed mosaics both as an art and a science. The Romans spread these techniques across their empire.

There have been other great flourishes of mosaic art. During the Byzantine period the eastern Mediterranean churches were richly adorned with mosaics floor to ceiling. Byzantine mosaics can still be seen today in Ravenna, Italy, for example. Later, Islamic artists of the Moorish Empire took mosaic in a different direction, producing exquisite patterns built on the perfection of mathematical ideas.

At the end of the 19th century, with the advent of Art Nouveau, mosaic was re-energised. One man of Catalan decent played a very influential role in this new approach to mosaic. Artist-architect Antoni Gaudí explored organic form and shape in both two- and three-dimensional projects. He created a long series of projects and buildings making great use of decorative, coloured and glazed tiles on building facades, and his highly personalised style featured mosaic prominently. His work was fanciful, bold and sculptural.

It would be impossible to try to illuminate the entire history of mosaics in such a short space, as each era has provoked artists in different ways. However, after reading this overview, hopefully you will be inspired to research particular historical styles and different masters for enriching new ideas.

A Short History of Mosaic

Ancient Babylon	Ancient Greece	Greco-Roman	Roman	Roman influence
In the ancient city of Uruk in Sumeria (in present-day Iraq, Warka) there is evidence of clay cones shaped like bullets pressed into a wet mud plaster to decorate the walls of the city's great temples; these are the first known mosaics.	Pebble mosaics dating from this time were most often mythological imagery. During this era, pebbles were chipped and shaped for greater definition, later it became more economical to prepare rectangular rods of stone from which individual small cubes could be cut as required.	Designs from this era were originally inspired by carpets and came to be typified by a central panel with surrounding borders. Early examples can be found wherever the Greek culture had spread: the Greek islands, Sicily, Alexandria in Egypt and Pergamon (in present-day Turkey).	From the early 2nd century, the fashion for mosaics grew in Italy. They were common features of private homes and public buildings. Not only were the mosaics beautiful works of art in themselves but they are an invaluable record of such everyday items as clothes, food, tools, weapons, flora and fauna. Simple black-and-white designs were prominent.	The Roman influence spread throughout the Mediterranean and North Africa, in Europe and Britain. Though essentially Roman in concept and in character, each province developed a highly individual oeuvre of mosaic work characterised by differences in virtuosity, colour and decorative and stylistic features.

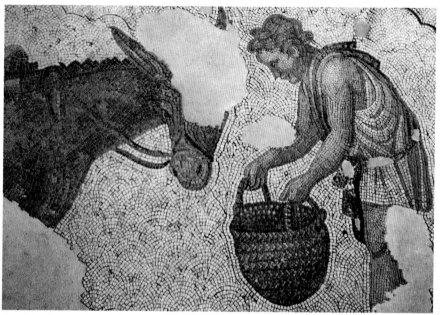

Far left: A Moorish design. Both the Greeks and the Moors contributed to the rich history of mosaics.
Left: This Roman mosaic – situated in Istanbul – is more than 2,000 years old. The Romans took the skill of making mosaics from the Greeks and developed it further.
Below: Deb Aldo looks to past masters for inspiration for her work, such as this pebble mosaic carpet: a modern interpretation of an ancient art form.

EXPERT TIP

From Deb Aldo, a lifelong art instructor and artist
Deb Aldo specialises in pebble mosaics.

Create something original by studying other artists. Look to history and the masters. Analyse what you like about the works you are drawn to: is it the colour, texture, pattern or the mood of the piece?

Early Byzantine	Mid–Late Byzantine	South American	19th century	20th century
Constantinople, also known as Byzantium (present-day Istanbul), was founded in 330 CE. Mosaic work was much encouraged – mosaicists were exempt from taxation – and a mosaic school was founded. Mosaics were lifted from the floors to the ceilings during this period, using glass material to create glowing areas of colour and luminescence.	From approximately the 10th to the 13th centuries mosaics flourished throughout Europe, the Arab lands and Africa. Gold backgrounds and colour blending played a dominant role in many designs.	During the 16th century Europeans marvelled at the artefacts arriving from South America – the spoils of the Spanish conquistadors pillaging Mexico and Peru. Some of the treasures were of Aztec origin and covered with precious stones, rare shells, mother-of-pearl and gold.	An upsurge of architectural mosaics occurred because of the pioneering invention of the reverse method (see pages 96–97) by two Italians: Antonio Salviati and Lorenzo Radi. In England, Queen Victoria spearheaded a mosaic renaissance with the erection of an elaborate memorial adorned in mosaic to honour her late husband.	A number of well-known artists worked with mosaic, at least in part, helping to explore and expand its boundaries. Diego Rivera and several Latin American associates produced large-scale public murals with a strong sense of social identity. Antoni Gaudí made his mark in Spain with mosaics of a totally different flavour.

Inspiration Around You

You can find ideas to develop your mosaic work from myriad sources: a piece of fabric, a vintage children's book, or even a particularly beautiful delicate leaf. Keep your eyes open for inspiration, whether you are visiting an art gallery, walking on the beach or looking through an old box of greeting cards.

Children's drawings

Paper and packaging

Fabric

Children's pictures are often inspiring due to their simplicity, and the unselfconscious way in which children put colours together and reduce things to simple shapes.
A wonderful way to preserve a child's memories would be to create a mosaic based on their artwork. If you have children in your life, make mosaics with them. You will be inspired by their fearless imagination and simple interpretation of their subject matter. Give yourself permission to play and make art like a child. You may find taking a lighthearted approach impacts your work in very positive ways.

Scrapbooking materials, wall papers, wrapping paper, even sheet music, all provide mosaic artists with lots of visual inspiration. Keep remnants of paper in a binder or box file and refer to them when you are looking for patterns and backgrounds to use in your own designs. Wrapping paper offers strong two-dimensional motifs that you can easily cut out or copy using a light box. Sheet music provides strong, graphic lines.

Quilts, woven and knitted fabrics and crochet motifs are often particularly suitable for adaptation into mosaic designs; they adhere to a simple geometric grid in the same way that mosaic patterns usually do. However, patchwork quilting is probably the fabric that most closely resembles mosaic. Each piece of the patchwork is, effectively, a cloth tile – some quilts you could almost duplicate using patterned pieces of tiles cut proportionally to the same shape and size.

You can collect swatches of fabric to refer to when looking for suitable colours to use in a design, and extend your collection by looking in charity shops, or visiting online auction sites, where you can find a truly amazing variety of fabrics from around the world.

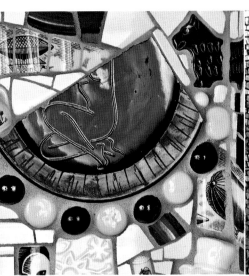

Crockery

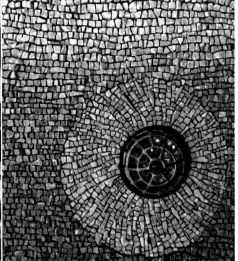

Think out of the box

Far left: This delightful penguin mosaic by aspiring young artist Madison Towle reminds us that simple can be very beautiful.
Centre left: 'The Phantom Musique' by Marley Goldman is a detailed mosaic interpretation of sheet music.
Centre: 'Kaleidoscope Quilt' by Cynthia Fisher captures the detailed repeated patterning in mosaic inspired by a quilt.
Centre right: Jolino Beserra created a visually stunning yet playful backsplash using a wide variety of broken crockery he had been collecting over many years.
Far right: Pondering her limestone gravel driveway, Rachel Sager was inspired to create 'Driveway' by varying the size and direction of just one kind of stone. The circular metal element is an old flower frog set deep into the substrate and underlaid with gold smalti.

Household crockery and floor and wall tiles are other readily available references for the mosaic artist. You can collect old pottery and tiles quite inexpensively – their condition is not too important as the odd chip or crack will not affect their value to you. Look for unusual colours and unique patterns to bring unexpected visual texture to your mosaic.

Use unexpected materials that you come across stashed away at home: a container filled with your dad's old screws and nails can be an interesting tesserae possibility. Grandma's button collection may make a very charming border.

Even the most mundane objects in your world can prove inspirational – either as a design idea, an unexpected mosaic material or both. How about the stones in your driveway or the broken pieces of some object once purely utilitarian? Be open to the possibilities these objects might contain.

EXPERT TIP

From Pamela Goode, a mosaic artist based in Charlotte, North Carolina, USA

Pam is the founder of Ciel Gallery, presenting juried international exhibitions focusing on mosaic art. She is also the founder of Mosaic Art Retreats, a blog featuring mosaic art travel adventures worldwide.

My solution to getting out of my own repetitious agenda is to get outside my head by getting out of my house. Even walking to the mailbox on the corner or driving through a few distant neighbourhoods is enough to reset the gears and give my creative side a treat. The sound of the birds replaces my routine inner humming; the curve of a petal resets my interior imaginings; a pop of chartreuse refracts possibilities through my eyes.

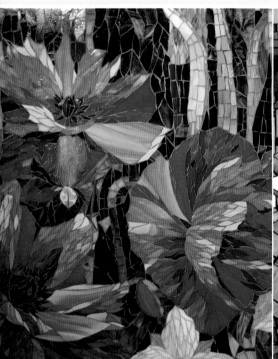

From nature

Nature provides a broad collection of inspiration-rich items from shells to pebbles, leaves and grasses, tree bark and flowers. There are countless natural objects that can be used as a point of departure to be interpreted in either abstract or realistic ways. Think about a beautiful landscape, an interesting weather pattern like a storm front or the ocean waves. These are all images filled with visual texture, strong lines and interesting possibilities for mosaic art.

Above: *This detail of Yulia Hanansen's 'Chippewa Creek' is a magnificent interpretation of red poppies.*

The creative environment

Are you feeling stuck? Reboot your creativity with some simple exercises. Go outside, get some fresh air: take a walk, shake off the cobwebs and clear your head. Sometimes a simple change of scenery gets you thinking in new directions. Even a walk down your street can prove energising and inspirational.

Travel close or far depending on your time and budget. Travel is a great way to recharge and to see things through new eyes. Art-driven travel can be especially rewarding: workshops that span several days or trips offering cultural experiences. Visiting new places, learning about a new culture and seeing new things always prove inspirational.

Cities provide strong imagery through architecture, industrial sites, transport and machinery, not to mention their colourful signs and logos. Imagine your favourite city in the world, whether you have actually been there or not. The skyline, the unique buildings and geography: what new images does this conjure up for you?

Above: *Brenda Pokorny's 'View of Prague' captures the beauty of the architecture in an old residential neighbourhood.*

Keep a scrap box

It may be that what interests you won't fit into a two-dimensional book or is impossible to pin to a board – pieces of china or natural objects like shells and pebbles, for example. In this case, create a scrap box – perhaps using an old shoebox or a plastic container so you can see what is inside it – and keep any three-dimensional objects that take your fancy. The scrap box shown here contains all sorts of images and souvenirs collected when travelling: postcards from art exhibitions and of the Byzantine mosaics in Ravenna, Italy, as well as illustrations clipped from magazines and catalogues.

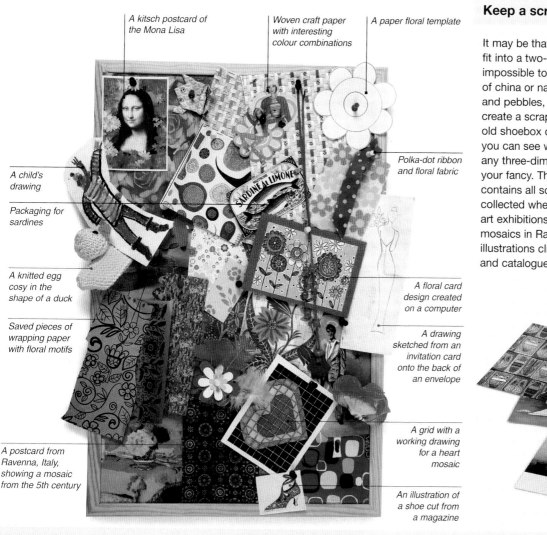

A kitsch postcard of the Mona Lisa

Woven craft paper with interesting colour combinations

A paper floral template

A child's drawing

Packaging for sardines

A knitted egg cosy in the shape of a duck

Saved pieces of wrapping paper with floral motifs

A postcard from Ravenna, Italy, showing a mosaic from the 5th century

Polka-dot ribbon and floral fabric

A floral card design created on a computer

A drawing sketched from an invitation card onto the back of an envelope

A grid with a working drawing for a heart mosaic

An illustration of a shoe cut from a magazine

Hang a pin-it board

A bulletin board or pin board above your work area, or a scrapbook kept close at hand, are excellent ways of recording ideas and inspiration. Get into the habit of collecting and keeping things that you find visually interesting or unusual – whether it is a torn-off corner of wrapping paper, a photograph you have taken or a postcard of a painting that you particularly like. What is often interesting about the things you collect in this way is the juxtaposition between them – try to keep things flexible so you can move pieces around to play with ideas. If you have the space, a bulletin board is especially useful in this respect, as it allows you to change things around and provides a constant reminder of the inspiration that you have come across. You can also collect content online using sites that allow you to share and save images, such as Pinterest or Flickr.

Look for creative hubs

Look at other art, both mosaic art and works by other kinds of artists. Visiting an art gallery or museum can remind you that creative people just keep working through their 'stuck' moments.

The Internet is loaded with information about mosaic organisations, materials, workshops and conferences; and there are tons of inspirational images at your fingertips. From the comfort of your home, resources abound. You will find many organisations listed in our resource section (see pages 156–157).

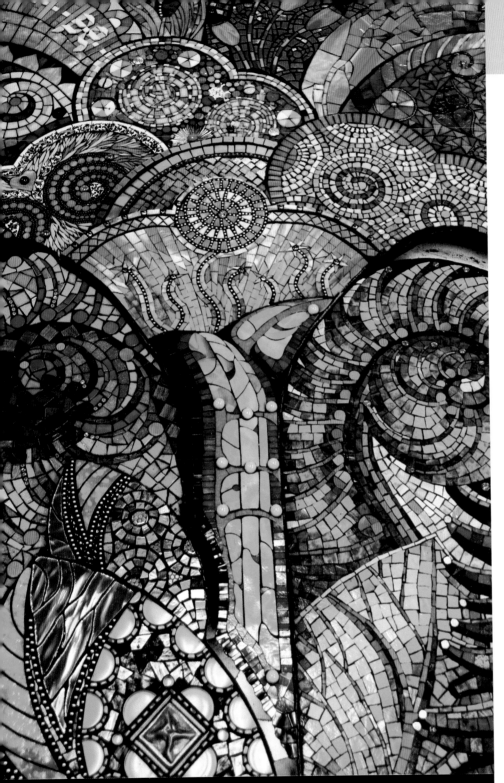

Pam Goode and Lin Schorr invited 55 international artists to create a section of this piece, 'Unfurled'. Each working in their own style, with their own voice, and in their own studios; a team later assembled, grouted and installed the finished piece.

Take your time and learn as much as you can about the different materials, master new techniques and take an interest in the technical aspects of mosaic making. Every new technique you learn can give you inspiration to work in a new way. Even once you believe you have found your style, there will be times you feel stuck. Here are some ideas for helping you find direction, stay motivated and get unstuck.

1 Use your senses

We learn best when all our senses are involved in the creative process.

■ **Sound:** What sound is made when you cut different materials?

■ **Sight:** Examine each new material closely: How does the light refract? What colours are you attracted to?

■ **Touch:** Feel each tessera as you place it: Is it smooth or rough? Think about how the texture might interact with grout and other materials.

■ **Smell:** Your sense of smell is a more useful tool than you might imagine. Does the process of tile cutting produce an odour? This could indicate the material is getting hot. Does the beach coral have a salty smell? What memories does this evoke?

■ **Taste:** We do not recommend you taste your tesserae, but certain materials are shiny and yummy to look at. As bizarre as it may sound, does your work whet your appetite?

2 Have fun

For any new undertaking to succeed there must be an element of fun. Play with your materials and try different arrangements. Combine different materials in unexpected or new ways. Laugh at your mistakes and revel in your successes.

Find Your Style

We each have our own personal style, our own likes and dislikes, and preferences for particular materials. Mosaic is a very big subject and finding your voice among the maelstrom is a challenge.

Cherie Bosela used the colourful world of insects as inspiration for this series of mosaics. Each is unique and each employs a different cutting style.

3 Become a master

Learn the techniques and technical realities: mosaics have been made for centuries; some things work and some things do not. Having a strong foundation in technical information – knowledge of adhesives, choosing the right substrates, understanding freeze-thaw ratings – allows you to create your artwork more freely, yet it will be constructed to stand the test of time. Once you understand the rules of mosaic from opus to design principles, you can break them with confidence.

4 Be curious

Curiosity is an emotional response to a thirst for knowledge. Find excitement in trying new things, experiencing new materials, focusing on a different subject matter and using colours that are not usually in your repertoire.

5 Make prototypes and sample boards

Have a great idea but not the time or treasure to expand on it right now? Make sample boards: keep small substrates handy, and appropriate adhesives, and make samples that you can refer to later. Keep these in your studio – when stuck for an idea they will serve you well.

6 Work in a series

By creating a collection of works that are related in some way – perhaps by theme or materials – you challenge yourself to more fully explore a concept.

7 Practice makes perfect

Even Rembrandt did not make a masterpiece every time he picked up a brush. Do not pressure yourself into having to make an award-winning artwork every time you sit down to work. The more you do anything the better you get at it, and a few mistakes are inevitable.

8 Experiment

An experiment is defined as an attempt at something new or different; an effort to be original. Ask yourself: What happens if...? Challenge yourself to new and original ideas. Let go of preconceived notions of what your work should look like.

9 Get out of your space

Leave your comfort zone, physically, emotionally and creatively. Set new goals that are specific and attainable, such as: 'Today I will go for a walk and come home with three new-found objects. I will use one of those objects as an anchor element in a mosaic I begin this week.'

10 Get feedback

Show your experiments and work-in-progress to others whose opinions you trust and value. If you have artistic friends they can be great sounding boards. There are many online groups for mosaic artists that you can join to ask questions and share your work. The community of mosaic makers is filled with interesting, like-minded people who want to share in the magic of mosaic making.

EXPERT TIP

From Pam Givens, the founder and creator of Contemporary Mosaic Art (CMA)

CMA is a dynamic international community encouraging member participation. It hosts forums, has numerous groups addressing countless aspects of making mosaics, and has a membership of over 2,000.

The Internet has become an invaluable tool for the mosaic enthusiast. It is now possible to be inspired by viewing exhibitions in Chartres, France, when you live in San Francisco; to get alerts about and visit exhibitions in your local region; to hunt down hard-to-find materials; and study with mosaic masters from all over the world. Having this snapshot of the contemporary mosaic art world is invaluable for the mosaic artist.

Get out of your comfort zone and have fun playing with unexpected materials, such as shells.

Design, Composition, Colour

The most successful mosaic work reflects an understanding and respect for fundamental design principles. By using the elements and principles of design, such as line, shape, space, form and colour, your work will develop a professional quality.

Three-dimensional form is captured by the light and dark areas in 'Bridesmaids' by Bonnie Fitzgerald.

Design and composition refer to the planning and arrangement of form and colour in two- or three-dimensional work. The rules of design apply whether your imagery is abstract, geometric, pictorial, figurative or symbolic. The most crucial factor in creating a successful mosaic is the interrelationship between the design and the placing of the materials.

Line

A line represents a path between two points. It can be horizontal, diagonal, straight, curved, vertical or zigzag. Lines suggest direction and imply motion. The direction and orientation of a line can also imply certain feelings. Horizontal lines imply tranquility and rest, whereas vertical lines imply power and strength. Oblique lines imply movement, action and change. Curved lines or S-shaped lines imply quiet, calm and sensual feelings. Lines that converge imply depth, scale and distance: a fence or roadway with lines that converge into the distance provides the illusion that a flat, two-dimensional image has three-dimensional depth. Because the line can lead the viewer's eye it is an effective and important element of design.

Shape

Shapes are the result of closed lines. Primary shapes include circles, squares, triangles and hexagons; and all primary shapes appear in nature in some form or another. Shapes can be visible without lines when an artist establishes a colour area or an arrangement of objects within the canvas of their work (see Form, opposite).

Space

Empty space is defined and determined by shapes and forms. Positive space is immediately created when shapes and

Right: 'Central Park in the Snow' is an excellent example of using 'line' to obtain perspective. Carl and Sandra Bryant draws the viewer up the path and to the building with curving lines, and defines the architecture with horizontal and vertical lines.
Below: Carol Shelkin balances positive space (on the left) with an equal amount of negative space (on the right) in 'Wishes'.

forms exist; negative space is the empty space around shapes and forms. This principle applies equally to two- and three-dimensional artworks; negative space is often the background area on the 'canvas'. For images to have a sense of balance, positive and negative space are usually used to counterbalance each other.

Form

Form refers to the three-dimensional quality (the shape) of an object, which is created in part by light and dark areas in art. When light from a single direction (the sun) hits an object, part of the object is in shadow. Light and dark areas within a two-dimensional image provide contrast that can suggest volume.

Colour theory

An introduction to some basic colour theory will help you to understand how different colours will work when placed together, and therefore help your choice and organisation

Yellow-orange
Yellow
Orange
Yellow-green
Red-orange
Green
WARM COLOURS
COOL COLOURS
Red
Blue-green
Red-violet
Blue
Violet
Blue-violet

This colour wheel, created by Lynn Chinn, used smalti mosaic pieces sorted into primary and secondary colours. The end result shows how a mosaicist is always limited by the tiles that are available to them – because you cannot mix your own colours, there will always be gaps in the colour palette available to you.

Bonnie Fitzgerald used mostly analogous colours in 'Green Apple Study', making for a harmonious composition. The simple colour choice and the opus tesselatum background both complement the main subject matter beautifully.

of colours within a mosaic design to produce different moods and other effects.

Unlike paints and other artists' media, the colours in the mosaic palette are determined by the tesserae pieces you have – you cannot mix your own colours. The advantage with mosaics, however, is the purity and brightness of the colours available: mosaic designs often work best with a bold and decisive use of colour that plays to the strengths of the raw materials.

The colour wheel

The colour wheel organises colours to show clearly how they interact with each other. The wheel places the three primary, or pure, colours equidistant from each other around the edge of a circle – red, blue and yellow. In between are the secondary colours that result from mixing the primaries on either side: purple (red mixed with blue), green (blue with yellow) and orange (yellow with red). The wheel continues in this way, with more colour gradations created by the mixing of adjacent colours – so, for example, to one side of orange will be a yellowish orange; on the other side a reddish orange.

Colours that sit next to each other on the colour wheel, such as red and orange, are analogous; they are usually described as being harmonious. Complementary colours are contrasting colour pairs that belong to opposite sides of the colour wheel – for example, red and green. When placed side by side, complementary colours make each other appear brighter.

The colours you choose should be led by the design itself, the effect you want to create, and the context in which the piece will be displayed – for example, a design made up of harmonious reds and oranges will look quite different when hung on a blue wall.

Gila Rayberg uses surprising and unrealistic colours – but that are the correct values – for the portrait 'Lost in Thought'. The strong red, blue and green tones are complemented by the yellow background.

Ilona Brustad uses naturalistic, realistic colours in 'Remembering'. Her choice to carry the monochromatic palette throughout the piece makes for a harmonious and thoughtful work of art.

Useful colour terms

■ **Hue:** These are the pure colours described by names such as red or purple. Within each hue, colours may be differentiated depending on their brightness or saturation – for example, electric blue; or the degree of lightness or darkness – for example pastel blue.

■ **Warm and cool:** Colours are often described as warm or cool depending on their associations. Warm colours are thought of as the colours from red to yellow, including browns. Cool colours include the hues blue and green, and also greys. Warm colours seem to push themselves forward within a design, whereas cooler colours tend to recede backwards.

■ **Value:** Value, or tone, is the degree of lightness or darkness of a colour. Two colours can be of the same value, though of different hues. To help understand this idea, imagine two tiles: one orange and one green, placed side by side. If the tiles were of the same tone they would appear identical in a black and white photograph.

■ **Contrast:** Contrast describes the variation in hue or tone within an area of colour or design. Where colours of opposite hues are placed against each other or where there is a variation between lightness and darkness, then this would be described as contrasting.

■ **Intensity:** This signifies the purity or saturation of the colour.

■ **Monochromatic:** This term describes the use of a single colour or hue, where only the value of the colour changes.

■ **Analogous:** Colours that are adjacent to each other on the colour wheel, such as yellow and green, are described as being harmonious. These analogous colours are often used in visual design and have a soothing effect.

■ **Complementary:** Describing colours positioned across from each other on the colour wheel, complementary colours exhibit more contrast when positioned adjacent to each other. For example, yellow appears more intense when positioned on or beside blue or violet.

Value

Value describes how dark or light a colour is (also called the tone of a colour). Two areas of different hues but of the same value will appear closer together and more harmonious than areas of very different or contrasting values. The value of an object will appear to change relative to its surroundings – so the same tile surrounded by lighter or darker tiles appears to be of a different value.

Within mosaics, value, or tone, is perhaps the most important consideration when choosing grout or if you colour your thin-set. In most mosaic designs there will be a range of tiles of different colours. To hold the design together it is therefore best to choose a fairly neutral colour – typically a grey that will not clash with any of the tile colours – then darken or lighten it to a tonal value close to the majority of the tiles in the design. Grout of the same value as the tiles will tend to hold the design together – a value that is too dark or too light will tend to fragment the design.

The easiest way to compare the values of different tesserae is to half-close your eyes – this suppresses the hue of the tiles, and makes it easier to see the relative lightness or darkness of the different tiles. A black and white photograph achieves the same effect more accurately – completely removing the hue of the elements of a design and clearly showing the relative light and dark of the components.

Within conventional pictures, lighter values and tones tend to recede into the background and seem farther away, while darker, stronger tones appear to be more in the foreground.

A gradation of value has a more natural attraction than flat areas. Using equal value, light puts an end to curves and planes – you will make your mosaic seem flat. If you want your mosaic to look flatter, use the same tone with no gradations. To make an impact and have texture that gives the impression and appears as if it is a three-dimensional surface on a flat substrate, use gradations. Make highlights bright and create deep, dark shadows.

Tonal Difference
Here, tiles have been laid out in vertical bands of the same value. When the image is reproduced in black and white, you can see the tonal differences (and similarities) of the different tiles more easily.

The lightest tones recede.

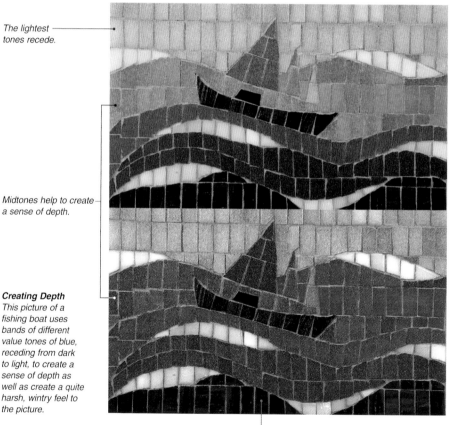

Midtones help to create a sense of depth.

Creating Depth
This picture of a fishing boat uses bands of different value tones of blue, receding from dark to light, to create a sense of depth as well as create a quite harsh, wintry feel to the picture.

The darkest tones appear to be in the foreground.

EXPERT TIP

From Carol Shelkin, creator of contemporary, fine art, original and intricate mosaic designs
Carol Shelkin teaches her signature style throughout North America and her work is widely collected.

Understand the power of light, dark, value and tone. Side lighting on your subject creates dark shadows, giving the illusion that your main subject 'pops' off the surface. To give a three-dimensional impression on a flat substrate, use gradations of colour. Make highlights bright and create deep, dark shadows.

Texture

Texture refers to the surface quality or feel of an object: smooth, rough or soft. Textures may be actual (felt by touch – tactile) or implied (suggested by the way an artist has created the work of art – visual).

For mosaic artists there are many tricks to creating visual texture: using the same type materials but from different manufacturers so there is a slightly different look is a good trick. Incorporating glass that is wispy, or art glass that has lots of visual activity can add unique texture. Using dimensional materials – smalti, rods, pebbles or shells – all add unusual and unexpected visual texture.

Contrast

Contrast is the difference in the colour and brightness of an object and its surroundings or background. The human eye is much more sensitive to these differences between things in its field of view than it is to the overall brightness or darkness of what it is looking at. Contrast is therefore very important in making elements of a picture or design stand out or, conversely, blend together.

Tonal contrast works in both directions – that is, a dark subject surrounded by a light background will stand out just as well as a light subject surrounded by a dark background.

Combining complementary colours

If you are working with ready-to-use mosaic tiles you can experiment with different colour combinations and effects before committing yourself with glue and grout. Mosaic tiles come in a range of pure colours and are easy to use – with no hit-or-miss mixing of colours involved. In fact, you can try out any number of colour combinations for a design to see what works best.

Combining complementary colours is an important colour technique you should experiment with and understand. These are colours that are opposite each other on the colour wheel, which, when placed side-by-side, gain an extra intensity. You can use this technique in simple geometric patterns to give a vibrant, sometimes almost

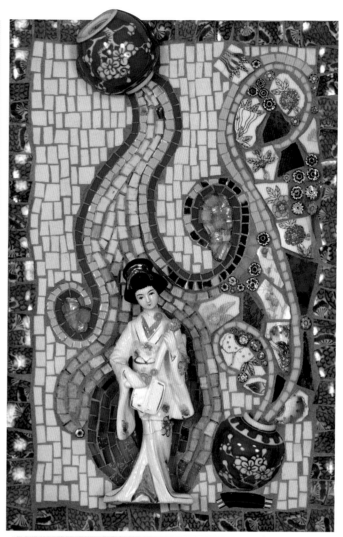

'Water Girl' by Ruth Tyszka has a abundance of visual and physical texture. The blue bowls and geisha are three-dimensional objects; the colourful broken dish pieces add unexpected and fanciful visual interest; and the flowing blue water is created using a number of different tones of blue.

Opposing Colours
A simple mushroom motif is rendered in contrasting colours in two symmetrical panels. Although identically sized, the yellow mushroom head appears bigger against a red background than its darker counterpart on a light background.

Formed of Contrasts
The main subject matter, the elephant, is not outlined in this mosaic piece. The form of the elephant is created entirely by the contrast between the alternating stripes of black and white – the strongest colour contrast possible.

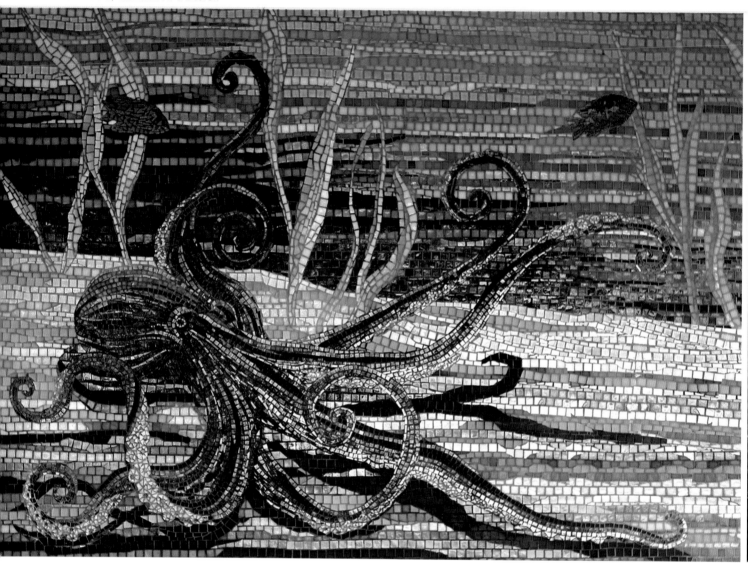

overpowering effect. But you can also use complementary colours more subtly, for example within illustrative pictures, by using dark tones of complementary hues to make shadows around objects.

As well as choosing the right hue, the effect of complementary colour pairs can be increased depending on the closeness in tone of the two hues. The nearer they are, the more pronounced the zing that their juxtaposition creates. But you can also use more atonal pairings, by utilising tile contrasts of light and dark tones to produce subtler effects. Alternatively, you can blend more natural colours that contain only a tint of each complementary colour, for example earthy browns and leaf greens.

The examples shown on the right are pairings of complementary colours that produce very different results.

Gradation

Gradation is a visual technique of gradually transitioning from one colour hue to another. In mosaic, gradations give a sense of movement and make an otherwise flat surface appear dimensional. There are several ways to successfully achieve colour gradations in mosaic: blending, shading, hatching and crosshatching your tesserae are all techniques that work well.

Above: 'Mosaic Octopus' by Carl and Sandra Bryant is a brilliant example of using analogous colours. Most of the colours used are close on the colour wheel. The soft blues, greens and beiges create a sense of harmony and mystery.

Complementary schemes

Deep orange and blue together create a shimmering effect.

Yellow and very dark purple create a strong yet complementary contrast.

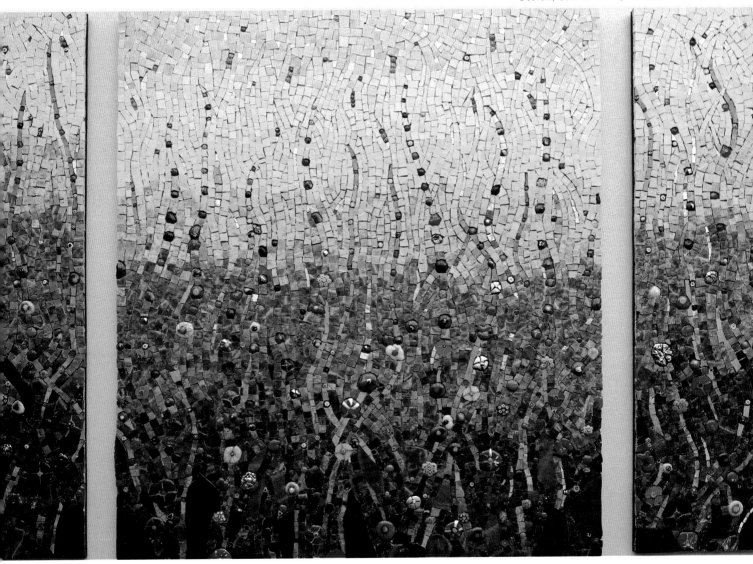

Marian Shapiro brilliantly blends the green tones in 'Field of View', creating a sense of movement and dimension in her triptych.

Earthy brown and leaf green create a muted pairing.

Orangey red and mint green are natural complements.

A strong red paired with very pale green causes the red to advance.

Darker shades of green and purple are a rich combination.

Bright yellow teamed with palest mauve makes the yellow stand out.

This light-toned blue interacts vibrantly with the bold orange.

Designing with Templates

A very simple technique to help you build and develop your mosaic designs is to use paper cutouts. Cutouts can help you to produce striking designs by overlaying and repeating simple shapes. This is a particularly useful technique if you feel your drawing skills are limited. You can use paper cutouts as an initial design tool, or develop them as full-sized templates to work with directly onto the mosaic substrate.

Designing with cutouts

Cutouts can be used to develop the composition of your design, allowing you to move around and experiment with different elements. Using cutouts saves you from repeatedly redrawing a design and enables you to develop ideas quite quickly.

1 Draw simple shapes
You can use any inexpensive paper to draw your templates on. For this design, simple flower and petal shapes were first drawn by hand. Alternatively, trace or cut out elements from other sources – perhaps from wallpaper or illustrations in magazines. When using cutouts as a design tool, you do not need to work full-size – you can always scale up the finished design later.

2 Cut out the shapes
Using scissors, carefully cut around the shapes. At this stage you could also colour the cutouts with markers, although you may find introducing colour a distraction best left until the structure and shape of the design are decided. Build up a stock of cutouts – you may want to copy some of the shapes so you have repeats of these elements.

3 Position design anchors
Cut a sheet of paper to the correct size for your background, and hold it in place with removable tape, then start to position the main elements of the design. In this case, the large circular shape (a vase) is a key element to establish first as an anchor. Try positioning main elements off-centre or even running off the canvas, to introduce variation. Then start positioning other main elements within the canvas – in this case, the larger flower heads.

4 Build up the design
Add other elements, but keep everything flexible – push elements around as you go. The beauty of using cutouts is that you can easily move and overlay different elements – try the same elements in a different order in the picture, perhaps bringing a background element to the front, or masking other elements to create new shapes and combinations. You can quickly add or modify things if you feel something is missing – here, some sharper petal shapes could be added, or two or three larger flower heads.

5 Trace the finished design
When you are completely happy with the look of the design, carefully lay a larger piece of tracing paper over the picture and tape this down. Then, using a pencil, carefully trace around the design to produce the final drawing. You can then transfer this to the substrate (see page 73).

Using cutouts as mosaic templates

You can also use cutouts as full-size templates. This is an ideal way to work with a repeat pattern – a design in which an identical element is repeated a number of times. Using cutouts is much easier than tracing and transferring a drawing; repeated elements need only be drawn once and this ensures that each repeat is nearly identical.

1 Draw the design
Begin by drawing your design – in this case, a simple paisley motif – onto a piece of paper. The drawing should be exactly the same size as you want the element to be in the finished mosaic.

2 Make a cutout
Cut carefully around your design to make a cutout – you can then simply draw around this onto other sheets of paper to make more cutouts of the same motif if required.

3 Position the cutouts
Work with the paper cutouts directly onto your prepared baseboard. You can see instantly the effect of spacing and positioning the cutouts differently. Try adding cutouts to see how crowded you can make the design, then try simplifying and refining the piece by taking elements away. In this example, some of the cutouts have also been flipped.

4 Draw around the templates
Once you are happy with the look of your design, draw around the cutouts onto the substrate. (To keep the pieces from moving around, hold the cutouts in place temporarily using removable tape.)

Designing with a Computer

While in the end there is no substitute for actually laying out mosaics in order to really understand the possibilities of the medium, computers can sometimes provide useful design assistance when exploring and testing ideas.

Playing with colours

You can use a simple painting program on your computer to quickly try out different colour schemes for your mosaic designs, or to test different combinations of colours before cutting or gluing a single tessera. With this type of program you can quickly fill whole areas of a design with flat colours to see what might work and what to avoid.

1 Draw up your idea
The easiest way to get your design onto a computer is to draw up your idea on an A4 size piece of paper – do the drawing in pencil first so you can make corrections, then when you are happy with it, go over it with a black felt-tip pen to create a strong outline. Next, scan the image. You will have a choice of formats to save the picture – choose a common format such as jpg or pdf, since nearly every drawing program can open these files and work with them.

2 Open in a drawing application
Open up your image in a drawing application. Most computers come with a simple drawing package – photo-editing software is also available to download on the Internet, either as 'freeware' or to use as a trial.

3 Fill areas of the design
The drawing program will usually have a fill tool – often represented by an icon of a paint can – which allows you to fill an area with a colour you select from the palette. Hold the tool over an area of the drawing to fill it with colour – the colour will flood as far as any containing outlines. This is why it is important that your drawing has strong lines separating the areas of colour.

Making a tile grid to colour

You can use the same method to design your own geometric patterns where you are planning to use a simple grid of tiles all of the same shape – for example, quarter-tile squares, or triangles made by diagonally splitting square tiles.

1 Create the grid
Use a dark felt-tip pen to draw your grid – in this example, the grid has been produced on the computer but you could produce a grid by strengthening some lines on an area of a sheet of graph paper. Scan the drawing and then open up the file in your drawing application.

2 Experiment with different patterns
As before, use the fill tool and different colours to experiment with different pattern repeats and colour combinations. If you are familiar with the software you should be able to create your own graph paper background using the line tools for a slightly neater result. There are also a number of mosaic-creation websites on the Internet where you can experiment with geometric grids and print the results.

4 Experiment with colour combinations
You can use the fill tool to quickly produce different colour treatments of the same drawing.

EXPERT TIP
From Becky Sehenuk, an award-winning graphic designer from Los Angeles
Becky Sehenuk has developed numerous award-winning graphic art campaigns and is especially fond of helping other visual artists master their computer skills.

Your computer can be an amazing tool, but like anything you need to take time to learn how to make it work for you. Review tutorials and be clear what it is you want to accomplish so you can work efficiently. And beware: the computer can eat up a lot of time. Find a balance that works for you.

Posterisation

'Posterisation' is a technique for simplifying the number of tones in a photographic image. For the mosaicist it provides a method for turning a complex image into areas of flat colour, which can be more easily rendered in the limited palette of colours or tones normally at your disposal in the form of mosaic materials.

Posterising with a computer

Many photo editing programs have a function that allows you to take any image and posterise it. Your source photograph could be a family snapshot (taken by a digital camera, or scanned into a computer) or a digital image from the Internet, or a picture scanned into a computer from a book or magazine.

1 Choosing a photograph

Find a suitable image to posterise. Images that work best have strong areas of light and dark tones. Avoid images with lots of delicate details or subtle tones – all these will be lost in the process. A good test is to look at an image and half-close your eyes – if you can still decipher what is happening in the picture, then it is more likely to be legible after posterisation. Open the image in a photo-editing program.

2 Converting the image to greyscale

Turn the image into a black and white version by changing the mode of the picture to greyscale using a drop-down menu, or using the 'Save as' function and selecting the greyscale option.

Choosing an image

Good choice

■ High contrast

■ Strong outlines and bold shapes

■ Distinct areas

Bad choice

■ No contrast

■ Thin lines and detail

■ Areas merge together

6 Contour drawing

At this point you can either print the posterised image and use this as a pattern, moving straight to step 7. Alternatively, you can print the image and use it to make a contour drawing. To do this, trace around the posterised areas of tone.

3 Despeckling the image

Most photo-editing software has a 'Despeckle' or 'Remove noise' function that allows you to remove any fine texture from the image. Apply this filter and you will see how your picture appears to instantly soften. This is a useful first step to simplifying your image.

4 Posterising the image

The 'posterise' command allows you to set how many tones the image will be reduced to. For example, if you choose '2' the image will be converted to just black and white – normally the end result looks stark and bleached out, and whole areas of the image may be illegible.

5 Retain some tonal variation

Generally, choosing three, four or five 'levels' will give sufficient tonal variation to retain the shapes and features of objects within the picture. As long as you keep a backup of your original image, you can experiment with different variations. As well as trying different posterising settings, you can also try changing the contrast of the image and to see what result this has.

7 Lay tesserae

You can now use the contour drawing as a pattern. After transferring the design to your substrate, begin laying your tesserae, in this case, beginning with the eyes, moving onto the nose, and then filling in the face. Referring back to the posterised image will help you with tonal variations.

Few projects are as daunting as a self-portrait. Posterising the image helped define specific tonal areas. This information aided greatly when making a detailed cut-by-cut pattern. 'Bonnie by Bonnie' by Bonnie Fitzgerald uses unexpected colours – yet the result is very realistic.

Patterns and Cartoons

Once you have created a drawing or pattern that you are happy with there is no reason to redraw or redesign it. This is especially true if you are making an artwork as a commission – if your client is happy with your work, then your next job is to get your design to the necessary size.

Patterns, also called cartoons, are the enlarged, simple line drawings you need to create for your mosaic design. There are several ways you can accomplish this: some very low-tech techniques involve little more than a pencil, paper and ruler; others involve technology; but all have the same goal: to give you a to-scale pattern to work from.

Using a light box

A light box can help to trace a design from a photograph or picture or to turn a design into a working cartoon. It is a translucent tabletop that shines light through the original drawing, making it more visible underneath the tracing material. Light boxes are inexpensive and available at many craft shops and photography shops. You can always improvise by taping your original drawing and the small grid onto the inside of a brightly lit window or glass door to get an effect similar to a light box.

1 **Tape down the original**
Use clear removable tape or masking tape to hold your source picture in place.

2 **Position your drawing paper**
Tape the paper you want to make the copy on over the top of the original.

Ramatuelle et le Méditerranée
from l'Écurie du Castellas (bathroom) 6 09/12/08

3 Turn on the light box
The light box produces a strong but even light that allows you to clearly see the original beneath the paper. The advantage of the light box is that you can more clearly see the detail within darker areas, or within areas of similar tone, which are not always visible to the naked eye even when using tracing paper.

4 Trace the design
Use a sharp pencil to copy the design onto your drawing paper. When working from a photographic original like this, copy the main elements of the design – in this example, the flower centres and petals. Don't be tempted to fill in all the detail; these would overcomplicate the drawing and make it impossible for a simple mosaic.

5 Check the finished drawing
Switch off the light box and check that you have not missed anything in your finished tracing.

Bev Delyea's sketch of 'Ramatuelle' invites you to the South of France; it is so beautifully realistic, why draw it twice? A light box makes quick work of getting the main elements of the drawing onto the substrate.

EXPERT TIP

Andrea Taylor lives in Pulaski, Wisconsin, USA
Her mosaic style often includes opus sectile, cutting larger, very specific glass shapes that are then laid like puzzle pieces fitting together. She teaches many mosaic workshops throughout North America.

A light box is also very helpful to use for drawing your pattern directly onto stained glass if you are wishing to cut a very specific shape. Simply lay the pattern on the light box, your glass on top and, with a felt-tip marker or grease pencil, trace the desired shape onto the glass. You can construct your own light box using tube lights with a sheet of Plexiglas over the top secured to boards on two sides.

Scaling with a photocopier

Photocopiers are widely available to use for a nominal charge in libraries or print centres. Using a photocopier is a very simple way of enlarging original drawings to the size you want the finished mosaic to be without any of the difficulties associated with using a grid to scale the design. If your design is very intricate, you will probably find it especially worthwhile to use a photocopier to produce your final artwork.

1 Strengthen the original

Depending on how big your finished design is going to be, it is likely you will need to enlarge your original drawing more than once. The copying process can degrade the design slightly at each step, particularly if the original was done in pencil or coloured crayon, so before starting it is worth using a thin, dark felt-tip pen to go over the design and darken the outlines.

2 Work out the finished size

Confirm the size the finished mosaic will be, then measure your drawing. To work out the percentage, you will need to scale the drawing. First divide the longest measurement (the width if the design is landscape, the height if it is portrait) of the finished piece by the measurement for the corresponding dimension of the drawing. Multiply this number by 100 to get the percentage enlargement. For example, if the finished width of the piece is to be 500 mm (20 in) and the original is 200 mm (8 in), then the enlargement is: 500 (20) ÷ 200 (8) = 2.5. Multiply x 100 = 250 per cent.

Proportion wheel

A proportion wheel will help you determine the per cent you must increase your cartoon by to enlarge it on a photocopier to the desired size. Adjust the inner wheel to the current size of the artwork, and the outer wheel to the desired size. The centre window will then give you the percentage you need to enlarge it by.

3 Copying in sections

Photocopy the original. Check where to position the original when making the enlargement. Enter the percentage enlargement you have calculated using the control panel on the photocopier. Some copiers have a maximum setting – for example 200 per cent. If so, make a first copy at the maximum setting. It is likely that not all of your drawing will fit onto one piece of paper when enlarged. Rotate the original in the photocopier and make a copy of the second part. You may need to do this more than once – in which case treat the original as four corners, each of which will need to be enlarged. If you have not been able to go as large as you wanted with the first copy, then copy the enlarged copy. You will probably have to change the scaling for the second copies to end up with the intended size. Measure the size of the interim copy. For example, the 200-mm (8-in) drawing in our example would have ended up at 400 mm (16 in) if the photocopier allowed a 200 per cent enlargement. Perform the same calculation again to work out the next enlargement: 500 (20) ÷ 400 (16) = 1.25. Multiply x 100 = 125 per cent. You would need to copy each of the sections produced by the first copy using a 125 per cent setting.

4 Assembling the image

When you have copied and enlarged all of your first copies (again, you may need to make more than one copy of each sheet to fit everything in) lay all the drawings out on a large table or the floor to line the pieces up. Check that the image is complete, use scissors to cut away any borders, then use clear tape to join all the sections together. The enlarged drawing can be transferred by scribing with a soft pencil on the underside of the photocopy to create a carbon-paper effect, or by using carbon or transfer paper.

If you are using a photocopier that only accepts letter-size paper, you may have to experiment a few times to get it right.

Sounds like hard work?

There are many print centres that have photocopiers that can accommodate rolls of paper 900 mm (36 in) wide and infinitely long. For very large patterns these can be a good solution, avoiding having to rotate the image in the copier and assembling numerous pieces later. Also, for an additional fee, these same copy centres can scan your small artwork into an editing program, scale it to the desired size and send it to the oversized copier, hassle-free.

Working out the scale for enlargement

Measure the longest side of the original and the length you want this side to be enlarged to. Divide the enlarged measurement by the original measurement: this gives you the factor of enlargement.

Example:
- Width of original: 15 cm (6 in)
- Width of enlargement: 75 cm (30 in)
- Factor of enlargement: 75 ÷ 15 = 5 (30 ÷ 6 = 5)

The factor is the amount by which you must multiply any measurement from the original to find out the size it will be on the enlargement.

For example, if the original is 120 mm (4.75 in) high, the enlargement will be 120 (4.75) x 5 = 600 mm (23.75 in) high.

If you chose an original grid of 10-mm (0.5-in) squares, then the grid for enlargement would be made up of 10 (0.5) x 5 = 50-mm (2.5-in) squares.

Enlargement by percentage

Sometimes an enlargement is given in percentage terms. For example, if you use a photocopier to enlarge a drawing (see left) you might need to know the percentage value of the enlargement. You can find the percentage by multiplying the factor of enlargement by 100. So, enlarging a drawing by a factor of 5 could also be expressed as a 500 per cent enlargement.

Example:

- A drawing in a book is 90 mm (3.5 in) wide. If you want to enlarge it on a photocopier to be 360 mm (14 in) wide you would calculate the percentage enlargement to use as follows:
- 360 ÷ 90 (14 ÷ 3.5) = a factor of enlargement of 4. 4 x 100 = 400 per cent.

Scaling a drawing using a grid

If you have drawn a design for a mosaic – or found a picture that you would like to turn into a mosaic – then you need to scale up the original to a larger size. There are a number of ways to do this – the traditional way is known as the grid method. The grid method of scaling requires you to draw two grids: one of smaller squares, which you will place over the original; the other, of larger squares, is used as a guide to help you copy the original.

1 Drawing the original grid

If you don't want to damage your original drawing, tape it to a flat surface, and cover it with a sheet of tracing material slightly larger than the image all around. Measure the image with your ruler and work out the size of the grid squares you will need. (Aim for a grid consisting of between 10 and 15 squares along the longest side.) Use a set square (also known as a triangle) to draw each vertical, then measure and mark the remaining horizontal lines of the grid. Alternatively, simply draw a grid over your drawing.

2 Drawing the enlarged grid

Now make the grid on which to create the enlargement. If you have a pre-cut board or wall area begin by measuring its width. Divide this measurement by the number of horizontal squares in the original grid to give you the size of the squares required for the larger grid. Draw up the larger grid to the same number of squares wide and high as the small grid. Choose one of the main features in the original design, then mark the corresponding place in the enlarged grid with a dot. Transfer each shape's outline in turn, carefully marking a dot on the larger grid wherever a line crosses the feature in the original grid.

Materials for scaling

When copying a drawing you need to use a transparent or translucent tracing material that will allow you to see the design underneath the grid. Clear acetate is the most transparent material, but its shiny surface means you must use special pens and it is easy to smudge the gridlines. Tracing paper, although not completely transparent, is probably easier to use as you can work with a pencil and erase any mistakes. Thin layout paper is an acceptable alternative, though it is more opaque than tracing paper, making it difficult to clearly see details, especially on photographs.

Tracing paper

Layout paper

Clear acetate

3 Joining the dots

When you have finished marking all the dots, join them up to reproduce the lines from the original. Check that the original and the copy look identical – with longer lines it is easy to miss a square and put a dot on the wrong line in the grid. (Numbering the squares along the bottom and sides of both grids can help ensure you are in the right square each time.)

Transferring a Drawing

Once you have enlarged your drawing you may still need to transfer it to the substrate. There are two ways to do this – using carbon or transfer paper or creating your own carbon paper by scribing on the back of the artwork. Transfer paper, a kind of carbon-free carbon paper, is available at most art supply shops. It allows you to transfer your design onto virtually any surface, leaves no wax residue, and does not smear like carbon paper does.

Transferring a design using a pencil
This method requires only a pencil. As a preference, use a soft pencil or chalk for scribbling on the back, and a hard pencil to draw over the outline.

1 Cover the reverse of the drawing
Start by turning over the enlarged drawing on a flat surface. Use a soft pencil or chalk to rub heavily over the back of the drawing – concentrating on the areas where the lines are. Aim to leave a fairly heavy deposit of pencil or chalk on the reverse of the drawing. If you drew your copy onto a transparent tracing material you will find it much easier to follow the lines of the original; a light box is also useful for this purpose.

2 Draw over the original
Turn the drawing the right way up and tape it in place on your substrate (use removable tape). Retrace the outline of the drawing – this time with a hard, sharp pencil or crayon. Use it almost like a scribing tool to press the pencil or chalk from the back of the drawing onto the substrate. (Using a hard, coloured crayon has the advantage of showing you which parts of the drawing you have traced over.)

3 Remove the drawing
When you have traced over the whole of the enlarged drawing, peel away one corner so that you can check that everything has transferred. Go over any weak areas with a pencil to strengthen the lines. When you have checked the whole drawing – work in from a corner at a time to avoid moving it – peel the drawing off completely. Go over the work surface with an eraser to clean up any bad smudges, and make any final corrections. You are now ready to begin cutting and laying your tiles.

Andamento

Andamento (plural andamenti) is the term used to describe the way the tesserae flow within a mosaic. Andamento is the unique property of the mosaic art form: the one element that is present in no other comparable visual medium. Also known as 'lay patterns', andamento is the manner in which you lay the tesserae.

'Coded Message: Invisible Ink' by Sonia King is a study in the 'spaces between' – the interstices are as important as the tesserae. The handmade substrate is reminiscent of a piece of parchment.

The physical directional flow of the tesserae – whether a smooth contouring around the design, or a jagged fill that breaks up or agitates the piece – is the extra dimension beyond shape and colour that mosaicists have at their disposal. To create the mood and general effect of the finished piece, a successful andamento is the product of two factors. First: care and consideration at the planning stage. Second: while laying your tesserae, absolute precision and care in the cutting and positioning of the individual pieces so that they combine successfully into a single, organic entity.

The section on opus (see pages 76–77) gives examples of some of the classic andamenti employed by mosaicists since ancient times. But there are no hard-and-fast rules – you can adapt, mix or ignore these rules in whatever way you feel works best. The picture of a swan (see opposite) mixes a number of different opera to create a variety of andamenti effects. This example was made using hand-cut vitreous glass tiles. Almost all tiles were hand-cut, giving a sense of hand-crafted rather than a manufactured or mass-produced feel. The effect is significantly more interesting than having used the tiles uncut or in grids.

The spaces in between the tesserae are called interstices. They play an important part in the makeup of the mosaic and the overall feeling of the work. If you choose to grout, the interstices are filled with colour, and this can dramatically alter the look of the final artwork. For many artists the space between the tesserae is an important relationship and many artists do not grout their work. Grout is a personal design choice.

Ideas for andamento

In this single work are collected several styles of andamenti. You do not need to use all the styles simultaneously, but combining calm movement with rigidity, for example, helps to bring a subject to life, pulling it away from its background.

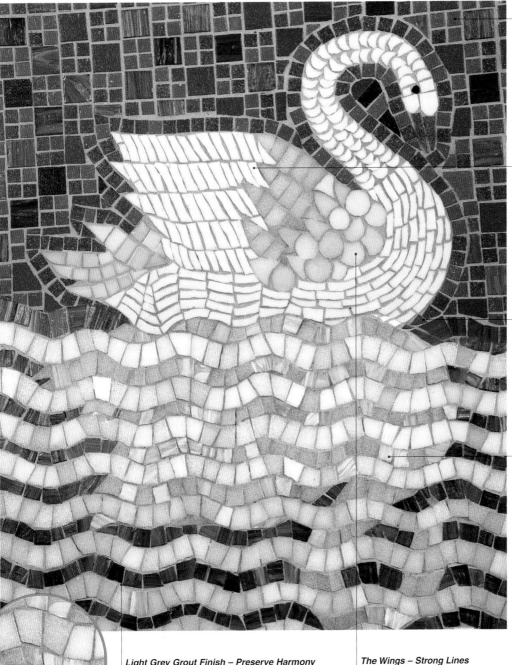

The Chequerboard Fill – Rigidity
The chequerboard background around the bird alternates whole tiles with squares made up of quarter-cut tiles. This preserves the background rigidity that a chequerboard provides, but the smaller tiles add a depth and distance to this area where using only whole tiles would have produced a flatter, deader effect.

The Body – Naturalistic Flow
The swan is rendered with a naturalistic flow of parallel rows of tiles to emphasise the delicate curve of the neck into the body. The tiles are subdivided into groups of scalloped semicircular tiles that interlock to create the head and neck, and then merge with denser, rectangular shapes that give weight to the lower half of the body.

The Outline – Halo Effect
The line of blue tiles around the swan is a traditional opus vermiculatum (see page 77); a snaking flow of evenly sized, square-cut tiles that form a darkened halo around the completed body of the bird.

The Waves – Fluidity
The wave forms used in the lower part of the picture give this area a separate, fluid feel – the parallel lines of tiles allow the eye to scan gently across the bottom half of the picture without interruption. The swan's reflection is created with areas of lighter-toned tiles – but notice how the andamento continues regardless. It is important to cut the pieces of the waves so that they dovetail together, and the grout lines are even and harmonious, allowing the andamento to flow uninterrupted.

Light Grey Grout Finish – Preserve Harmony
The harmony of the tiling and the colours is best preserved with a light grey grout – too dark and it will fragment the body of the swan, too light and it will break up the unity of the background and the waves.

The Wings – Strong Lines
The wings of the bird blossom out from the breast, with circular cuts of tiles that then flow into a more rigid herringbone pattern that gives strength to the flight feathers. Note how different colours have been mixed with off-white and pearlescent tiles to add interest.

Opus

The word 'opus' (plural, opera) is used in mosaics to describe the different ways in which tiles can be laid. The different opera are like different rhythms that cause tiles of exactly the same shape and colour to have a very different impact within a design, depending on how they are laid. The examples on these pages demonstrate some of the main, classical opera being used to complete the background of the same design so that you can appreciate the differences between each one.

Opus regulatum

This may look like the easiest way to lay tiles – a simple chequerboard pattern. In fact, to keep the rows and columns of the background in straight lines requires very careful cutting of the tesserae so that the design can be accommodated without bunching of the tiles and maintaining even grout lines. It can be particularly difficult to take out small pieces from a single tile to accommodate extrusions within the design.

Opus tessellatum

Opus tessellatum is similar to opus regulatum, but the tiles are lined up in alternating rows – rather like the effect of bricks in a wall – with each tile centred neatly above the joint between the two tiles below. Like the regulatum, this opus lends a sense of stillness and solidity to a design and creates order.

Opus palladianum

Sometimes referred to as crazy-paving fill, this opus gives a busy feel to a flat area, as there are no soothing lines. It is deceptively tricky to complete. Every piece needs unique cutting to fit, but you need to keep pieces evenly sized – you cannot make do with broken bits and pieces. Work on a fairly large area at a time, checking that everything fits together before you start gluing pieces down.

Mix your opus

Understanding classical opus styles allows you to introduce a system to your work. Although these rules may feel restrictive, they also provide a kind of freedom on their boundaries. Take this information and mix it up. Try using many different cuts and lay patterns in one artwork and see where it leads you.

Bonnie Fitzgerald's opus study used only one material, vitreous glass tiles, cut in a variety of sizes and shapes for a striking work.

'Grizzly Bear' by Bev Delyea uses a non-traditional opus. The tesserae are cut in a brushstroke, painterly manner, making for perfect bear fur.

Opus vermiculatum

Opus circumactum

Opus sectile

This opus is used to outline an element within a design and consists of evenly cut pieces of tile that snake around the edge of the element (the word comes from *vermes*, Latin for 'worms'). The outline is sometimes executed in a lighter or darker colour than the surrounding background to emphasise the halo effect. Detail of 'Farm' by Sandra Groeneveld.

Opus circumactum is a pattern that, as well as being seen in mosaics, also appears in the laying of old cobbled streets. The tiles are laid in a fan shape, with the different sections overlaying and butting against each other in a pattern like fish scales. The effect creates a relaxed, undulating surround to a design.

This style sits at the boundary of true mosaic, and close to traditional stained glass territory: each tessera is cut to form a complete shape in itself. Here, Kyra Bell captures her pet's personality using the striations in the stained glass. Opus sectile is the perfect selection for this artwork.

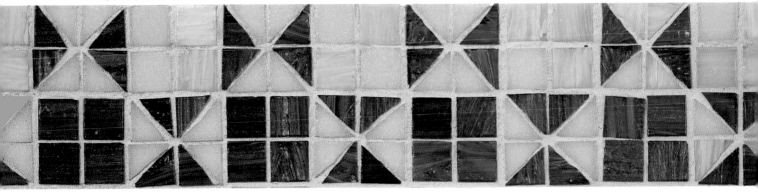

Grids and Borders

Grids are a great opportunity to hone your mosaic-laying skills and design sensibilities. The organisation of a repeated geometric grid pattern is especially useful to frame an artwork. Effective border designs provide interest to large, plain areas and help define a neat and clean edge.

Using split tiles in a grid

You can add further variation to a simple square grid by splitting tiles into rectangular halves, square quarters, or using a diagonal cut to create two triangles. You can vary the placement of split tiles (for example, splitting the tiles at set intervals within an overall grid), combine split tiles of different colours within a single 'cell' of the grid, or combine different splits within the overall design – the design combinations are without limit.

Remember that joined pieces of split tiles make larger shapes than the original whole tile because each split requires the addition of space for grout. Therefore half and quarter tiles actually need to be cut slightly smaller to allow room for a dividing grout line so that the edges do not protrude from their alignment with neighbouring whole tiles.

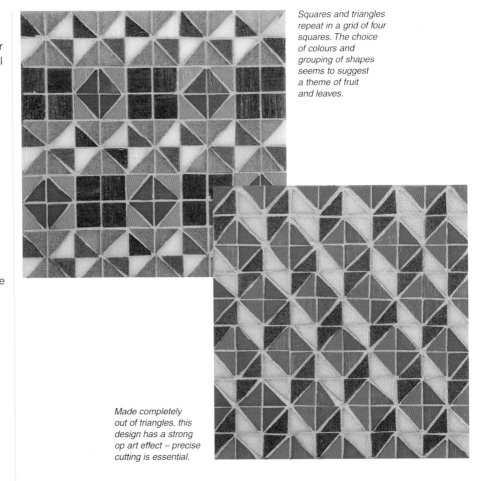

Squares and triangles repeat in a grid of four squares. The choice of colours and grouping of shapes seems to suggest a theme of fruit and leaves.

Made completely out of triangles, this design has a strong op art effect – precise cutting is essential.

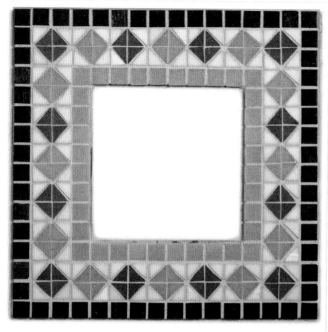

Top right: 'Daisy Chain' by Carl and Sandra Bryant takes a seemingly more organic approach, yet still consists of repeating elements with regard to colour and shapes. **Bottom right:** Carl and Sandra Bryant's 'Organic Mosaic Mirror' uses a grid base. Individual little artworks are then constructed within the specific quadrants with rich earth colours and glass gems.

Top: A frame motif based on a simple square grid has added interest from the diagonal splits used to create a diamond pattern. **Above:** A border of split tiles creates a running arrow motif.

Planning borders

You need to plan borders carefully so that the design and the border work together in terms of size and colour. You also need to be sure your border design is complete, rather than cut-off at the edges: every pattern has a frequency or repeat, which is the physical length – the number of grid squares – before the pattern starts again. For example, the pattern shown above left has a repeat every four squares. If you wanted to use a patterned border to frame a picture, then the width and height of the picture would have to be a multiple of the border pattern repeat.

The pattern-repeat rule applies to even the simplest border pattern – two alternating colours, for example; in this case, the repeat would be two squares. To surround a picture with a single band of alternating coloured tiles, the perimeter would have to contain an even number of squares (to avoid two pieces of the same colour being placed together at the end). However, if you wanted the frame to be symmetrical – with the same coloured tile in every corner, and opposite tiles always of the same colour – then the sides of the frame would need to be an odd number of units. It is a good idea to lay out your tiles before gluing, ensuring they line up as you wish.

Recording Your Progress

As an artist, it is a great idea to document your progress. Stay organised and keep good files so you will know where to find information when you need it. Photographing your work-in-progress can become a visual journal – this way you can easily see progress and implement changes.

Notebooks and journals

It is a good idea to use a simple notebook to keep a log of each project as you proceed with it. You do not have to be too detailed, but it is good to record things that go right (and those that go wrong) for future reference. Keeping this information in one place means that you can easily refresh your memory about a particular technique or material when you want to try something similar in the future.

You can use your log to record how to mix different adhesives, or the different materials you needed to complete a particular area of a project. Think of the log as your mosaic recipe book, which will help you to quickly repeat successful techniques and avoid repeating past failures.

Sample boards

A great way to keep track of materials you have successfully used or are especially attracted to is to make your own sample boards. Glue a small piece of the material to a board (foam core, cardboard or a scrap piece of plywood) and record the manufacturer's stock number and any other pertinent information. You can quickly reference these boards as you plan future projects.

Sample boards and sketches of proposed artwork can help communicate to a client your idea and the materials you have in mind.

12TH OCTOBER

Grey cement grout for 'slate piece'
Used a 1 kg (2 lb) bag of 'Outdoor tile adhesive and grout' from DIY warehouse. (The 'and grout' is important – they sell an adhesive in a similar bag which cannot be used for grouting as well.) Mixed in old margarine tub – not big enough, and began to split as mix was stirred. Overdid the water (instructions on back maybe too generous?) so next time, add water more slowly, particularly near end. Also mixed too much – using a yoghurt-pot as a scoop, added six scoops – four would have been plenty for a 60 × 60 cm (2 × 2 ft) piece. Grout only workable for about 30 minutes so needed to work fast!

1?TH NOVEMBER

F___ painted tiles
W___ed OK but oven was perhaps over-hot 180C (___F) or left tiles in too long (10 minutes next ti___). Red tile paint looked a bit 'faded'. Also black c___es bubbled a bit – avoid painting on too thickly n___ time or try building up with two firings?

1?TH DECEMBER

B___ers from old tiles edges – pliers trick!
U___ edges of Dutch looking tiles to create narrow border t___me 'Pepper' picture. Had to use nippers as tabletop c___ could not split thinly enough – struggled to snap ___ges thinly – eventually used old pair of pliers to h___ snapped-off edge then used nippers to break off th___arrow piece I wanted (could not grip narrow piece re___ed in fingers!)

Using your camera

With the advent of digital photography, the camera can be a versatile and useful tool. Even smart-phone cameras can be adequate for recording inspiration images and tracking your work progress.

■ Take photographs of your travels, photograph things that interest you, textures – close-up of bark on trees, sunsets, anything that inspires you.

■ Photograph your work-in-progress. The image will be flattened and you will quickly see changes you wish to implement, as well as appreciate what is working within your composition.

■ Upon completion, photograph your work – capturing your finished work in a professional manner is essential (see pages 82–83).

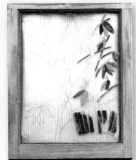
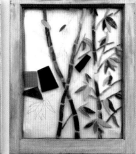
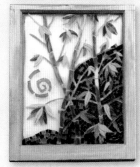

Mark Brody took many photos as he worked and used the images to help with colour selection and tesserae placement.

After the work was complete, a professional photograph shows off the final product.

Your artwork image will be flattened by the camera, allowing you to see where changes are needed. Up close, the individual tesserae become abstracted, enabling you to see the tesserae that need to be replaced and what shapes to cut.

Photographing Your Work

Mosaics present a unique set of challenges for photographers. The visual texture creates unusual and, at times, unwanted shadows or light reflections. It can be difficult to fully capture the true beauty of the artwork. However, a good photo of your work can often mean the difference between being accepted for shows and exhibitions or not.

Equipment

You will need a camera, tripod and computer with photo-editing program. Lights are optional. Your tripod needs to accommodate your camera and not wobble. If you have space, photo strobes are a great way to ensure consistent and professional lighting. However, they can be costly. You can get excellent results using a couple of inexpensive tree-style floor lamps, each fitted with three natural-spectrum bulbs. An alternative to these could be clamp lights from the hardware shop fitted with as bright natural-spectrum bulbs as they will safely accept.

Lighting

The reflective quality of mosaic artworks makes them especially challenging to light. Set up your lighting so that it falls fairly evenly across the surface of your artwork with light coming from both sides. With mosaics you may find having the light shining a bit unevenly enhances the artwork. If the light is too even it may flatten the perceived texture. If your room has an overhead light source, turn it off.

If possible have the artwork facing a dark wall. Anything bright in the room, such as white walls, a window, a light floor or ceiling, may reflect in the surface of your mosaic. If need be, you can hang black fabric behind the camera to reduce room reflections.

Some people prefer shooting outdoors in the shade or on an overcast day. Unlike using studio lights, you cannot direct the sun to hit a special spot on your mosaic as a highlight – you'll have to move the artwork to fit the sun!

Camera position

Mount your camera to your tripod and set it a comfortable distance from your artwork. There is a balance to reach here and it will vary with different cameras, lenses and surfaces. The farther back you are, the less textural glare will reach the camera. The image should almost fill the frame.

Using the viewfinder, set your tripod height and angle to be as square as possible with your artwork. The grid overlay may prove helpful. The camera should be parallel and centred with the surface of your artwork.

If your camera has an anti-shake or image-stabilising feature, turn this feature off. When mounted on a stable tripod, the anti-shake actually creates electronic feedback that will result in a soft image. Some cameras and lenses are designed to correct this automatically, but many do not.

Once you have your mosaic correctly in your frame, focus and shoot. You can manually focus, but usually the auto focus is right on. Set the self timer so that there is a two-second delay between pressing the shutter and capturing the photo. This will prevent any shake to the camera when you press the shutter.

For detail shots, you may want to zoom in on an area. Optical zoom is a true zoom and it produces much better quality images than digital zoom. The zoom usually starts in optical but will finish digitally. You may feel the motor stop when it switches and the status screen will tell you it is magnifying beyond the optical zoom range. You will also notice the image becomes grainier.

Post processing

Once you shoot your artwork the next step will be to load the image into your computer and convert it to a file that you can work with in a photo-editing program. These digital manipulation programs can help easily crop, sharpen and enhance your photographs, but in the end the photograph must accurately represent the artwork.

Always save the full-size, uncompressed and unchanged original digital file. Do your digital manipulation on a copy and save that file as large as possible, knowing you may need to reduce the size for emailing to exhibitions or uploading to your website.

The three most common digital image formats are JPEG, TIF and RAW. JPEGs work best with photographic images because they rely on a blending of colours. However, a challenge with using JPEGs is that they are a 'lossy' format, meaning that each time you save after editing the file slightly degrades. TIF and RAW formats are 'lossless' meaning the image data is not lost when the file is compressed. If your system allows, do your editing as a TIF or RAW format and then save the final image as a JPEG. The image quality will not degrade.

Develop a system for cataloguing your photographs so you can easily find them when you need them, and, of course, make digital backups and store off-site.

Tilt the camera so that it is at a 90° angle to the painting surface.

Place the lights on either side of the camera at a 45° angle to the painting surface.

Photographic setup
Set your artwork on a table with a neutral background. Place two lights either side of the artwork so they hit the artwork almost equally to eliminate unwanted shadows (a touch of unevenness will allow for more visual texture in the photograph). Your camera goes in the middle, on a tripod, level with the artwork.

EXPERT TIP

From Brit Hammer, artist, author and award-winning photographer
Brit Hammer's work has been featured in dozens of international lifestyle magazines and design blogs. Brit lives in Rotterdam, the Netherlands.

Take images that make people say 'I want to own that!' Use a tripod and set your camera to the 2-second timer to avoid camera-shake. Shoot against a neutral background. Colourful artworks look best against medium or dark grey, or black; dark artworks look better against white or off-white. Use uneven lighting, because even lighting flattens the perceived texture of the mosaic. Uneven lighting is what shows off the texture, and it's the contrast created with uneven lighting that makes the artwork pop off the page.

In a nutshell

■ **Equipment:** You need three pieces of equipment: a camera, tripod and a computer with a photo-editing program.

■ **Lighting:** Set up your lights so light comes from both sides onto your artwork, but a touch uneven for mosaics.

■ **Background:** Shoot against a neutral background (black, white or grey).

■ **Settings:** Set your camera to the 2-second timer to avoid camera-shake. Turn off any anti-shake or image stabilising feature in your camera as it may cause feedback.

■ **Backup:** Make digital backups of your photographs and store off-site.

Photographing mirrors

Many artists make mirror surrounds as decorative mosaic art. These pose many challenges when photographing; there will be reflection from both the mosaic surface and the mirror itself. There are two effective solutions:

▓ Position your camera, and 'dress your set' so the reflection in the mirror is a pleasing part of the composition (see right).

▓ Eliminate the mirror and the reflection by using a neutral surface as the reflection. You can also achieve this effect by processing your photograph in a photo-editing program, such as Photoshop.

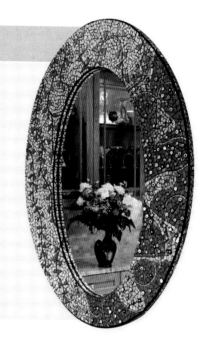

Mosaic
Techniques

Technical expertise will enable you to make mosaic art that meets and then exceeds your expectations. There are traditional techniques of mosaic making that have stood the test of time; learn these skills and you will quickly find ways to make your work more pleasing. This chapter also explores new practices and techniques to help you develop your work in fresh and exciting ways.

Direct Method

The direct method is the most basic technique for creating mosaics and it is how most people start to experiment with this art form. It is called the direct method because you cut, lay and adhere your tesserae directly onto the substrate or mounting surface. For larger installation works this method is only possible where the location is suitable and allows you time to complete the piece.

In a nutshell

- **Plan:** Good planning will make the creation process more pleasurable.

- **Draw:** Make a cartoon to work from.

- **Gear up:** Make a pool of pre-cut tesserae to work from.

- **Get ready:** Properly prepare your substrate; a 50/50 solution of PVA glue and water works well if you are using PVA glue as your adhesive and your tesserae are not transparent.

- **Stick it!** Dry-lay your design until you are happy with your cuts – then commit and glue it down. Use the appropriate adhesive for the job at hand.

- **Watch:** Step back and look at your work as you go along; be objective, and if you do not like it, change it.

- **Tidy up:** Clean your tools when done working for the day.

- **Wait:** If you plan to grout, allow your adhesive to completely dry.

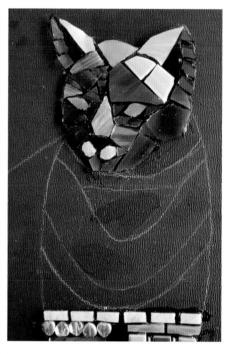

1 **Surface preparation**

Make sure the substrate's surface is clean and dry. Properly prime the surface and transfer the cartoon onto the substrate. If working with transparent or translucent tesserae, your substrate should be prepped with a white primer or white thin-set. Priming with black or grey paint may prove helpful if you are not sure you will grout your finished piece. The eye will not notice the black or grey as much as a white ungrouted background. Alternatively, prepare your surface with a 50:50 PVA–water solution. Prepare your substrate so that it is ready to install: pre-drill any necessary mounting holes, cut it to the exact size needed, and check it fits into the area in which it will be installed. If creating a three-dimensional work, consider how it will stand or be mounted. Double-check your measurements.

2 **Where to begin**

The magic of mosaic making is piecing together the individual tesserae into a coherent design. It is essential you process your materials in advance. Unless you are using pre-manufactured tiles you need to cut down your materials so you have a pool to choose from. If you are using tesserae of a generally similar size, cut up about 50 per cent of what you think you will need before you start. That will help the laying down process go quickly and smoothly. You can do any special cuts as you go along. Do not cut everything: you will need materials for special cuts and you do not want to waste materials.

There is no right order in which to tile a mosaic – different rules apply to different designs. Begin by dry-laying a small area of your design, maybe a simple line. Move and rearrange pieces until they are just right, and do not be afraid to discard a piece that is not cut exactly right or has any imperfections.

Lisa Clark's 'Cat Dandy' used a variety of materials with varying thicknesses: stained glass, millefiori, broken dishes, ball chain and more, making the direct method her best work option.

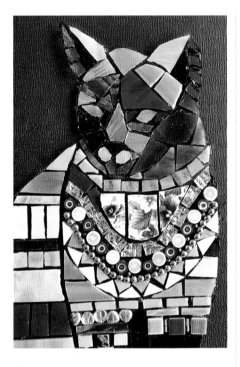

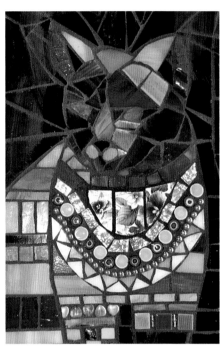

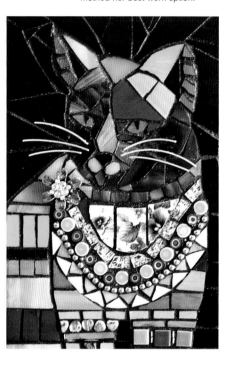

3 Stick it

When you are happy with the area, start gluing. Do not over-think your dry-laying: commit to gluing. Some people put down a line of glue and begin pressing the tesserae into it. Others glue individual tesserae: it really depends on the scale of your artwork and your personal working style. Do not put down more glue than you can cover before it starts drying.

Adhesives

Always use the appropriate adhesive for your final application and materials. Most adhesives, especially PVA glue and thin-set, have a memory. If you choose to remove a tesserae after about 10–15 minutes, you will need to scrape off the adhesive and put down a fresh layer.

4 Interstitials

The spaces between your tesserae are called interstitials. If your design calls for grouting, then remember to leave gaps between the tesserae for grouting later. These should be wide enough to accommodate enough grout to surround and support each tile piece, but should not be so wide that the finished design appears fragmented, with tile pieces floating in a sea of grout. You will learn the right balance through practice – the aim is to achieve an even, consistent grout line that seems to make the tiles flow as a unified whole. Grouting is optional; if your design does not call for grouting, then you may wish to work your tesserae more closely together.

5 Checking your work

Periodically take a step back and look at your piece objectively. Do not tolerate any wonky or mismatched tesserae. Pry out tiles you are not happy with – a flat-head screwdriver will do the job – cut fresh pieces, and reglue them. Be patient and enjoy the process. When you believe you are finally done and you plan to grout, you must wait a minimum of 24 hours before grouting. If possible, carefully turn your dried artwork upside down to check there are no loose tiles that will fall out during the grouting process. You can add enhancements after you grout for those final details; here, the artist added whiskers and eye details to complete the work with flair and whimsy.

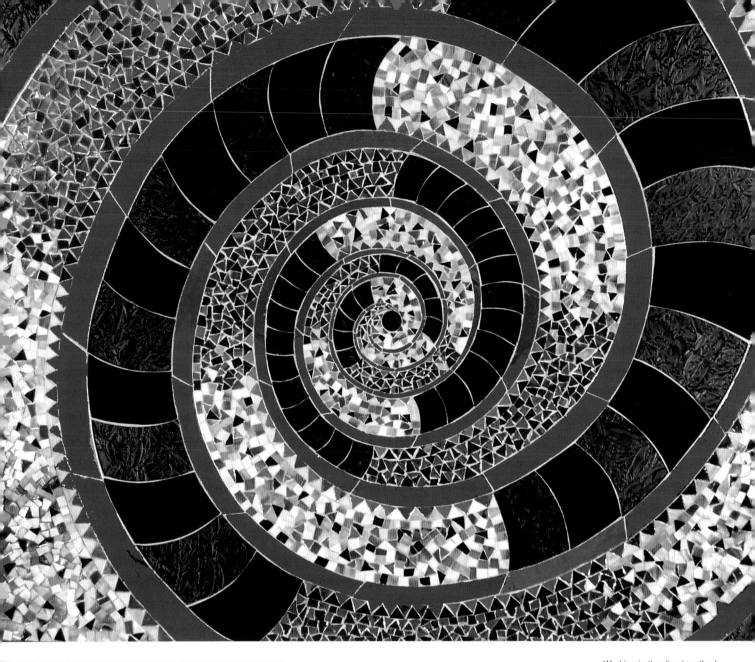

Working in the direct method, with the spiral pattern on her substrate, Patty Van Dolson could more easily mix tones and tesserae shapes in 'The Power of Pink'.

Reasons to use the direct method

■ The direct method is immediate – you can see the results as you work and know exactly what the mosaic will look like as you go along.

■ A perfectly flat surface is not important: if your substrate is sculpted or concave the tesserae must be laid directly.

■ It allows more control over gradations in colour because the faces of the tesserae are visible.

■ It is perfect if your substrate is small enough to allow direct placement.

■ Recommended when your tesserae are not of a uniform depth, shape or size and you want to retain surface irregularity and texture.

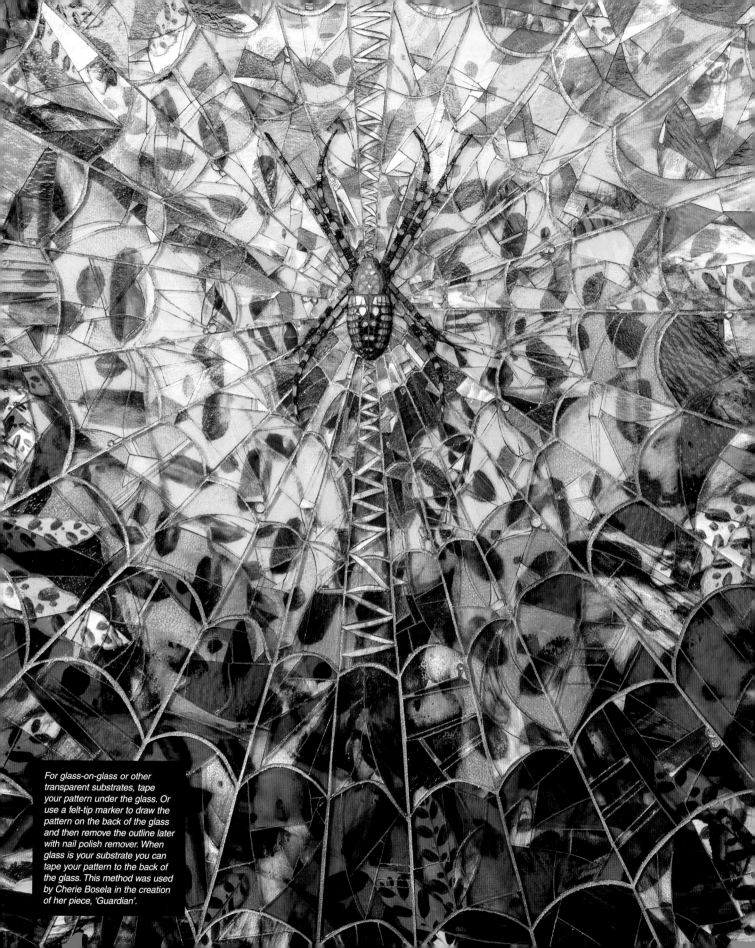

For glass-on-glass or other transparent substrates, tape your pattern under the glass. Or use a felt-tip marker to draw the pattern on the back of the glass and then remove the outline later with nail polish remover. When glass is your substrate you can tape your pattern to the back of the glass. This method was used by Cherie Bosela in the creation of her piece, 'Guardian'.

Indirect Method: Mesh

Mosaic tile mesh is a net of flexible fibreglass material. Once your tiles are glued to the mesh it acts as a temporary support so that you can move your mosaic to its permanent site and set it in adhesive, making it an indirect method of working.

The big advantage of mesh is that you are working with the tiles the right way around, so you see the tesserae in their true colours and shapes. You can work on large or small mosaics using this method; it is very easy to cut the mosaic into sections and transport it to the installation site. This technique also allows for designs to be modified easily: if you are unhappy with an area simply cut it away and insert a new piece of mesh to work on.

1 Design and scale your artwork

Prepare your to-scale design on paper and lay the finished drawing on your work surface. As with any mosaic, think about the flow (andamento) and how the background will look. Works done in this method are typically grouted, so plan accordingly.

2 'Seeing' your pattern

On your worktop, place your cartoon and cover it with inexpensive, transparent plastic sheeting. This is vital to ensure that you can lift off the mesh and tiles when they are dry and they do not become permanently attached to your pattern. The sheet should be comfortably wider and taller than the design – about 50 mm (2 in) bigger all around.

3 Cutting the mesh

Mosaic tile mesh is available from specialist suppliers in pre-cut squares or as lengths cut from a roll. The mesh must be alkaline resistant (A/R mesh) to avoid rusting or rotting after installation. Measure and cut the mesh to the size of your cartoon and place it over the drawing on top of the plastic. Tape each layer in place at the corners.

EXPERT TIP

From Ali Mirsky, an award-winning artist

Ali Mirsky creates mosaic art for all environments; she often works in glass materials. Her studio is in Maryland, USA, and her works have been commissioned for many residential and commercial clients.

Whether using PVA glue or thin-set to adhere your tesserae to the mesh, do not overdo it. The adhesive at the installation site will hold the mosaic in place – the mesh is only an intermediate surface allowing for easy construction and transport.

Reasons to use the mesh method

■ You can work over a cartoon or photograph as your guide.

■ Using mesh, you can see the tesserae in their true colours and shapes.

■ It is easy to make changes to your mosaic – if you do not like an area, simply cut it out and lay a new piece of mesh under your plastic.

■ It is easy to work in overlapping sections, allowing you to create artwork that would be difficult or impossible to do on site because of its size or location.

■ You can cut up large sections and transport them for installation. Always take photographs of where cuts have been made – it is easy to lose track.

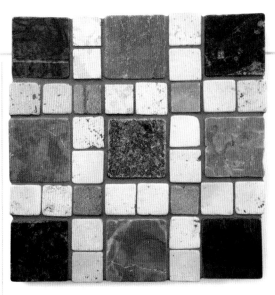

4 Where to begin

Proceed with laying the tiles exactly as if working in the direct method (see pages 86–87). It is a bit more challenging to dry-lay your design on the mesh, especially if your tesserae are small; however, it is easy to peel off tesserae after they have been adhered to the mesh, so just go for it! Glue a small area at a time, making sure to cover the strands of mesh, and place your tiles. Do not overdo the glue – you do not want to fill in the cells of the mesh forming a barrier preventing the back of the tiles from adhering in their final location. Allow the adhesive to dry thoroughly – be patient and avoid moving the tiles, as you risk dislodging them from the mesh.

Adhesives

The adhesive used for the final installation of your mosaic impacts what adhesive you should use to attach the tesserae to the mesh. If you plan to set the mesh-backed mosaic in a bed of PVA glue then use PVA glue to adhere the tesserae to the mesh. You may also do this for works you plan set into thin-set, but an alternative is to use a small amount of thin-set as your adhesive on the mesh. By using the same adhesive at both stages there is the added security of easy bonding between the same adhesives: as the saying goes, 'like likes like'.

5 Lifting the mosaic from the plastic

After the mosaic is completed, allow it to dry overnight. The next day you can turn the mosaic upside down, peel the plastic sheeting from the back, and allow it to finish drying (tiles face down). With a craft knife or scissors, cut off all remnants of mesh as close to the edge of the tiles as possible. Carefully peel off and discard the plastic release sheet.

6 Transporting and mounting the mosaic

For small mosaics, spread a generous layer of adhesive on the substrate and gently place the mosaic right-side up into the adhesive. With a grout float, pat the mosaic pieces into the adhesive, making sure every piece has adhesive under it and up the sides just a bit. For mosaics larger than 45 to 60 cm (18 to 24 in), cut the mosaic into puzzle pieces along your grout lines. None of the cut pieces should be larger than about 60 cm (24 in) square – something that can be handled easily by a single person. Make a map of your puzzle cuts (pieces), and take lots of photos if you can. Carry the mesh and tile sheets to the site – support them on a board if necessary. Spread a generous layer of adhesive to match the area of the first sheet and press the mesh backing firmly into it. Use a float or mallet and board to bang on the mosaic surface of the tiles to ensure they are level. Now lay the next sheet, taking care to line up the design. When all the sheets are laid, leave them to cure. Finally, grout and clean (see pages 116–117).

Above: Ali Mirsky's butterfly and lily pad mosaic was fabricated using the mesh method. The artist was able to see the photograph she was working from under the mesh and it was easy to install the finished mosaic onto an appropriate substrate.

Below: Bonnie Fitzgerald's 'Shenandoah Fields' employed two indirect methods. The wheat field, tree and apples were built using the mesh method, because the different heights of the smalti and the intense design made that method the most efficient. The background was built using the face tape method, because the vitreous tiles were the exact same thickness, making that method most practical.

Above: Helen Miles frequently constructs her mosaics using the mesh method. Her contemporary version of the 'Unswept Floor', shown in progress here, is a testament to how easy and versatile this method of working can be. She can see the pattern below and the work is easily transported for installation.

In a nutshell

■ **Temporary stage:** The fibreglass mesh is a temporary surface on which to build your mosaic for installation at a different site or at a later date.

■ **Make a sandwich:** Create your to-scale cartoon/pattern and place it on your workspace, then place a sheet of plastic over the cartoon to prevent gluing it onto your drawing. Finally, place the A/R mosaic mesh over the plastic and tape each sheet in place.

■ **Just like other methods:** Prepare a pool of pre-cut tesserae to work from.

■ **Stick it!** Proceed with laying the tiles exactly as if working in the direct method.

■ **Choose your glue:** Use the appropriate adhesive for the job at hand. PVA glue is fine for interior pieces; exterior-rated thin-set should be used for outdoor works.

■ **Patience is a virtue:** Be patient and allow the adhesive to thoroughly dry before removing the plastic release sheet. This can be expedited after the adhesive has set overnight by gently turning the mosaic over and peeling off the plastic sheeting.

■ **Be gentle:** A grout float or a board tapped with a mallet or hammer can be used.

■ **Direct view:** This is sometimes called a double-direct technique, because you are working in a direct fashion, seeing the front side of your tesserae as you lay them in place. The mesh temporarily holds your tesserae in place until installation.

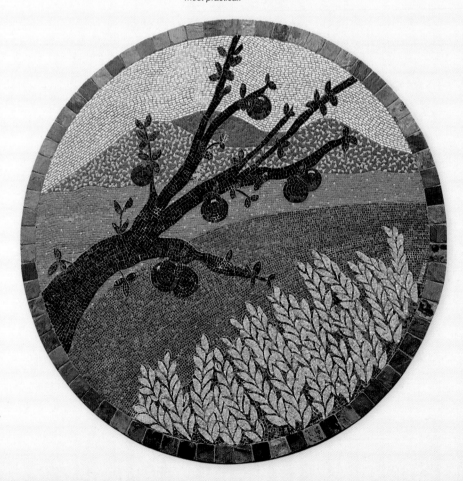

Indirect Method: Face Tape

With this method, you apply clear tape to the front side – the faces – of your tesserae, holding them in place until they are fixed in their final setting. You can work directly and see how your mosaic is taking shape and then, by placing tape on the surface of the laid tesserae, you can preserve your work for installation later.

Sometimes the use of mosaic face tape is called a double-direct technique, because you can see the right side of your tesserae as you lay them, therefore you are working directly. Here, we refer to this as an indirect method, as mosaic face tape is another method used for mosaics that are built flat in the studio and taken to their final location later.

The mosaic face tape method is a good technique for works that have large, flat areas and where the tesserae are relatively the same thickness. Whether you are working on a small or large scale, the same principles apply. Use a clear tape (mosaic face tape, packing tape, even Scotch tape will work in some cases); the tape must be strong enough to hold the tiles taped on the front side of the mosaic, enabling you to flip the mosaic over and reset into a bed of adhesive. There are a few different options for working this method, depending on the scope of your project and the size and weight of your tesserae.

Dry mounting

This technique can be employed regardless of the size of your tesserae, although it works best with relatively simple designs. On a horizontal surface, lay your tesserae in the desired pattern. If you have a cartoon to work from, transfer that image directly onto the surface and work on top of it. Once an area is completed to your satisfaction the tesserae are taped using a clear tape. When working in this manner it is important that you do not accidently bump your work. Once you have taped the face of the tesserae, making sure all the pieces are stuck to the tape, you can gently lift the mosaic and place it in the adhesive.

Using contact paper as a temporary adhesive

This technique is especially good if the tesserae are small or the design is complex. After preparing your cartoon, cover it with clear contact paper, sticky-side up. The contact paper allows you to

see the cartoon and acts as a temporary adhesive. Once an area is completed to your satisfaction, the tesserae are also face-taped using ceramic mosaic face tape. The mosaic can then be cut into smaller sections for easy transport to the installation site (see pages 110–111).

Reasons to use the mosaic face tape method

■ As mosaic face tape is transparent, you can work directly and see the mosaic as it is taking shape.

■ The mosaic face tape method works especially well for mosaics that have large, flat areas, as the mosaic can be cut into manageable sections and easily stored or transported to the job site.

■ Because the face tape has excellent strength, it protects the mosaic during transport and installation from damage.

■ As the tape is fully transparent, installation is greatly simplified, because you can easily match the grout joints when installing the final project.

■ Allows full surface contact of the tile back to the mortar bed for the best adhesion, which makes it the best technique if water is part of the design, such as for a fountain or basin.

■ Professional-grade mosaic face tape releases cleanly, without leaving a sticky residue on the tiles.

■ The mosaic face tape protects the mosaic from dirt or damage.

Face taping small projects

1 Tape the top

If you have dry-laid your design you can save yourself the work of removing and gluing each individual tessera by taping the face of the tiles. Lay the sticky side of clear tape over the face of your tesserae, taking care not to disturb them – the tape will help keep the design in place.

2 Flip and stick

Flip the mosaic over, exposing the back of the tiles. Apply adhesive to your substrate and, if you wish, a little on the back of your tiles. Here, we are using PVA glue as our adhesive.

3 Place in position

Position your mosaic into your adhesive bed on the substrate. With a small float or even your fingers, wiggle the mosaic gently, making sure even the smallest pieces have made contact with the adhesive. Allow to dry for several hours.

4 Remove the tape

When dry, gently peel the tape off, exposing the mosaic.

5 Finishing touches

Complete the simple parts of the mosaic (here, the background) in position and grout, if applicable.

In a nutshell

■ **Save for later:** With the face-tape method you use a temporary surface to build your mosaic for installation at a later date – the mosaic face tape holds the mosaic together until you are ready to install.

■ **See your work:** This is sometimes called a double-direct technique, because you are working in a direct fashion, seeing the front side of your tesserae as you lay them in place. The mosaic face tape temporarily holds your tesserae in place until installation.

■ **Easy:** For large works, face taping can greatly simplify installation.

■ **Quick:** For small works, this is a great time saver, although it only works well when your tesserae are approximately the same thickness.

■ **Water-friendly:** This is the recommended technique if water is a part of your design, such as for a fountain or birdbath, as there will be nothing except mortar between the back of your tesserae and the surface the mosaic is being mounted on.

■ **Clean first:** The mosaic face tape may not stick if tesserae are dirty: it is a good idea to wash your tesserae.

■ **Even tiles only:** This method does not work well with smalti or if your tesserae are of various thicknesses.

■ **Check strength:** The mosaic face tape needs to be stronger than the temporary adhesive (contact paper) you are using.

■ **Cheap fix:** There are many companies that manufacture ceramic mosaic face tape; a cost-effective alternative to professional-grade mosaic face tape is clear packing tape, which works fine as long as your tesserae are not too heavy.

Face taping large projects

Your work area should be large enough to accommodate a good portion of your mosaic and related supplies.

Working over your pattern, place a piece of contact paper sticky-side up over the top. Position your tesserae right-side up on the contact paper, using the pattern beneath as your guide.

Once you are happy with an area, apply mosaic face tape over the surface, taking care not to disturb the design: you will need to overlap the tape to join the pieces together. The mosaic face tape must be stronger than the contact paper.

The mosaic can then be cut into manageable pieces for transport to the installation site.

Above: Once face taped, the mosaic can be cut into sections for transportation to the job site where it will be reassembled. It is important you develop a system for keeping track of what pieces go where – for example, using registration lines and taking lots of photographs.

Right: 'Yucca' by Bonnie Fitzgerald was most easily fabricated using the face-tape method. The tesserae (ceramic tiles) were all the same thickness. The work was made in the shade and comfort of the studio and flat on the workbench. It was installed on the wall in two pieces. After the adhesive cured, the work was grouted in place.

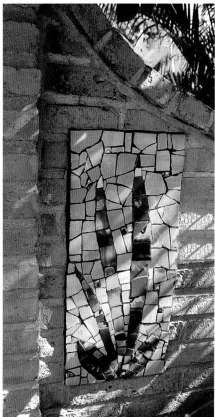

EXPERT TIP

From Kim Emerson, an award-winning artist
Kim Emerson's public artwork portfolio ranges from large installations for municipal hospital and commercial settings to residential commissions. She most often works in high-fire ceramic and uses the face-tape method extensively for these installations.

It is important you clean your tesserae after cutting and before you start placing them. They should be clean before applying the face tape. The tape may not stick if the tiles have residue from the wet saw or other tools. I rinse and dry every single piece of tesserae before using it in a mosaic to be face taped.

Reverse Method: Paper

The reverse method is a traditional way of creating a mosaic off-site. The mosaic is laid the wrong way around – with the surface of the tiles that will be finally displayed facing downwards and the tile backs facing towards you. It is not until the very end of the process that you will see the front face of the tiles or be able to view the design the right way around.

1 Cutting the transfer paper

Use brown craft paper for this method – it is strong and stable and, most importantly, will soak up water when you want to remove it from the tiles at the end. Cut a sheet to accommodate your design comfortably. If you are working on a large design, break it down into sections no larger than 300 x 300 mm (12 x 12 in) so that the sheets will be manageable when covered in tiles.

2 Transferring your design

Transfer your drawing onto the brown paper. Remember that the end result will be back to front – make sure that letters and numbers are the correct way around (writing should appear backwards). If you have access to a light box you can flip the design by tracing over the back of the sheet and using this as the drawing that you transfer (you can improvise using a window, see pages 68–69). Go over the transferred design with a permanent marker so that you can see it clearly.

3 Laying the tiles

Make a batch of 'Pasta Amido' (see below). Start laying the tiles – remembering to place them upside down – pressing the right side of the tile into the paste. Complete laying the mosaic as normal, working on a small area at a time and then allowing it to dry. On small works a paintbrush is helpful for spreading the paste.

'Pasta Amido' flour paste

The best adhesive to use for adhering the tesserae onto the paper is a simple flour paste called 'Pasta Amido'.

Ingredients

- Flour
- Water
- Salt, glycerine, gum arabic or borax

Method

1 Mix about one tablespoon of flour to one pint of water in a saucepan.

2 Heat in a saucepan on medium heat on the stovetop.

3 Bring to a boil to form a translucent syrupy consistency.

4 Add a pinch of salt, or glycerine or gum arabic for added adhesion, or borax for preservation.

Reasons to use the reverse method

- Tiles will eventually lay flat even if they are of different thicknesses.

- The ideal method for tabletops and floors.

- Work can be done off-site and transported easily.

- Changes can be made to the mosaic design before it is permanently installed.

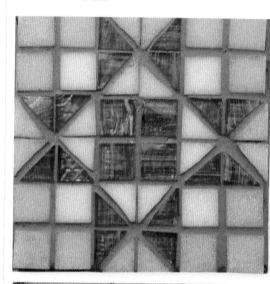

Below top: The simple grid pattern was made using vitreous glass tiles. It was a useful exercise to learn the reverse method on paper.
Below bottom: The pattern can be transferred onto the brown paper. Here, the planes of the face are detailed and the artist is laying the skin tones in smalti.

4 Gluing the tiles

Move the finished sheets to the site. The small sample piece shown uses vitreous glass tiles, setting into PVA glue. For larger installations and thicker tesserae, use thin-set as your adhesive. Flip the mosaic sheet over, and lay the back surface of the tiles carefully onto the glue. Check and adjust the position, then press the sheet down more firmly using a rubber squeegee or roller. Complete all the sections, aligning them carefully. Allow the glue to dry thoroughly: overnight is best.

5 Soaking away the backing

Use a wet sponge to soak the brown paper thoroughly. Leave the water to sink in and then give it a second soaking. Allow the water to soak into the paper for 15 minutes, splashing on more if necessary. Eventually, the paper should loosen and, if you are lucky, you should be able to peel the brown paper off in one gentle movement. Work carefully; you may need to re-stick any loose tiles as you go. After removing the paper, clean the surface of the mosaic and allow it to dry before grouting in the usual way.

EXPERT TIP

Gary Drostle is an internationally recognised artist and a former President and Chairman of the British Association of Modern Mosaic
Gary Drostle works from a studio in southeast London, producing murals and mosaic works.

❝ *The glue I use for the reverse method is a traditional flour and water paste, Pasta Amido (see left), which you can see in Cennini's* Craftsman's Handbook, *written in the 15th century. It still works well for me, so why change it? Personally, I do not use PVA glue, because if the concentration of PVA is too high the paper will not come off.* ❞

Choosing a Substrate

The substrate is the base material that you will lay your mosaic onto. The correct choice of a substrate for your mosaic depends on the conditions it is to be displayed in – indoors or outside, in the bathroom or a bedroom – and the materials, adhesives and laying technique you are using.

It is important to select the right substrate for your application, and here you will find the most common and readily available choices. First you must decide which technique you will be using – such as the direct method, reverse on paper, or on mesh (see pages 86–97). The most important issue is whether the mosaic will be exposed to water and/or freeze-thaw conditions. Another consideration is the weight of the finished artwork. If your tesserae are very heavy you may want to invest in using a substrate that is more lightweight.

MDF (Medium-Density Fibreboard)

MDF is an ideal substrate material for interior mosaics. It is relatively lightweight and provides an even and stable surface to fix tesserae to. MDF can be cut with standard tools and is widely available from DIY shops and building suppliers. Sheets normally go up to 244 x 122 cm (8 x 4 ft) and vary in thickness from 6 to 25 mm (¼ to 1 in) – however, 12-mm (½-in) thick would be adequate for most of the projects in this book. Buying large sheets is generally most economical – some shops will cut the sheets down into smaller pieces for a small fee. If you are using this service, take along a cutting plan, or work out in advance a standard, simple subdivision of a whole board to give you substrates that will meet your needs.

The main shortcoming of MDF is that if it gets wet it will absorb water and swell – it is therefore not suitable for exterior locations or wet areas such as the bathroom. Before using MDF as a substrate it is important to prime it with PVA glue diluted with water or a paint primer. You may also choose to score the surface with a box cutter, giving it a 'tooth' – something textured for the adhesive to grab onto.

Wedi board

Ideal for heavy works, mosaics that you plan to keep outside and mosaics that use thin-set mortar as the adhesive. Developed for the tile trade as an alternative to cement backer board, it is composed of polystyrene encased in fibreglass mesh. The surface is cementitious, meaning it is a cement-based product, making it ideal for wet areas; and it will readily accept thin-set. Wedi board has found its way to the mosaic arena because it is easy to manage and very lightweight. Always follow the manufacturer's recommended applications. Wedi board and similar products require you plan your hanging system in advance (see pages 118–119 and 150–153).

Temporary surfaces

Temporary substrate surfaces include brown paper and mesh – these are not standard products, but are specially adapted for mosaic.

Brown paper

Brown paper is used in the reverse method (see pages 96–97) as a temporary support for tiles that are glued to its surface using flour paste. If using brown paper for the reverse method, be sure it is wax-free, otherwise the flour paste will not hold. Mosaic suppliers sell this paper in pre-cut sheets that are the right size to work on a design in sections. You can also buy brown paper in rolls for use in wrapping parcels – however, you should only use the uncoated type as it is essential that the paper can be thoroughly soaked to remove it after the tiles have been stuck in their permanent location.

Mesh

Mosaic tile mesh is a flexible lightweight material – generally made from glass fibres – which allows you to assemble a mosaic on a workbench, then transfer it easily to where it is to be installed. Tiles are stuck to the mesh, either with PVA glue or a small amount of thin-set (see pages 90–92). Sheets come in a variety of sizes, and mesh is also available on rolls for larger projects. Large designs can be created, cut into sections, and then assembled together on-site. The fibreglass mesh used for mosaic is designed for the construction industry; it is alkaline resistant (A/R), meaning it will not degrade over time.

Aluminium honeycomb

This product was originally developed for the aerospace industry, for use in airplane wings. Aluminium honeycomb is sandwiched between fibreglass epoxy faces and is extremely strong. It is suitable for outdoor installations. It may be cost-prohibitive, but worth considering for large-scale projects. Its use may dramatically reduce your installation time. There are a few mosaic supply vendors who carry this product and you can purchase modest sizes for your smaller projects. For large projects, the product is available in sheets, generally 122 x 244 cm, 2-cm thick (48 x 96 in, ¾-in thick).

Cement backer board

Cement backer board is a good choice of substrate for mosaics intended for wet conditions, such as bathrooms. It is a cement-based material that can be used to line existing floors and walls. The fixed board provides a robust tiling surface that will be unaffected even by soaking conditions. Backer boards are available from home superstores, building supply stores, and specialist tile shops. Always follow the manufacturer's instructions carefully. Floors or walls may need a waterproof membrane between them and the backer board, with specified gaps to allow for expansion after installation. Cutting and jointing boards may also require the use of specialist tools and materials.

Glass or Plexiglas

Perfect for stained glass, these substrates allow light to pass through to the tesserae. Plexiglas is a shatter-resistant alternative to glass. When using glass, be sure that the edges are honed down and not sharp.

Plywood

Plywood consists of layers of wood bonded together, with the grain of each layer running in a different direction. This gives the bonded sheets great strength. Plywood is a good choice for mosaics and is readily available. Regular plywood is not acceptable for exterior works: it will warp from moisture. If using plywood, look for sheets with no knots and few splinters.

Marine ply

Marine ply is treated to prevent rotting and can therefore be used as a substrate for mosaics in areas where there are high levels of moisture. However, it is important that all exposed surfaces of the board are thoroughly sealed using an external-grade varnish or paint. Both plywood and marine ply are available in a variety of thicknesses from 4 up to 25 mm (⅜ in to 1 in).

Making Substrates

An alternative to purchasing a substrate is to make your own, a unique surface to mosaic. If you are looking for a surface that has a rough, more primitive look, or a surface that has dimensions and undulations, then consider creating a substrate. This technique can bring movement and a fresh dynamic to your work. It is also a very inexpensive process that can be made to withstand freeze-thaw environments.

Many artists are experimenting with the process of making their own durable, exterior-rated substrates. By creating your own undulating substrate you can mimic the folds of fabric or the ripples of water. Below is the simplest approach to creating a dimensional substrate. To get started you will need fibreglass mesh – the same mesh used for the indirect method discussed on pages 90–92. You will also need inexpensive plastic sheeting and thin-set mortar. A good selection of tools to smooth the thin-set will prove helpful – consider tools used by builders for spreading plaster or joint compound. For more dramatic undulating effects you may need to add a support system of sorts – polystyrene is an easy-to-use support material.

Why choose thin-set?

By using the thin-set in conjunction with a unique support system you are not only creating a signature work surface, you will also be creating a new topography and shapely surface that does not need to be framed. Additionally, by using thin-set as the adhesive for your mosaic, the substrate will become stronger. This is an exciting new development for mosaic art.

Creating fabric-style substrates

1 Prepare your mesh
Begin with several pieces of mosaic fibreglass mesh, available from mosaic suppliers. Cut several pieces exactly the same size – the larger the substrate, the more layers of mesh you will need.

2 Prepare your work surface
Place a piece of plastic on a work surface that can remain in place for several hours: the plastic should be slightly larger than your mesh pieces.

Marian Shapiro captures the spirit of her favourite quilt, including the undulating folds of the fabric in her piece 'Blue Kilim'.

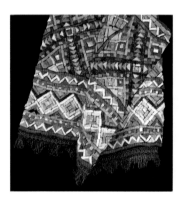

EXPERT TIP

From Marian Shapiro, who lives and works in Australia
Originally trained in fine art and theatre, Marian Shapiro's work reflects her fascination with the creative vision of using ancient techniques and traditional materials.

When making a curvy substrate, be aware of how the shape will impact your mosaic. A sharp ridge or 90-degree angle will result in a very obvious grout line that disrupts the flow of your mosaic work. A very tight curve will mean that you need to cut smaller tesserae for that area. It may be easier to use tiny tesserae over the whole piece.

In a nutshell

■ **Unique:** Creating your own substrate is a great way to make totally unique work.

■ **Cheap:** These unique substrates are very inexpensive to create.

■ **On the rise:** The undulating shapes – hills, valleys, sculptural ribs – all add movement and unexpected texture to your mosaic

■ **Patience please:** It is important you allow your new substrate to fully cure (dry) before trying to manipulate it or move it too much.

■ **Going large?** The larger you make your substrate, the more layers of mesh you will need.

■ **Regular use:** If you regularly work with thin-set, think about having a workstation dedicated to handmade substrates – at the end of the day when you have leftover thin-set, you can add another layer to a substrate work-in-progress.

■ **Layer up:** You can constantly add to your substrate. Thin-set loves thin-set; attaching ribbons or second layers of mesh is easily accomplished.

■ **Presentation:** Hanging devices can be added in much the same way as other cemetitious products – washers, bolts and D-rings (see pages 118–119)

■ **Colour options:** Your top layer of thin-set and the thin-set you use to adhere your tesserae can be coloured with concrete colourants (pigments) (see pages 114–115).

3 Apply thin-set
Mix thin-set, following the manufacturer's directions, and coat the first piece of mesh with the thin-set. If you use exterior-rated thin-set, then your finished substrate will be suitable for exterior exposure.

4 Layer
Take another piece of mesh and place it on top of the first, then coat with another layer of thin-set.

5 Repeat
Repeat the stacking and coating process for at least four layers. Depending on the size of the substrate you are creating you will need to add additional sheets of mesh. At the third or fourth layer you may find you have an abundance of thin-set seeping through the mesh, in which case just add an additional piece of mesh and smooth the thin-set with your palette knife.

6 Create unique forms
To create folds or undulations in your substrate you can place polystyrene pieces or other objects between the layers. You can also make ribbons and smaller undulations to add to a larger substrate. Allow your substrate to cure (dry) overnight, or longer, depending on how many layers of mesh were used.

Deb Aldo added ribbons to her handmade substrate and then mosaiced selected areas. There are countless unique directions you can take this process.

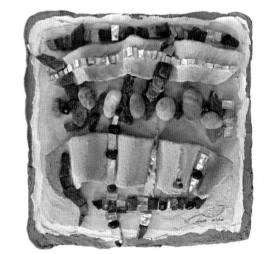

Adhesives and Glues

The adhesive best suited to your mosaic depends on the materials you are using as your tesserae, the substrate and the environment in which it is to be housed. The three most common adhesives for mosaics are thin-set mortar, PVA glue and silicone-based glue. Successful mosaics are dependent on the tesserae being applied to your substrate with the appropriate adhesive. The adhesive is key to the longevity of your artwork.

Thin-set

For many mosaic materials thin-set mortar is the adhesive of choice. Thin-set is an organic product, composed of portland cement, silica, sand and moisture-retaining agents. It is called thin-set because it is a thin-setting bed – as opposed to a thick-setting bed used in construction. It has the bonding properties of concrete, making it a cementitious product. Thin-set is the most appropriate adhesive for exterior projects. In the tile trade, thin-set is often called 'mud'.

Thin-set is manufactured in grey and white. It can be coloured with cement pigments, available in a limited palette from building supply shops (used in the building trades for stucco colouring), and are available from several mosaic suppliers in a wide variety of colours. Pigments are available in both powder and liquid forms (see pages 114–115).

Thin-set is available in a powdered form to be mixed with water or polymer additive, depending on your final application. You can also purchase premixed thin-set. An advantage to premixed products is convenience – just be sure the product you choose is rated for your intended use, since not all thin-set is rated for freeze-thaw conditions.

PVA glue

PVA glue is white in the bottle but transparent/translucent when dry. It is the ideal glue for mounting flat-backed tesserae to most surfaces, particularly MDF and other wood-based substrates. There are many manufacturers of PVA glue; choose one with some body, not a school glue which is diluted with water. These adhesives are water-based and clean up with soap and water. They do not emit any toxic fumes and are not hazardous to the touch.

Silicone adhesive

Transparent, flexible and watertight, this is a product that is perfect when both surfaces are non-porous, such as glass-on-glass. There are several manufacturers of silicone-based products, the common property being a flexibility of adhesion. It is especially helpful when working on a vertical surface, as it is sticky and has body. Exterior-rated silicone, such as that recommended for windows and doors, can be used for most exterior applications.

EXPERT TIP

From Helen Bodycomb, a contemporary mosaic artist from Central Victoria, Australia
Helen Bodycomb practises predominately stone and glass mosaic and sculpture. She studied mosaics at the Spilimbergo School in Friuli, Italy, and has taught several technical workshops in North America. Her work is collected internationally.

Don't dab your tesserae with thin-set: hold the tesserae with tweezers and dip each one into the adhesive and place it as desired. To keep the glue nice and fresh (a batch stays workable for about 4 hours) keep it in a zip-lock bag so it doesn't form a crust. Squeeze a little out onto a plastic lid every so often.

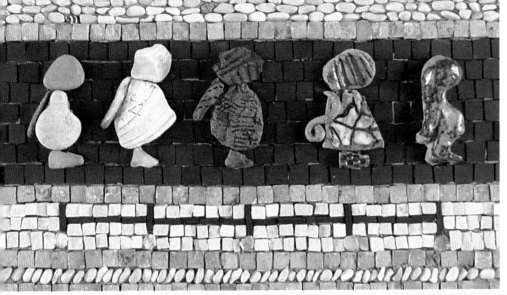

For 'Evolution' by Bonnie Fitzgerald, the author used several adhesives: thin-set mortar for the marble, unglazed porcelain and pebbles; silicone to adhere the shells onto the substrate; and epoxy to secure the substrate to a slate roof tile in lieu of a frame.

Epoxy resin

Epoxy resin is a two-component adhesive that will bond permanently to almost any surface – ideal for quick fixes and repairs, particularly for outside applications. It is great for quick repairs, but not recommended to use for your entire mosaics. It has a strong odour and very short dry time. To use, squeeze each component from its container so that equal amounts lie side by side on an old tile or plate. Mix them thoroughly with a stick and use the mixture fairly quickly. The setting time varies. A dispenser makes it easier to mix the correct quantities of two-component epoxy glues.

Mastic

Tile mastic is a sticky adhesive that comes premixed. It works especially well on vertical surfaces and for tesserae with varying thicknesses such as dishes and crockery. It is not rated for floors, exterior applications, or very wet environments; but it is convenient and easy to use. Like thin-set, mastic can be coloured with pigments.

MAC glue

Available from mosaic speciality shops, MAC is a multipurpose, quick-drying, clear glue. It is flexile, crystal clear and water resistant. It is an excellent choice for glass-on-glass projects and tempered glass works. Because it has a very thin body it is best used on flat and horizontal surfaces.

UVA adhesive

Developed for the commercial glass trade, UVA adhesives have a very strong bonding quality and are ideal for working glass-on-glass. Their adhesion is ignited by ultraviolet light, in the form of direct sunlight or a special UV lamp. This is a professional-grade product so use it with respect.

■ **Choose wisely:** Use the appropriate adhesive for your project.

■ **Simple starter:** White PVA glue (polyvinyl acetate) is a rubbery synthetic polymer and is the most common adhesive on the market (also known as white craft glue).

■ **Indoors only:** PVA glue is water soluble; therefore, it is not rated for exterior applications.

■ **Safety first:** Always follow the manufacturer's instructions and read relevant health and safety information. Work in a well-ventilated space. Wear rubber gloves and a mask when mixing thin-set.

■ **Leftovers:** Never pour cement-based adhesives down the sink or household drains; concrete gets stronger under water.

■ **Dry time:** Be patient and allow your adhesives to cure or thoroughly dry before grouting or mounting.

■ **What tool?** Depending on the glue there are lots of applicator options: paintbrush, craft stick, palette knife and trowel. Always clean your tools when you are done working for the day.

Mosaicing 3D Surfaces

Recycle, repurpose, reuse: you can breathe new life into existing three-dimensional objects with mosaic surface adornments. When you find an object that interests you, inspect it for cracks, imperfections and anything that may compromise the full adhesion of your mosaic to the surface.

When working on a three-dimensional surface, especially one that is not new, it is important to properly prepare your substrate: begin by thoroughly cleaning the object. You can use all sorts of different surfaces – just remember to select the appropriate adhesive for the tesserae and the material of the substrate you have selected. You will probably need to work on a relatively small area at a time, keeping that part of the object horizontal until the adhesive has set. You will also find that you can improvise temporary support for tesserae while they set, using masking tape, cling film or other materials.

1 Prime your surface
The bowl in this example is made from wound bamboo. Priming its surface with slightly watered-down PVA gives the cement or tile adhesive further encouragement to form a strong, permanent bond.

2 Work on a small area
For this artwork, the appropriate adhesive is thin-set: because the surface is curved, an adhesive that has body is required. Only apply as much adhesive as you can work on in a period of 10 minutes or less. This is to avoid the thin-set drying out and becoming unworkable – if this does happen, scrape the waste off and discard.

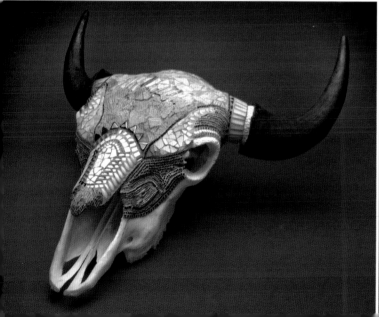

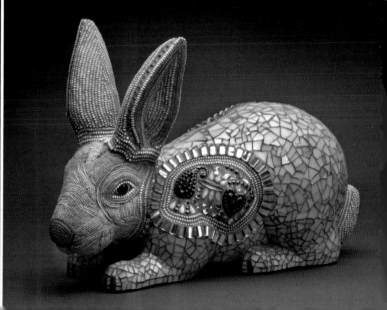

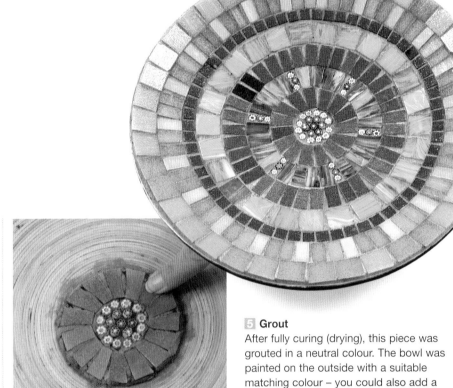

5 Grout
After fully curing (drying), this piece was grouted in a neutral colour. The bowl was painted on the outside with a suitable matching colour – you could also add a further protective layer of clear varnish to the outside.

3 Use the object's shape
The logical place to start this mosaic is from the centre – build the design outwards and upwards in rings. This means the tile pieces have nowhere to slide under the effect of gravity. Here, thin-set has been used and the mixture kept fairly stiff to ensure that pieces do not slip. A cluster of millefiori becomes the centre of the design.

4 Work outwards
Cutting this design is similar to working on any circular motif. You will need to dovetail the pieces – that is, taper each piece to fit neatly together and test that they fit before gluing them. Work outwards, a ring of tiles at a time. On deeper bowls with steeper sides, you may need to cut the tesserae pieces smaller to avoid a stepped look.

Left: *Joan Schubert repurposed 3D objects with beautiful mosaic enhancements. 'Remains on the Range' (far left) is a bison skull with Raku ceramic, vintage glass beads and mirror mosaic. 'White Rabbit' is constructed from a wood base, over which the artist applied stained glass, vintage glass jewels and beads.*

EXPERT TIP
From Laura Rendlen
From her studio in Kansas City, Missouri, award-winning artist Laura Rendlen creates dimensional mosaic artworks. Thin-set is her adhesive of choice, often colouring the thin-set and using a variety of repurposed materials.

It is much easier to pick at your thin-set, cleaning up a messy area or a place where too much was used, if you wait about 20 minutes. The mortar has begun to cure and with a toothpick or dental tool you can easily remove unwanted mud without disturbing the tesserae. If you try to clean up immediately, chances are you will dislodge the piece you are trying to clean!

Exterior Mosaics

While all successful mosaics require the correct combination of materials – tesserae, substrate and adhesive – this is especially true for exterior works. Be sure the materials you plan to use can withstand the weather conditions they will be exposed to.

You can mix different materials, but be sure each is rated for your climate. It is essential your substrate is clean and in some cases it will benefit from a scratch coat of thin-set or a paint primer. The appropriate adhesives for exterior mosaics are thin-set mortar or silicone. Confirm with the manufacturer that you are purchasing exterior-rated products.

It is essential that an exterior mosaic be constructed on a weather-appropriate surface. The most common exterior surfaces are concrete-based – paving stones, Wedi board or cement backer board. Marine-grade plywood and aluminium honeycomb are also rated for exterior work, although both will benefit from a scratch-coat of thin-set (see pages 98–99). These surfaces work especially well with thin-set. Exterior-rated tesserae include high-fire ceramic, many glass products and natural materials such as stone.

Many garden centres carry three-dimensional sculptures and birdbath structures, and these pre-cast concrete forms can make great mosaic surfaces. Another popular pre-made substrate is composed of resin, a synthetic substance, which can be used but the adhesive of choice here would be silicone or epoxy. Benches are a terrific garden enhancement and are made even more beautiful with mosaic enhancements, but beware of sharp edges or pointed shards on horizontal seating areas.

Mosaic flowerpots are a natural ornament for outside. Terracotta pots are an acceptable substrate for exterior works, but not freeze-thaw environments, so bring your pot indoors for the cold months. The inside of the pot should be sealed with a penetrating concrete sealant to prevent water from leeching through to the back of your mosaic. House numbers and artwork to hang on the exterior of your home are a unique and personal enhancement to your environment.

Andrea Shreve Taylor used stained glass to cover a handmade concrete basin.

In a nutshell

■ **Tile choices:** Tesserae for exterior mosaic should be carefully considered; if it will experience extreme weather, then the artwork may need to be brought under cover during the winter months.

■ **Glue decisions:** Always use an adhesive rated for exterior conditions; thin-set and silicone are your best choices.

■ **What surface?** Use an appropriate substrate; outdoor mosaics will last indefinitely if constructed on a weather-friendly surface.

■ **Use nature:** Pebbles and shells are ideal for outdoor mosaic because they are naturally unaffected by the weather.

■ **Bird-friendly design:** Birdbaths are beautiful garden additions, but remember the purpose is for birds to safely bathe, so watch for sharp edges.

■ **Safety first:** Watch for sharp edges on garden benches, especially horizontal areas.

■ **Slippery glass:** Concrete paving stones are often used to create stepping stones. Beware if using glass tesserae; the stepping stone may become very slippery. Make these items decorative, not functional, garden objects.

Top left: This stained glass mosaic birdbath by Mark Brody is a colourful addition to a garden. **Top centre:** You do not need to completely cover your surface with mosaic, as with this urn by Brigitte Messali. **Top right:** Made with stained glass over Wedi board, this house number by Michele Falvo is a welcoming addition to a home. **Centre:** These beautiful cast concrete benches by Sandra Groeneveld are made even more beautiful by her expertly crafted mosaic enhancements. **Bottom left and centre:** These beautiful planters by Julie McKee were made using stained glass over large terracotta pots. **Bottom right:** Tabletops are a popular mosaic item for patios. Use tiles of the same thickness if you wish to have a flat eating surface.

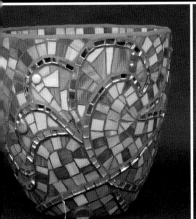

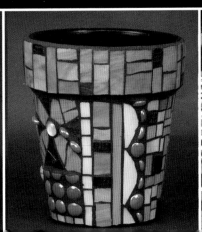

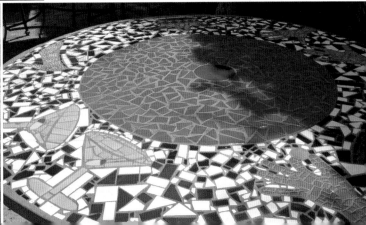

Architectural Works

For centuries mosaics have graced building facades, walkways, floors and interiors. Mosaics, when properly constructed, are durable and will last for a very long time. Many contemporary artists are finding success working on large-scale commissions in the private and public realm. Public commissions will need planning permission. Here, we focus on mosaic possibilities in your own home.

The possibilities are endless when it comes to architectural mosaic enhancements for your home: fireplace surrounds, steps, shower and bathroom enhancements and kitchen backsplashes are just a few examples of areas that would benefit from having a mosaic makeover. Regardless of the scope of work you are presented with, there are basic construction and design principles to be observed to ensure a successful installation.

Because architectural installations are permanent you will need to thoroughly plan your design and may need to get your designs approved before you begin. Take into account who will live with the mosaic: does it suit their taste and can they relate to the artwork? You want to be sure to use materials, colours and textures that you are confident will be pleasing to look at for a long time and that are appropriate for the job site.

Most architectural works are best executed in one of the indirect methods of mosaic making: the mesh method, face taping or the reverse method (see pages 90–97). Whenever possible it is helpful to construct as much of your mosaic as possible flat, on your studio table. The work can then be transported to the job site for installation. You do not want to be kneeling in a shower or bending over a kitchen counter making the mosaic on location unless absolutely necessary.

In a nutshell

■ **Enhance the space:** Think about adding mosaic details in unexpected places – a simple border can transform a room.

■ **Know your site:** If at all possible, make a pattern and fit it at the job site. If this is not possible, take exact measurements and lots of photos. These will prove invaluable as you construct the mosaic in your studio.

■ **Check the fit:** Carefully measure, and measure again. You want to be sure the mosaic you are making is going to fit properly.

■ **Be prepared:** There will be portions of the mosaic that will have to be created on site; be sure to take extra materials with you on installation day.

■ **Work in comfort:** Most architectural works are best constructed in one of the indirect methods, using mesh, brown paper or mosaic face tape.

■ **Use best practice:** Finish your work with appropriate construction and building principles in mind. Proper lighting makes a huge difference.

■ **Aim for a lifetime wear:** Your mosaic surface may require sealing if it is a high-traffic area or exposed to food and liquids.

EXPERT TIP
From Ken Fitzgerald
Ken Fitzgerald is a longtime collaborator with Bonnie Fitzgerald and supervises all installations for their company, Maverick Mosaics.

‘ *When planning for an architectural installation I NEVER trust anyone's measurements but my own. I always visit the job site, take detailed measurements, and usually make a template that fits exactly to the space. By using the template for the basis of my cartoon I am guaranteed the artwork will fit as it should come installation day.* ’

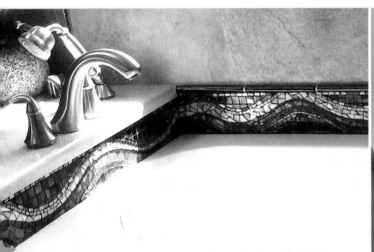

Top left: This beautiful mosaic border by Ali Mirsky is a gracious and flowing addition to an otherwise uninteresting bathing area. **Centre left:** Michael Kruzich created a beautiful floor floral medallion using classical design principles, ancient techniques and traditional mosaic materials. **Bottom left:** Made with ceramic tiles, these fanciful steps are a perfect location for a mosaic enhancement. **Top right:** Ali Mirsky created a striking kitchen backsplash using stained glass. She built it in her studio on a flat surface; the mesh method allowed her to see exactly how the mosaic was shaping up.

Installation

Installing your mosaic is as rewarding as it can be stressful. Typically, large-scale works have been in process for a long time, often months, and installation is the final chapter of a long story. Here, you will find installation methods applicable to mosaics built in one of the indirect methods.

If your mosaic is intended for exterior life you will be dependent on weather for your installation days. Humidity, cold weather and rain all affect the cure time of thin-set and grout. Be sure to allow enough time for proper installation; however long you think it will take, double it! The job of installation is fraught with unforeseen challenges. That being said, once your installation is complete, the pride and reward you will experience is immeasurable.

Preparing to move

Once you have completed laying out the mosaic on a temporary substrate (see pages 100–101) you will need to cut your artwork into sections for installation. Begin by taking photos of the mosaic before you start cutting it into puzzle pieces. Devise some sort of registration mark system – a simple way you can reassemble the mosaic on site. Divide the mosaic into sections that are manageable – no more than 45 x 45 cm (18 x 18 in). Work to keep the back of the mosaic tiles clean, perhaps carry the sections to the site on boards or drop cloths.

Preparing the job site

Thin-set is the adhesive of choice for most installations (see pages 102–103). Premixed thin-set is not recommended for large installations. Mix just enough thin-set to cover an area that you can install within 1½ to 2 hours, and set aside to slake for the required time.

The surface you are installing on should be clean, dry and properly prepared with a scratch coat or vapour barrier where necessary (you need to research this in advance, depending on the substrate you are working on).

Find a clean, nearby space where you can lay out the mosaic exactly as it will be installed. Put down a tarp or plastic sheeting to lay the mosaic on so it does not pick up dirt or debris that could cause problems with adhesion. With the mosaic laid out in its correct configuration, it will be simple for you to go directly to the piece you need, as you need it.

When your thin-set has slaked, stir it again really well. Stir the thin-set each time you go back into the bucket to trowel a new area. If you are working with a large

This column, by Bonnie Fitzgerald, was made with high-fire ceramic using the face tape method. Working in the round was challenging and, although most of the mosaic was constructed flat in the studio, there was significant mosaicing to be done on site.

In a nutshell

- **Safety first:** Wear gloves when working with thin-set, hard-hats on construction sites, proper footwear and a harness if up on scaffolding or high ladders – and don't forget your first-aid kit.

- **Scratch coat:** Your surface (e.g. a brick wall) may require levelling or smoothing before you begin. If so, prepare the wall by applying a 'scratch coat' – a very thin layer of thin-set to receive the new thin-set and mosaic.

- **Vapour barrier:** A vapour barrier helps to protect the surface you wish to install onto from moisture (e.g.

floors and walls). These are typically special sheets of plastic or foil that are applied to the work surface with a special adhesive. The adhesive for the mosaic is then applied to the vapour barrier and the mosaic is built over the top.

- **Read the instructions:** When working with thin-set, read the package directions and mix accordingly. Follow the manufacturer's instructions.

- **Then follow them:** Do not continue using the thin-set mixture after its stated period of working time.

- **Keep it fresh:** To help keep thin-set pliable and to prevent a crust forming over it while you are working, stir frequently and lay damp kitchen paper over the surface.

- **Clean up:** If using face-taped sections, you must remove thin-set from joints. Cut the tape with a box cutter and dig out the messy area with a flathead screwdriver.

- **Wait:** Mosaic face tape can be completely peeled away after 24 hours. Then you can grout.

amount of thin-set, it helps to place a wet cloth or some kitchen paper over the surface to keep a skin from forming over the top.

Installation

If you are installing onto any cementitious surface, mist the surface lightly with water. Start applying the thin-set with the notched side of the trowel, holding it at a 45-degree angle. When you hear the trowel make a scratching sound you will know that you are pressing hard enough and getting an even coat of adhesive.

When installing on a wall, if possible, start with a bottom corner, working section by section, pressing the pieces into place. If necessary, place a board or some other straight object below the first row of sections to keep them from slipping down the wall. If this is not an option, try using masking or duct tape to hold the sections in place until they set. Stretch a piece of tape from the centre of the mosaic section up and onto the wall area above it. Do this in as many places as necessary, forcing your puzzle pieces to fit tightly together.

As you place each section, gently press it into the thin-set, making sure that all of it is in full contact with the adhesive. The mosaic will adhere to the thin-set pretty quickly and stay in place. If you have trouble with the thin-set squishing out too much and getting on the face of your mosaic, you are probably using too much and/or using too large of a notched trowel for the thickness of your tiles. Wipe any thin-set off the faces of the tiles as you go, and if any pushes out past the front of a tile, scrape it back. Once the first piece is in place, move sideways to the next piece.

If a tessera falls out, simply backbutter the offending piece and push it back into place. Do not leave any thin-set on the faces of the tiles, and be sure that the thin-set comes at least 25 per cent of the way up the sides of the tesserae (but not so far as to interfere with grouting). Let the completed mosaic set for at least 24 hours before grouting. If conditions are fairly hot, mist the mosaic lightly to keep it from curing too quickly.

Top: Registration marks on the large pieces will allow the mosaic to be reassembled at the site.
Centre: Apply thin-set with a notched trowel held at a 45-degree angle.
Bottom: Backbutter any tesserae that fall out during installation.

All About Grout

Grout is the material that fills in the interstices (the spaces in between your tesserae). The grout can transform your artwork into a unified, coherent design. Grouting is a personal choice and it is not a requirement of mosaic making. There are a variety of grouts and grout colours available with which to finish your mosaic piece.

Most grout manufacturers have free sample 'chips', similar to paint swatches, so you can see what the colour will look like next to your mosaic before making the purchase.

Grout is available as sanded or unsanded, ready-mixed or in a powder form, and with or without latex additive (those that contain latex are also called 'polymer fortified'). Sanded grout is usually the most appropriate choice for mosaics, because grout lines are inconsistent. Only use unsanded grout if your grout lines are less than 2 mm (¹⁄₁₆ in). The vast majority of grout that is commercially available is polymer fortified and rated interior and exterior, however, the manufacturer may recommend sealing grout to prevent staining in exterior or high-moisture environments. The major grout manufacturers do extensive research and development and, as a consequence, there are grouts available that contain additional polymers and other secret ingredients that ensure colour uniformity and added durability, making them stain resistant.

Epoxy grout is a two-component grout intended to provide a seal to tiles that is not only completely waterproof, but also resistant to corrosive substances. This grout is particularly suitable for kitchen worktops and other areas that will be subjected to a range of temperatures and will need to withstand the use of strong cleaning materials. It is the only grout warranted by some manufacturers as stain-proof. The colours do not fade in the sun (it is UV resistant). Follow the manufacturer's instructions closely when using epoxy grout or you may find it difficult to work with. Epoxy grout is also quite expensive.

Ready-mixed grout is readily available from hardware shops and is supplied in reusable tubs that, if handled correctly, allow you to use the grout for several weeks after opening. Ready-mixed grout

is not generally suitable for outdoor use; always read the label.

Until you need to use grout – as well as after you have applied it – make sure you tightly reseal all containers to prevent the grout from drying out and becoming unworkable. If you are using grout that has been on the shelf for a while, check for lumps – it should be a sanded powder, lump free. If it is hard, throw it away; humidity has altered the chemical composition and the integrity of your grout will be compromised.

Grout comes in a generous range of ready-made colours. Your local home supply shop may stock basic colours – predictable whites, greys, dark browns and blacks. Mosaic supply shops stock a wider variety of grout colours, and in smaller amounts. You can also colour your grout using colour pigments – also available from mosaic suppliers.

Be respectful of safety issues when working with any cement-based (cementitious) product. Work in a well-ventilated area and always wear a mask when mixing grout. Grout contains silica, which is dangerous to inhale. It is a good idea to wear rubber gloves to project your hands, and if you do get grout on your skin moisturise generously once you have completed the grout session.

Sealants can be applied to grout after it has cured; these are readily available wherever you purchase grout. Sealing is a personal choice and your grout may already have sealant qualities as a part of its composition. Sealing grout helps prevent water and other liquids from being absorbed into the grout that may result in staining.

Mixing grout and other cement-based products

Although thin-set and grout are different – thin-set is an adhesive, grout is not – they are both cement based and mixed in the same way. You should aim to mix up just enough for an area that you can cover in one sitting. The product instructions will give information on how much square footage the thin-set or grout will cover.

Prepare your work area and budget your time before beginning the grouting process. You cannot leave the process until you are finished. Cover your work area with newspaper or plastic sheeting for quick clean up and to protect the surrounding surface. You will need a sponge or two, a squeegee, mixing containers, water, stirring sticks, rubber or latex gloves, kitchen paper, rags and a dust mask.

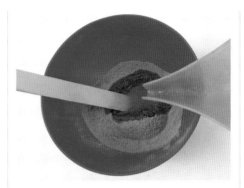

1 Measure and mix

Pour or scoop the required amount of grout into an appropriate size of mixing bowl. Wear a dust mask and gloves. Create a small well in the powder and slowly add water. Use a palette knife or stick to stir together, adding small amounts of water at a time.

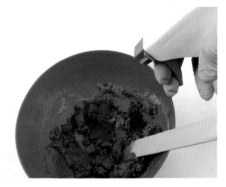

2 Mix to the proper consistency

Continue mixing until the grout is smooth and has the consistency of stiff brownie batter. It is very easy to overwater your grout. If you do overwater it, try pouring off some of the water and then add more powder until you have the right consistency. Some manufacturers do not recommend this; however, with a small art piece, where there is little wear and tear on the grout, it should be okay. A great trick is to use a spray bottle to add water to the grout mixture when you just need a little liquid – this will ensure you do not over-water.

3 Leave to stand

When the correct consistency has been achieved, set aside and allow it to slake for the required time, as recommended by the manufacturer. Slaking is an important step – a chemical reaction needs to take place – so be patient. Skipping the slaking step may compromise the integrity of your grout.

Once the chemical reaction is underway with your grout there is little you can do to slow it, although the manufacturer may supply specialist retardants to lengthen the setting time. Using the grout in cooler/humid conditions may also slow it down. If a batch of grout begins to dry out too soon you have no choice but to throw it away. Thoroughly clean out the mixing container (any residue may act as a catalyst, accelerating the drying time of the next batch) and mix a smaller, more manageable quantity of fresh grout.

In a nutshell

- **Work safely:** Wear a mask when mixing grout, use rubber gloves and work in a well-ventilated area. Always read the manufacturer's instructions.

- **Sanded or unsanded?** Use sanded grout unless your grout lines are less than 2 mm ($\frac{1}{16}$ in).

- **Underwater?** All grouts are waterproof to some extent, but a grout that is going to be submerged in water, or subject to extremely low or freezing temperatures is a specialist product.

- **Outside?** Ready-mixed grout is convenient, but not rated for exterior applications.

- **Do your research:** Use the appropriate grout for your project. The minor additional cost for grout fortified with UV inhibitors and stain resisters may be worth the expense.

- **Protect it:** Make sure your grout is properly stored and protected from humidity and moisture, or it will be ruined.

- **Test it:** You can test how a grout colour will look by sprinkling a little dry grout onto an area or two of the mosaic. Then stand back and take a look.

- **Cure time:** The humidity and overall weather conditions will affect the cure time of cementitious products. The more humidity, the faster the cure time.

- **Bin it:** If your grout (or thin-set) begins to dry out too soon you may have no choice but to throw it away. It is important to clean the container thoroughly as residue may act as a catalyst, accelerating the dry time of the new batch.

- **Colour it:** There are lots of grout colours to choose from, or mix your own colour. You can use more than one colour of grout; mix separately and either tape off an area to avoid getting a colour where you do not want it, or feather or graduate the colours from one into another.

Colouring grout

Grout colourants come in liquid and powdered forms. Only use powdered grout with powdered pigment – always mix dry with dry. It will take quite a bit of experimenting to get exactly the colour you want. Keep a chart or journal with a sample of the mixed colours, so that in the future you can replicate the colour. When using the liquid additive, remember you will need less water, as the liquid of the pigment replaces some of the water. The same colourants can be used to colour thin-set. For the truest colour, begin with white grout or thin-set. There are many exciting colours available in paint pigments. Some artists simply paint their grout with an acrylic wash. However, mastering this technique will take some time and the acrylic paint will fade over time. Always test the colour before committing.

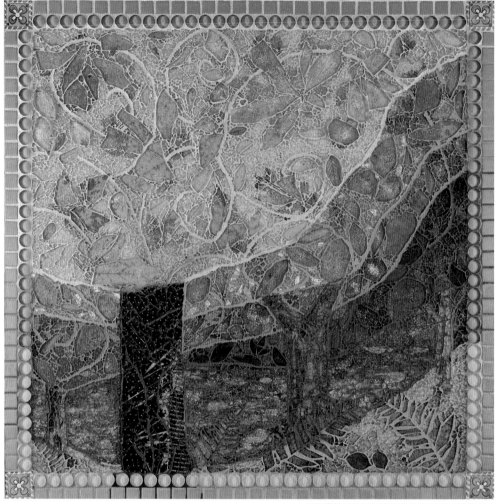

Above: Using more than one grout colour in your artwork can add a dramatic effect. Susan Crocenzi used several custom-coloured grouts in 'Sierra Fall'. The effect is stunning – the blue unifies the background and gives a sense of perspective. The warm tones of grout make the leaves stand out.

Right: The pale grout used in Cherie Bosela's 'Drake Elm' gives the piece a calm and elegant aesthetic.

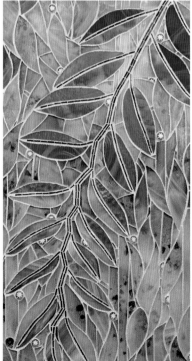

EXPERT TIP

From Cynthia Fisher, owner of Big Bang Mosaics in Massachusetts, USA

Cynthia Fisher's award-winning mosaics are collected internationally and she teaches mosaic art at many venues in North America.

❝ *If you love your mosaic but are unhappy with a grout colour, try 'over-grouting' with a different colour. Once your original grout is cured, simply go over it with the new colour. If you are concerned about grouting where you don't want the new colour to be, you can tape off areas. Mix your grout as you would normally, and, with a squeegee or sponge, work it over the surface and into the grout.* ❞

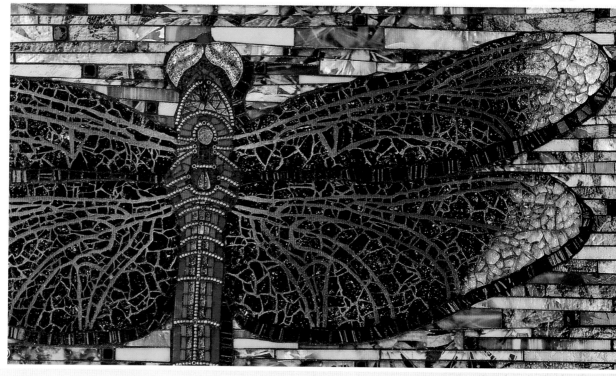

Cherie Bosela's grout colour selections transformed her piece 'Dragonfly'; the orange lines in the wings 'pop' off the canvas and give a realistic feel, while the darker grout in the green area unifies the background.

The effects of different-coloured grouts

Having spent hours working on your mosaic, it is important to get the grout colour exactly right. Here you can see how the choice of grout can completely alter the impact produced by an identical use of colours and arrangement of tiles. For most mosaics a mid-grey is a safe colour choice. This tends to enhance the colours of the tiles it surrounds, rather than clash or overpower them.

Black or dark grey grout
This is one of the most effective grout choices. It gives the tiles a strong emphasis – rather like the leading in a stained glass window. The orange and red tiles are given particular definition and sharpness by the dark tone of the grout. It is a choice that works well on this particular colour mix – on lighter, pastel shades this grout choice would probably prove overwhelming.

Grey grout
A light to mid-grey is often the safest grout colour to choose – grey appears neutral when combined with most colours, while tonally it tends to form a bridge between tiles rather than a separator.

White grout
The high contrast of the grout with the colours of the surrounding tiles tends to fragment the design. Sometimes that effect may be desirable, but generally white grout overpowers the tiles and is best avoided. (Bear in mind too that white grout tends to discolour over time and stains easily.)

Applying Grout

Once your mosaic is in position and the adhesive has dried, it can be grouted. Before you apply or mix grout, make absolutely sure that the tiles are firmly in place and the glue has dried thoroughly. PVA glues are water-based, and unless they have completely hardened they will soften under the action of the grouting and your tesserae may come unstuck.

1 Starting to grout
After your grout has been mixed and slaked for the appropriate time, place a small mound of freshly mixed grout onto an area of the mosaic. Use a rubber grouting squeegee or a dry sponge, to press the grout into the gaps between the tiles. Concentrate at first on downwards pressure to fill the gaps to their bases – then go in the opposite direction, thoroughly working the grout into the interstices.

2 Adding more grout
Depending on the width and depth of your grout lines, even a small mosaic can absorb quite a bit of grout. At this stage you want there to be excess grout on the surface of the tiles. Work your squeegee or dry sponge in a back-and-forth motion, making sure all the empty spaces are filled.

3 Move on to the next area
Repeat the process for the next part of the mosaic. Again, concentrate on a manageable area, pressing the squeegee downwards and then across the surface.

4 Scrape off the excess
When you are satisfied that the gaps between the tiles can absorb no more grout, use your squeegee, a scraper or your gloved hand to lift off the excess. Discard this grout – don't add it back to your stock of grout to reuse. It will spoil fresh grout.

EXPERT TIP

From Shug Jones, co-owner and founder of Tesserae Mosaic Studio
Shug Jones creates fine art and architectural mosaics. She served as President of the Board of Trustees of the Society of American Mosaic Artists (SAMA) from 2010–2014.

I prefer to minimise the amount of water used when cleaning grout off the mosaic during the grouting process. I use packing paper or dry, lint-free kitchen paper to carefully scrub the surface, changing out the paper as soon as it becomes covered in grout. This technique helps to keep the grout lines flush with the surface, while a wet sponge can wash too much grout out of the interstices.

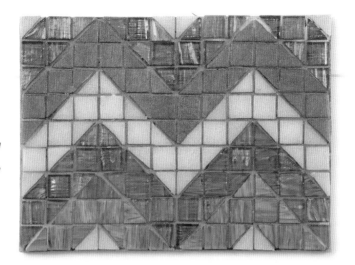

Cleaning up and polishing your mosaic adds the finishing touch.

5 Wipe off tile-surface grout
Leave the grout for 15 to 20 minutes, then check with your finger that it has largely set. With a very lightly dampened cloth, wipe over the surface of the mosaic to clean off the worst deposits of grout. Many artists use dry non-lint kitchen paper or newsprint to remove the grout at this point and avoid using the damp cloth. How difficult the removal of your grout is will depend on many environmental factors, including humidity and temperature. The less water re-introduced in the grout process the better. You will find a light film of grout still remains – you can polish this off when the piece has completely dried.

6 Remove grout residue and glue spots
A couple of hours after grouting a mosaic, you may find that there is a light haze of grout over the entire surface of the tiles that noticeably dulls the tile colours. You may have the best success by wiping with a dry rag. If the grout haze is stubborn, use a slightly damp sponge to remove this residue. After 24 hours, if the grout haze is stubborn, use a 50/50 mixture of white vinegar and water to remove this residue. You may also use a professional product called 'grout haze remover' – follow the manufacturer's directions.

7 Scour off glue spots
If you used PVA glue as your adhesive there may be small deposits of glue on top of your mosaic. Because PVA glue is water-soluble the liquid in the grout will help reconstitute the glue and it can be easily removed. Provided that the grout has completely set, you can attack any small deposits of glue with something quite abrasive such as a pan scourer. It is easiest to remove these glue blobs while you are grouting and they will usually come off quite easily with your fingernail or a flat-head tool such as a screwdriver.

8 Repair any grout holes
If you notice any spaces you missed with your first grout session, mix up a small amount of matching grout and use this to repair any holes in the grout lines. A wooden toothpick may prove helpful, or your fingertip. Clean up as previously described.

Mounting and Finishing

Sawtooth

When you place the last tessera on your substrate or polish the last remaining smear of grout from your work you will have a well-deserved feeling of relief: the project is finished! Once you have had a moment to celebrate, remember professional finishing and mounting is a final and important step in mosaic making: the icing on the cake. Your artwork deserves this final touch.

Finishing and framing

Professional-quality framing and finishing of your mosaic is an extension of the artwork – it completes the work and often takes it to a new level of artistry.

There are many options and techniques for finishing your mosaic and many are quick and inexpensive. Of course, clean and buff your mosaic as needed.

For mirror backs, or items that will sit on a countertop, cover the back of the artwork with a piece of felt or plain paper. This will protect your wall and the artwork.

Mounting and hanging

There are two parts to the process of hanging your finished mosaic: mounting hardware on the frame or substrate, and mounting the frame on the wall. Plan in advance how you will mount a two-dimensional artwork onto the wall.

Finished mosaics can be quite heavy and mountings should be appropriately substantial. It is a good idea to attach any hanging hardware before you begin gluing your mosaics, as adding them afterwards risks damaging your work.

To hang smaller two-dimensional works, you can use screw eyes or D-rings and wire – a common solution. Be sure the screw portion of the screw eye is not longer than your substrate and that the hanging wire is pulled tight: the weight of the mosaic will stretch the wire. The wire manufacturer will give recommended weight limits. If you have your artwork professionally framed it should already have the hanging wire.

Sawtooth picture hangers work well for lightweight mosaics and are easily installed; however, these are not recommended for anything large and most professional

Making concealed corner mounts

This is one of the simplest ways to neatly and safely mount mosaic pieces to the wall, while concealing the fittings. 'Demounting' the piece will mean damaging the surface of the mosaic to remove the hidden fittings, so take photographs of where you hid the screws – and do not forget where you put the photos!

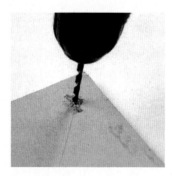

1 Drilling the screwholes
Before drawing up your design on the baseboard, drill holes in each corner, positioning them so that they will be underneath a whole tile if possible.

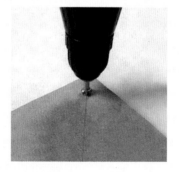

2 Countersinking the screwholes
Use a countersink bit to bevel the hole so that the screwhead will be completely flush with the surface of the baseboard.

3 Concealing the fittings
Complete your mosaic, but leave the pre-drilled holes exposed. Mark the four corner holes on the wall, then drill and plug the holes. Screw the mosaic firmly into the wall. Place and glue the missing tiles over the screwheads and, when dry, grout and finish added tiles in place.

exhibitions and galleries will not accept artwork with these hanging devices.

A cleat system is a good mounting choice for heavy mosaics. Cleats are interlocking brackets designed for flush mounting canvas, art and open-back frames. The interlocking brackets provide safety and security and are advisable for works of significant weight. These can be purchased at most home stores where hanging hardware is sold. You can also make a cleat by cutting a piece of wood lengthwise with a mitre saw.

Make sure the wall can support your mosaic. Whenever possible try to use the studs in the wall for additional support. Most walls have construction studs every 40 cm (16 in). By driving a nail or wall screw into a stud you will have added support and structure. For very heavy mosaics, or a hanging situation in which you cannot work into a stud, use a screw and anchor system: First drill a hole into the wall and insert the anchor into the hole,

then twist the screw in place. The anchor slightly expands while keeping the screw in place and makes for a strong hold. If the work is for exterior display, be sure to use galvanised screws and plastic anchors.

Some substrates require you to install the hanging device before you begin your mosaic artwork. Wedi board, aluminium honeycomb and handmade substrates fall into this category. Using a washer and nut-and-bolt system, you can attach the hanging hardware into the substrate. Allow for the artwork to be screwed directly into a wall with an anchor. Using washers will keep the screw from puncturing the substrate and pulling through. Use two washers on the front, another on the back: align the two washers and poke or drill a hole through the substrate and both washers. A flathead screw goes through the front washer and comes out the back. You can then add a D-ring to the back and secure with a bolt, to later secure a picture wire.

Framing ideas

■ Consider framing the edges of your mosaic with a strip of metal, or coating with thin-set the same colour as your grout or the thin-set used for the project.

■ You can wrap your design around the edge of the substrate for added interest. However, if you choose to mosaic the sides of a two-dimensional piece, always handle it with care. This is not recommended for works that will get a lot of handling.

■ For plywood or MDF substrates, paint the back and sides of your artwork, even if you will be framing. The painted back completes the artwork and gives you a clean place for your signature, the title and the date.

■ Floating frames – where the mosaic floats inside the frame – can be found at most custom framers, or search online for framing companies.

Floating frame

Screw and anchor

D-rings

Screw eye

Cleat system

Picture wire

Projects

Ten projects have been illustrated and explained in detail for your use as inspiration and to adapt to your own style. The projects have been selected for their versatility of materials, techniques and applications. Whether you choose to follow every step exactly or use them as a jumping-off place for your own interpretation, you will find nuggets of valuable information and learning within each step.

Leaf Table

This project, by Teresa Mills, uses household tiles to decorate the surface of a small table, although the design could be enlarged to cover a larger tabletop by repeating the leaf motif outwards in rings. Ceramic mosaic is well suited to tabletops because it provides a tough, heat-resistant finish that can be easily cleaned.

This project uses a table kit from a mosaic supplier as the substrate – the top has a routed surface with a lip around the edge that neatly protects the edges of the tiles. Alternatively, you can tile onto a circular piece of MDF, then use a metal or plastic strip as a trim around the edge of the tabletop, nailed or screwed into the side of the substrate. This table is for interior use only, as the table base is wooden and not suitable for exterior weather conditions, and it also uses a water-soluble adhesive, PVA glue. It is advisable to seal the grout, or use premium grout with sealants incorporated before you use the table, as it is liable to stain.

Materials

- Table kit (includes tabletop substrate and legs)
- Ceramic tiles
- PVA glue
- Grout
- Varnish or furniture wax to finish the wooden table legs

1 Use cutouts to draw up the design
Prepare the substrate in the appropriate way, sealing MDF, if used, with primer or a 50:50 mix of PVA glue and water. Make a template of the leaf to help you keep the design elements consistent – it will also allow you to play with the motif placement. By making several copies you can position the leaves evenly around the surface. When you are satisfied with their placement, carefully draw around each one using a thick pencil.

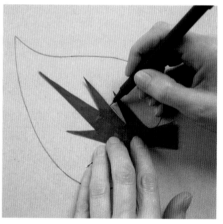

2 Draw in the leaf stems
Make a second cutout for the shape of the leaf stem, then trace around this in the centre of each of the leaf shapes.

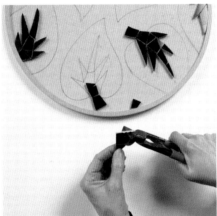

3 Process your materials
Start processing the household tiles, cutting each tile into evenly sized strips using a tabletop tile cutter.

4 Shape the tile pieces
Use tile nippers to cut each of the strips into spiky shapes for the leaf stems. Try to keep each piece fairly large so that this element of the leaf has a strong, linear feel. The colour contrast between the red and black also contributes to a robust design element.

5 Glue the stem pieces in place
After dry-laying the tesserae, start gluing the tiles. Use a small paintbrush to apply a generous amount of PVA glue to the substrate – a paintbrush will make it easy for you to place the glue exactly where you want it. Press your tile pieces into the glue: complete all the stem shapes and then leave the tiles to set.

6 Move on to the leaves

The leaves are completed using a similar spiky cut, but with smaller pieces to give a busier effect. Work on one leaf at a time, completing it from the centre around the stems, and working outwards to the pencil outline. When working an area using a crazy-paving style, it is a good idea to cut a big stock of different geometric shapes of tiles so that you can try different combinations of pieces to get a neat fit. You will need to use your nippers to make lots of adjustments by nibbling down tile edges.

7 Complete the background

The background is intended to deliberately contrast with the leaf motifs in a soft monotone. Lay the tiles in a traditional opus vermiculatum – the fill is completed in uniform tile pieces that flow gently around the outlines of the shapes they contain (see pages 76–77). To give further uniformity to the background, a mid-grey grout is used, which almost blends with the background colour. Once the grout is dry, clean up the tiles thoroughly, then assemble the table. Seal any bare wood using a suitable varnish or furniture wax. Use a water-based grout sealer on the mosaic surface (unless your grout already has these properties). If sealing the grout, be sure to completely wipe away any sealant from the mosaic surface, as it will dull the tiles, and, once dry, it is very difficult to remove.

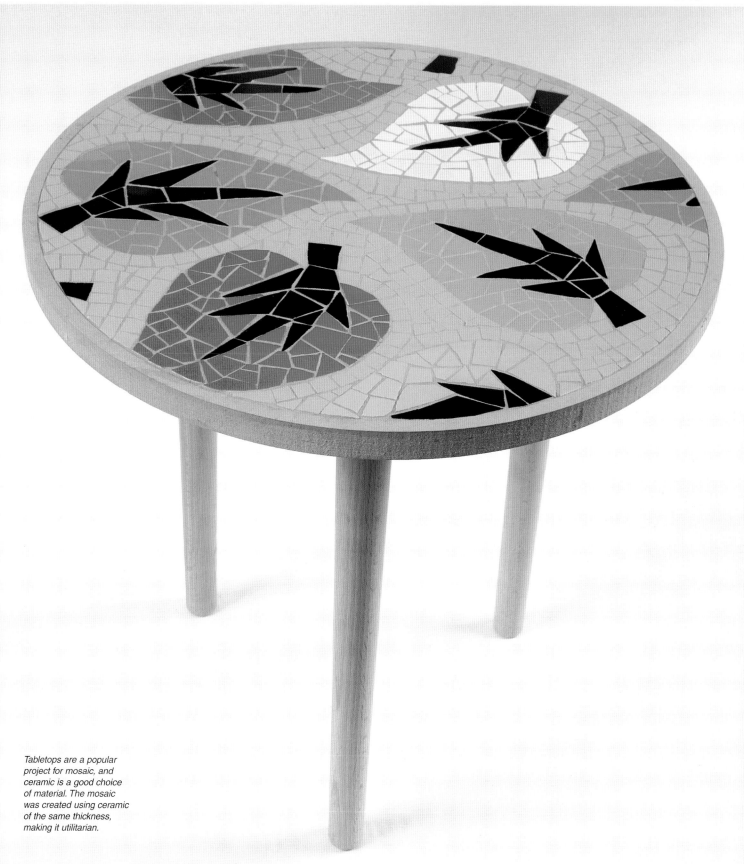

Tabletops are a popular
project for mosaic, and
ceramic is a good choice
of material. The mosaic
was created using ceramic
of the same thickness,
making it utilitarian.

Circular Mirror

This beautiful mirror surround, by Elaine Goodwin, was inspired by a mosaic originally made for the floor in the apse of a building dating from the first half of the second century in England. The controlled and skillful use of three colours in the fluting of the fan-shaped shell is striking. The marine imagery is carried further by the simplified, centrally placed waterfall motif, and the semicircular frame in which the wave crest pattern is used. The limited palette and the eradication of any extraneous detail make the image at once imposing and unforgettable.

Materials

- 12-mm (½-in) plywood or medium-density fibreboard (MDF) cut in a circle to the desired size
- Circular mirror cut to size, allowing generous space for border mosaic design
- Three shades of white vitreous glass tiles or white stained glass cut in consistent sizes
- Mirror tiles
- Black vitreous glass tiles or black stained glass cut in consistent sizes
- PVA glue
- Mirror mastic
- Grout
- Two S hooks
- Length of chain

1 Divide the circle

The drawing was worked out on paper to encompass 16 scalloped edges, thereby giving 16 segments of fluting, each area having an angle of 22.5 degrees at the centre (360 ÷ 16 = 22.5). The substrate pictured here was cut to a circle 76 cm (30 in) in diameter; if your substrate is smaller you will need to adjust the measurements.

2 Begin the design

Trace or rework the drawing onto the circular wooden base. Glue the circular mirror centrally to the wood using mirror mastic. Surround the larger mirror with small, pre-cut mirror tiles. Use a glass cutter or mosaic nippers to make a quantity of irregularly shaped tesserae of mirror and fit them to fill the shape between the scalloped edge and the outer rim.

3 **Continue the outlines**
Outline the dividing lines and scalloped inner edge with the black glass tesserae.

4 **Work the bands**
Subdivide the segmented sections into three: use the strongest colour in a band three tesserae wide at one side, and the palest colour in a band three tesserae wide at the other side.

The limited colour palette emulates that of the Roman period, relying heavily on the gentle optical effect created by the juxtaposition of a muted triple-colour palette.

5 **Finish the filling**
Fill in the remaining triangular section with the third shade of the same colour. Grout the mosaic following the manufacturer's instructions: protect the large mirror in the centre with painter's tape or cover with newspaper. When completely dry, polish the central mirror. On the base of the mirror, tap two staples into the wood, taking care that the length of the staples is no greater than the thickness of the wooden base. Use the S hooks to join the staples to the chain, and hang from a hook positioned on a picture rail.

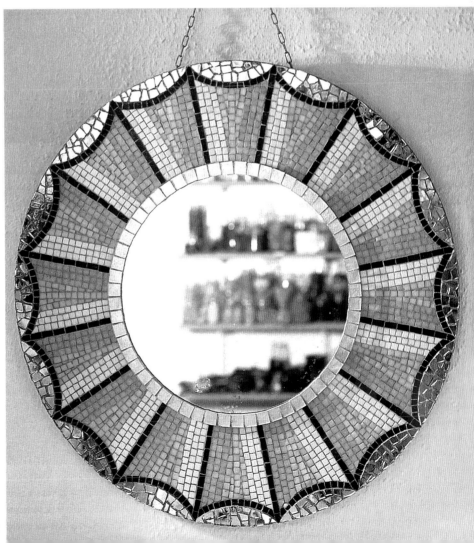

Bird Wall Panel

This striking wall panel, by Elaine Goodwin, is a traditional mosaic pattern seen in Ravenna, Italy. A pair of birds drink from a fountain bowl: the design is a classic. In Roman times the image was made as realistic as possible, and great attention was given to the sheen of the plumage and the curved golden rim of the bowl. Here, however, the reality of the image is denied. The birds have become symbols, doves of peace. They drink or stand beside the water of life, symbolising Christ. The birds are shown in profile with a simplicity of style and colour.

Materials

- 12-mm (½-in) plywood or medium-density fibreboard (MDF) cut to the desired size
- Several shades of blue vitreous glass tiles
- White/copper vitreous glass tiles
- White smalti
- White gold tiles
- Mirror tiles
- Black and white ceramic tesserae
- PVA glue

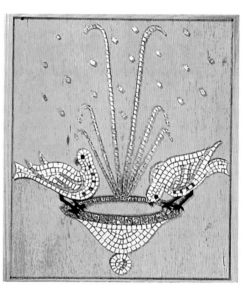

1 Draft the design

The design incorporates both the fountain and the drinking doves to make a composite image, accentuating the element of water as an exciting feature of the panel. The birds are almost life-size, which determines the size of the substrate. The drawing should be strong and simple. To acknowledge the unreal quality of the image, the drinking bowl is given a rounded base. Outline the basic pattern onto your substrate. You may wish to sketch out and colour in a plan for the mosaic. Working with mosaic is an organic process, so you will not need to mark out every piece per se, but rather provide yourself with a guide to the outlines, shapes and colours.

2 Tile the outlines

Use ceramic white tesserae to outline the bowl and the birds – this helps define the image. Follow the main contour. Use contrasting glass to define the wing shape and eyes. Use rippled white gold to outline the rim of the bowl and further rippled gold to pick out the curve of the birds' chests. Cut the mirror in strips to mark out the upwards thrust of the water fountain, and place random pieces of mirror to create droplets.

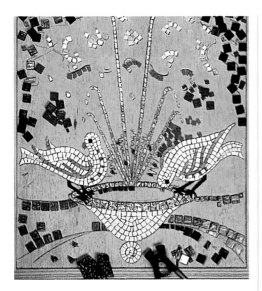

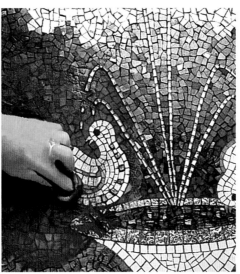

4 Finishing

Finish using a sanded grout mixed to follow the manufacturer's instructions. This richly coloured mosaic benefits from a neutral grey grout. Don't rush the grouting – where areas of varying height and material are used, grouting takes a little more time and patience. Clean carefully, checking that grout is not left in sunken areas of the tile surfaces.

3 Filling the background

To build up the background, mark the areas of lighter or darker colour and those of lesser or more textural interest. For example, an area of copper glass forms a divider between ground and background. The lower ground is dark blue with some raised and inverted gold in the corners. This imparts a textural interest to the mosaic surface. The upper background is set off by an area of white spray – a mixture of ceramic and glass in shades of white. Below this, a graded area of lighter blues deepens to a strong blue in the centre of the mosaic.

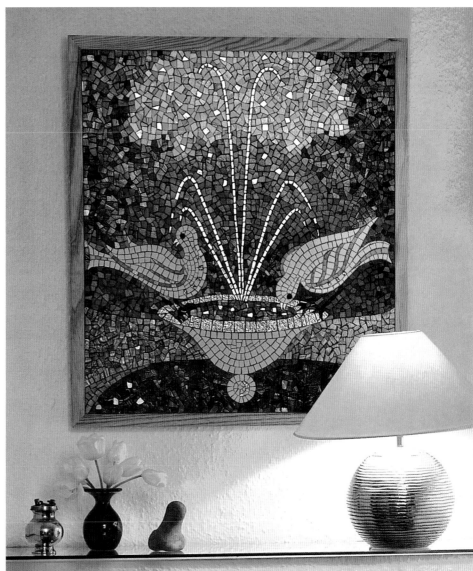

The image remains a classic with an appeal that is eternal. The varied background of blues and turquoise with iridescent copper tones provides an intense and rich colour backdrop against which the bird images are picked out in bold, white silhouetted shapes.

Celestial Ceiling

Celestial themes are popular mosaic subjects. In this project, by Elaine Goodwin, you'll find ideas and some unique tricks to help you create a glowing and dazzlingly beautiful mosaic. By using a limited colour scheme and some dimensional accents, the celestial sky is both dramatic and wondrous. The following guidelines illustrate how to make a galaxy of large radiating stars, small six-pointed stars, large rosettes and tiny mirror domes. This project is designed to be mounted on a ceiling: panels are cut and fitted in advance and the mosaic was built flat on the workbench.

Materials

- 12-mm (½-in) marine-grade plywood or another appropriate substrate (see pages 98–99) cut to panels as required
- White patterned china
- Assorted black and white tesserae
- Variegated tiles
- Mirror tiles
- Glass baubles
- Silver or aluminium leaf
- Thin-set
- Black grout
- PVA glue

1 Cut the panels to fit
Cut the wood to the desired size; for these panels, the plywood was cut to fit a ceiling 3.5 x 1.8 m (11 x 6 ft). It was divided up into 11 equal panels for easier and more manageable working. Before commencing work, the wooden panels were fixed in place onto the ceiling, with holes drilled and countersunk. The panels were then taken down and the fronts and undersides numbered 1 to 11 for easy reassembling. It is much easier to build mosaics flat and right-side up on a workbench to install on location later.

2 Create the dome shapes
For the mirror domes, make up a quantity of thin-set to form a thick paste. Using a pointed palette knife, spread a little directly onto the plywood, forming a small cement dome. Using the nippers with great care to avoid any splintering, cut the thin mirror into small tesserae and fix the pieces to the cement dome.

3 Begin the sky
Surround the mirrored mound with black glazed ceramic tesserae in opus palladianum – irregular-shaped pieces (see pages 76–77). This material is used solely for the background to create a uniform colour on which the stars may shine to greatest advantage.

4 Fill the smaller stars
For the small pointed stars, use simple white tiles for the six-pointed fingers. Keep clear of the countersunk drill holes. Tesserae will be inserted after the ceiling has been fixed in permanent position, to camouflage the fixing points. A glass pebble is inserted at the centre of each star.

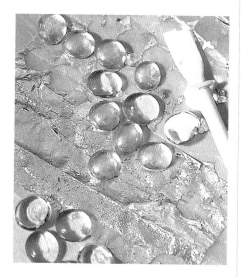

5 Add sparkle

For the rosettes and radiating stars, use an assortment of china, glass tesserae, tile and mirror. Compass-drawn circles will help mark the layers for fixing the encircling tesserae. Here the colour scheme was limited to simple black, white and silvered mirror. Make the rosettes somewhat smaller than the radiating stars. Some glass pebbles are transparent. Rather than allow the wooden base to show through, the glass can be backed with silver leaf. Spread a little white PVA glue uniformly over the flat back of the glass pebble and place on a square of aluminium or silver leaf. Leave for approximately two hours before gently lifting off. The silver leaf makes a perfect metal backing for the glass pebble, which can be placed at the centre of the small star. (Leafing 'kits' can be purchased at many craft shops.) When completed, grout black and clean and polish with a soft cloth before permanent fixing.

The china, with its curved surfaces and patterned designs, provides a surface rich with reflective power and interest. The little mirror domes catch the movement of anyone passing below – any coloured clothing reflects as pinpoints of momentary colour. The highly glossy black tiles lend mystery and depth.

Middle Eastern Niche

This Middle Eastern-inspired mosaic, by Elaine Goodwin, is bold and arresting. The interlocking floral design and broad calligraphic border on a dark blue background are framed within a sculptured marble border. Inset into a wall niche it is a permanent installation that appears centuries old. The contrast between the pale marble border and the deep polychromatic and golden smalti is stunningly worked to give a controlled and integrated architectural reference to the highly intricate pattern.

Materials

- 12-mm (½-in) marine-grade plywood, or another appropriately rated exterior-grade substrate, cut to the required measurement
- Gold smalti or gold china
- 4 shades of blue smalti
- White smalti
- White Carrara marble cut into cubes
- Thin-set

1 Plan the work

Measure where your mosaic will be housed and make a template. Work out a design to fit the required shape. Keep the design simple but with a certain symmetry. Transfer the design to the substrate – here marine-grade plywood. Firm up the drawing with a felt-tip pen.

2 Process your materials

Seal the cut ends of the substrate and front and back of the plywood with a paint primer. Frame the board with small marble tesserae using exterior-rated thin-set. Process your materials in advance so you can work swiftly once you begin mosaicing. To cut the marble for delineating the main contours of the design you may wish to use a hammer and hardie or an appropriate hand tool.

3 Outline the main shapes
Use white smalti, with the riven edge side up for outlining the flower forms; this helps to maintain an equal height, level with the marble. The smalti adds delicacy to the flower forms.

4 Fill the main shapes
Use blue and gold smalti to fill in the flower head. The riven-cut edge of the smalti should now be used for these inserts to give maximum reflective power. Continue to use thin-set throughout since this project will live permanently outdoors. Be sure to cover the entire substrate in thin-set so no wood shows through, because the mosaic will not be grouted.

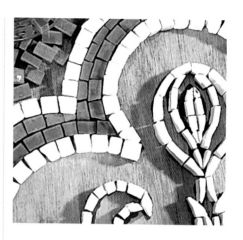

5 Fill all areas
Continue to fill in the mosaic, carefully cutting at any corners.

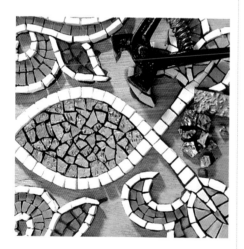

6 Add sparkle
Use the gold smalti or china for the central features; this will reflect warmly in any external setting. Turn the board around while working. This will greatly assist the placing of the tesserae.

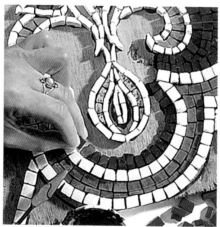

7 Add background
Fill in the background with the darkest blue glass. Fit each tessera into the thin-set, individually setting each at a slight angle – the light will catch these angles in a magical way. Closely fit each tessera next to the previous one, keeping in mind the interstitial, working tightly, as smalti is not typically grouted.

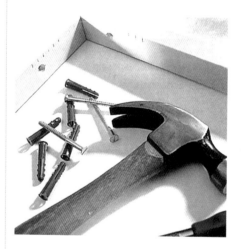

8 House the mosaic
Make up a simple frame to fit the opening of the niche at the required depth, approximately 5 cm (2 in). Fix and seal. The mosaic will be fixed to this using an exterior construction adhesive and anchored screws: this will ensure a sound and upright fixing for the mosaic. Seal the mosaic surround with a silicone-based sealant. If necessary, paint any surface surround to correspond with the exterior wall colour.

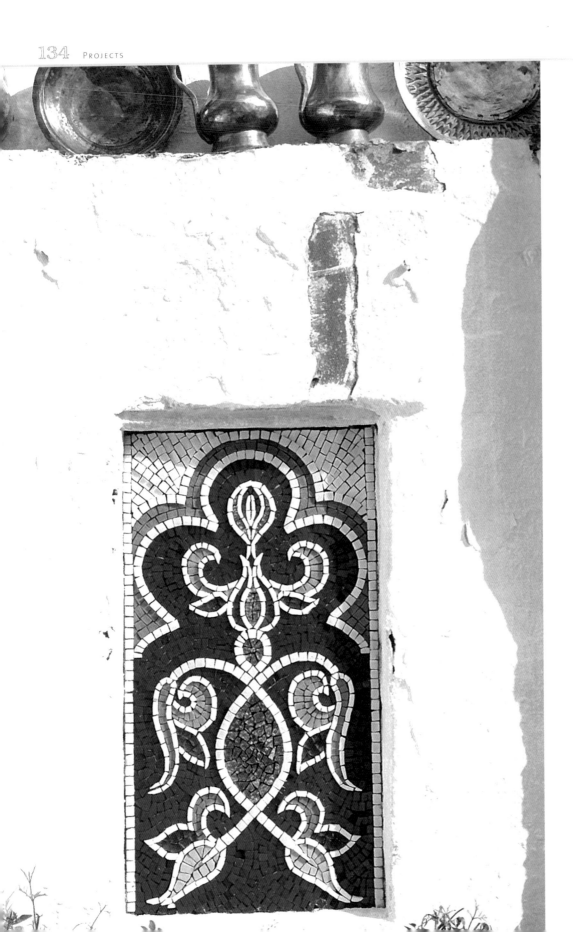

The classical Middle
Eastern design incorporates
traditional materials with
a modern twist. It is a
bold statement with strong
colours, and yet lyrical and
graceful with moving lines
and delicate craftsmanship.

Lizard Wall Sculpture

This lizard sculpture, by Elaine Goodwin, is a marvellous garden accent and the added dimension of mosaic medium is reminiscent of works by Spanish architect and artist Antoni Gaudí. Spain is famed for its tiles, a legacy enhanced by the Arab conquests from the eighth century. Gaudí used this ceramic material almost exclusively to add colour, texture and vibrancy to his creations throughout the Catalan region of Spain, particularly Barcelona. These fanciful tile enhancements were created along with glass and found objects. Much of his work is sculptural, introducing more fully a new area for the mosaicist to explore, with curves, spheres and cylindrical shapes.

Materials

- Lizard sculpture (either make it yourself, see below, or buy a ready-made garden sculpture, about 46 cm/18 in)
- Assorted golden and orange china, roof tiles, lustreware, turquoise earthenware, glass tiles or anything else with sparkle
- Wire
- Grout
- Thin-set

1 Choose a design

There are many options to create the three-dimensional base. The lizard sculpture can be made using a wire frame with scrim or gauze coated with cement, or bought ready-made. Much of the mosaic material used for the lizard mosaic was recycled from broken chinaware, plus a miscellany of found materials.

2 Prepare the substrate

The lizard was coated with a scratch coat of thin-set adhesive to give a sound, clean and smooth binding base for the mosaic. Mixing the thin-set to a slurry – a thin, watery consistency – allows you to paint it onto the sculptural surface. Remember to process plenty of materials for your tesserae.

3 Mark up the design

Very simple guidelines were drawn on the back of the lizard with soft pencil marks. Thin-set adhesive rated for exterior environments was used to adhere the central golden spine onto the tail.

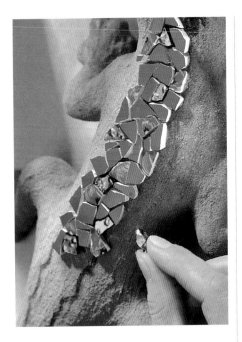

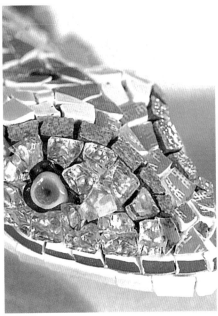

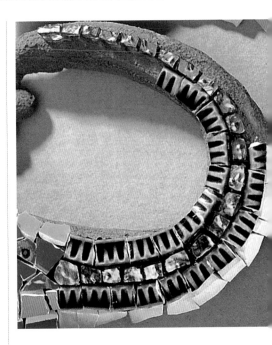

4 **Fill the sculpture**
Cut small tesserae out of china and fix to the back area.

5 **Fill the details**
Vary the china for the head, and delineate the eye area. The eyes are glass eyes from a taxidermy supplier. A plastic version would do fine as well. Use assorted materials to give a rich texture and colour.

6 **Fill the tail**
Continue to mosaic the tail area. The fluted border of a plate gives added interest.

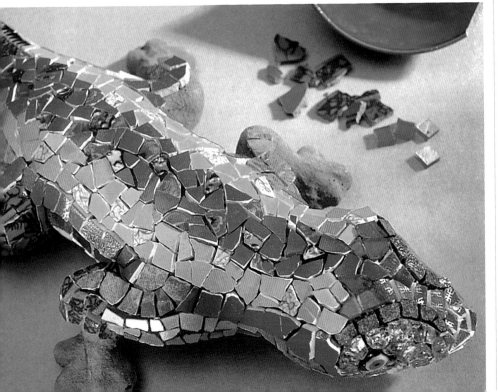

7 **Revise the design as required**
While introducing the turquoise colour for the legs, the previously fixed white markings were removed before permanent setting and replaced with reverse silver with its turquoise glass backing for greater colour intensity. Feel free to change the chosen colour palette while work is in progress. When finished: grout, clean and polish.

The finished lizard basks in the sun on a sun-warmed wall, its colours fiery and glowing. The once pale and understated garden creature revels in a shiny new skin. Broken, discarded and recycled china and tiles celebrate their regeneration in a riot of colour combinations. The mosaic is a fabulous use of fun materials and a terrific addition to the garden.

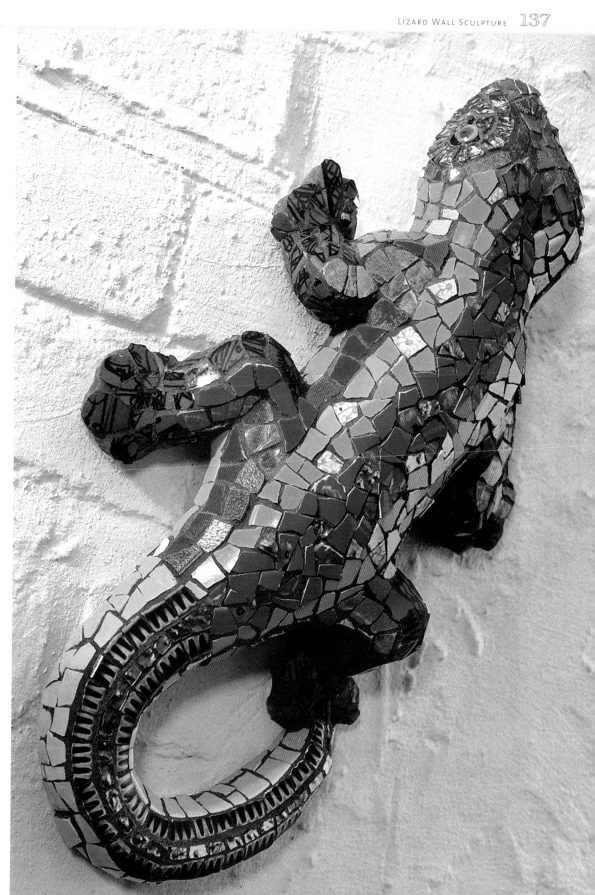

Goldfish Backsplash

In this project by Tessa Hunkin, glazed ceramic wall tiles have been used and cut into simple forms. It is elegant in its simplicity. Some of the design is constrained by the practical limitations of shapes that can be cut from single pieces of tile. In other areas, such as the background of the fishbowl, using several differently coloured pieces of tile helps to give the impression of reflected light on water and glass. It is a balanced design thanks to the careful use of black in the background.

Materials

- Mosaic mesh cut to the size of your design
- Cement backer board or another appropriate-rated wet-area substrate cut to size
- Ceramic tiles in various colours
- PVA glue
- Thin-set
- Black grout

2 Process the materials
Cut the ceramic tiles using the tile cutter. Begin by cutting long strips – other shapes can be cut from these using a tile snapper. Draw the shape on the tile with an impermanent felt-tip pen and then follow the line with the scoring wheel, pressing quite hard.

1 Set up the layers
Joints in areas of background colour have been avoided and a black grout has been used to further emphasise the outlines. The project was built using the indirect mesh method (see pages 90–92), flat on the workbench. It was mounted to a pre-fit substrate appropriate for watery environments. Make your design to fit a template of your installation area to ensure a proper fit. To begin, place your design cartoon under a piece of clear plastic sheeting that is cut slightly larger than the finished piece, and place the mesh on top. The plastic prevents the mesh from sticking to the paper cartoon and it should be slightly larger than the cartoon and mesh.

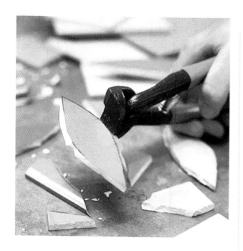

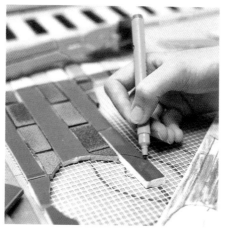

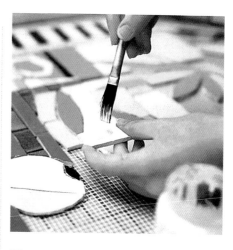

3 Create smaller tesserae

Place the snapper across the score line and press. This will break the tile along the score line. The tile may not break perfectly along the line but the edge can be tidied up with the tile nippers. You can make many unique shapes using these tools.

4 Mark and cut

As you work, lay the pieces on the mesh and use a pen to mark the line of the desired cut. Short cuts can be made with the tile nippers and long, straight lines can be made with the scoring wheel and snapper.

5 Glue the tiles

Stick the tiles down by applying PVA glue on the back of the tile with a small brush and then positioning on the mesh. Do not over-glue; you need just enough PVA glue to hold the tesserae in place on the mesh. Leave enough space between pieces so that thin-set can pass through the cells of the mesh during installation to adhere to the sides of the ceramic pieces.

This beautiful backsplash is not only aesthetically pleasing, it is a durable and practical addition to the room. Glazed ceramic is an excellent and economical choice of material for bathrooms. In this instance the design adds unexpected colour and interest to an otherwise plain space. The bold design elements are especially pleasing.

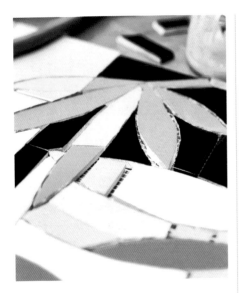

6 Laying the bigger pieces
Try to make up the shapes of the design using single pieces of each colour where possible. Joints in the black areas, however, will be concealed by the black grout.

7 Dividing the mesh
You may find it easier to fix the finished piece in smaller sections. The mesh can be cut along a joint in the tiles with a sharp craft knife.

8 Finishing
Thin-set should be applied to the substrate with a notched trowel. In this case the mosaic is being fixed to a precut piece of cement backer board, which is suitable for use in potentially wet areas. Tiles in each corner have been removed so that holes can be drilled and the panel fixed with screws to a wall. When the panel is in place the tiles can be fixed back in position, concealing the screw heads. The mosaic can then be grouted with a black grout to emphasise the joint lines.

Dressmaker Mural

Looking to master painters can provide fascinating inspiration. This project, by Tessa Hunkin, is based on a painting called 'Project for a Screen', showing two women examining bolts of fabric by Edouard Vuillard. The use of pattern and textile designs creates a complex visual effect. The figures almost disappear against the wallpapers and carpets, absorbed into the play of light on the surface pattern.

Materials

- 12-mm (½-in) plywood or medium-density fibreboard (MDF) cut to the desired size
- Smalti or vitreous glass tiles in various colours
- Flour paste (see page 96)
- Brown paper
- Thin-set

1 Plan the design

The small units of mosaic cubes lend themselves to making patterns, and the uniformly fragmented surface is also a feature of mosaic work. This is an arresting and interesting composition. The project was made in Italian smalti because of the interesting colours available and the lively reflective surface of the material, but it could equally well be made in vitreous glass.

This project is visually complex and requires some careful planning before starting. Work out the composition with a line drawing, then make a colour drawing on the layout paper. The colours are chosen with reference to the tesserae palette.

2 Enlarge the design to fit

When the design drawing is complete the basic outlines can be traced on tracing paper and the image enlarged on a photocopier (see pages 70–71).

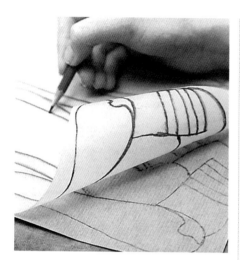

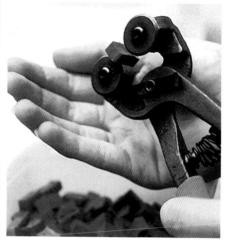

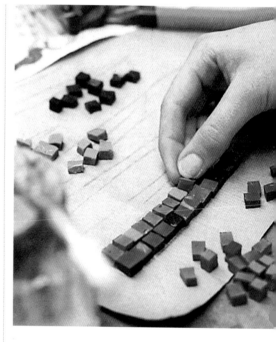

3 Transfer the design
Because the reverse paper method is being used (see pages 96–97), the image needs to be reversed onto brown paper. This can be done on a light box or by tracing the enlarged image and then turning over the tracing paper before transferring the outlines onto the brown paper.

4 Process the materials
This is quite a small panel, so the smalti pieces have been halved to make a smaller unit size. Use wheeled nippers to cut smalti with accuracy, or use a hammer and hardie, which also reduces wastage.

5 Temporarily adhere the tiles
Stick the pieces to the brown paper with flour paste (see pages 96–97 for the reverse method). Starting with the figures, apply the paste with a paintbrush to a small area of paper and start to build up a pattern, cutting tiles as necessary to fit the drawn outlines.

The fabric designs are executed beautifully, filled with interesting texture and patterns. There is a bold graphic quality to the finished mosaic, due in large part to the cube nature of the cut smalti.

6 Check the scheme

Before completing all the figures fill in some of the background so that you can check if the colour balance is working.

7 Butter the back

When the piece is finished and you have made any necessary alterations you will have to cover the back face with cement-based adhesive before fixing. This is called 'buttering the back' and is necessary when fixing uneven materials such as smalti. This process will make the mosaic quite heavy and it is a good idea to divide it into two sections by cutting the paper along a joint line with a craft knife. The adhesive is applied with the plasterer's small tool in a thin layer to even out the irregular service.

8 Prime the substrate

Apply cement-based adhesive to the surface of the board with a notched trowel and turn the mosaic section over into the bed. Do not let the adhesive on the back of the section dry out or skin over. Press the mosaic lightly onto the board so that the two wet adhesive surfaces merge.

9 Finishing

Wet the paper, leave until the glue is dissolved (about 15 minutes), and carefully peel back. You will find with this method that some adhesive inevitably comes up between the joints. This can be scraped out with a small screwdriver and is easier to do neatly when the adhesive has started to go off (after about three or four hours). The adhesive will dry pale and if it is visible between the joints, particularly in areas of dark colours, you can darken it with a little linseed oil applied with a small brush.

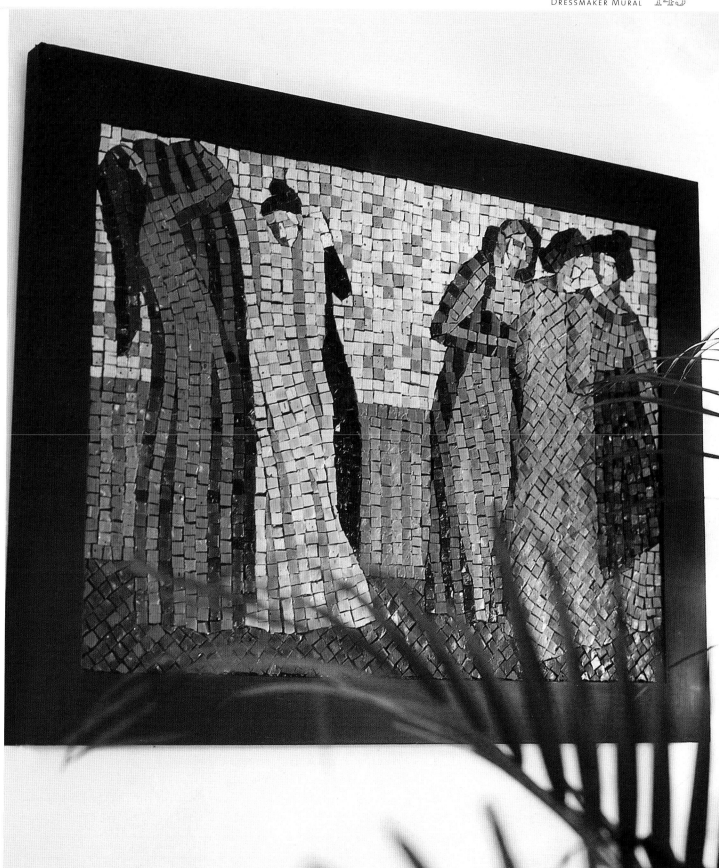

Dog Garden Sculpture

Materials

- Copper tube, 1 cm (⅜ in) in diameter
- Screen or aluminium mesh
- Galvanised steel wire
- Silicone glue
- Thin-set
- Charcoal
- Unglazed ceramic mosaic tiles: pearl, black and white
- Grey grout

This marvellous three-dimensional garden sculpture, by Tessa Hunkin, is a clever design constructed out of aluminium mesh over a simple armature. The conical nose and barrel-shaped body are characteristic shapes easily formed out of the mesh, and the absurd curving tail is made with a bent pipe. The materials are combined to create an object that is authentically doglike. This simple construction technique makes exact symmetry difficult to achieve but this adds to the liveliness of the finished piece. It has been covered with long triangles of unglazed ceramic to convey the impression of dog hair. The pieces are laid quite randomly but the directions altered to allow the curving surfaces to be covered in a uniform way without ugly junctions.

1 Designing the sculpture
Begin with a rough sketch of how you want your creature to look. It can be useful to draw a side view and a front view. If you draw to scale or enlarge your drawing to scale, you can mark the underlying armature framework and work out how long the pieces of copper tubing will need to be. Thin copper tubing can be easily bent by hand and cut with a small hacksaw. If making the dog as shown, cut two hoops for the front and back legs and a long piece to run from the end of the nose, down the neck, and along the back and the tail. The legs can be attached to the spine with pieces of galvanised wire wound tightly around the junctions.

2 Covering with mesh

Measuring from the scale drawing, you can also work out some rough sizes to cut pieces out of the aluminium mesh. You will need separate pieces for the body, neck, nose tail, each ear and each leg, with four small extra pieces to form the paws. Cut the mesh with an old pair of scissors and bend into shape. Fix each piece into position using little twists of wire and blobs of silicone glue. Creases in the mesh will add to its strength and can be concealed later under the thin-set skin. You do not have to make a completely rigid structure at this stage because fragile junctions will be made more secure by the thin-set.

3 Spreading thin-set

Mix the thin-set as per the manufacturer's directions. The thin-set should be pressed into the mesh using a plasterer's small tool. Spread a layer that is at least 0.5 cm (¼ in) thick: it can be built up in places where necessary to improve the overall shape. While wet, the adhesive is very heavy and you may need to build up some areas in layers, letting the adhesive dry out overnight before adding the next thickness.

4 Smoothing

When you are happy with the overall shape and the thin-set has cured overnight, you can smooth down the surface with a concrete sanding stone or file, which will scrape off the worst of the lumps. You are now ready to mosaic. You may need to add an additional layer of thin-set or patch areas that are not as you wish.

This sculpture is striking and imaginative. The design embodies a childlike and primitive quality yet it is a realistic representation. Ceramic tesserae are perfect for exterior environments.

5 Mark the eyes

Draw the position of the eye with wax pencil, making sure it looks right from all angles and mark on the other eye at the same time to ensure symmetry. Apply a small area of thin-set with a small tool and stick on the pieces. In some areas, for instance at the top of the ears, you may need to build up a greater thickness of adhesive to bed the pieces securely. Try not to let the adhesive come up between the joints.

6 Laying the tiles

Lay the triangular pieces in the direction of the dog's fur, with a random approach that will accommodate changes of direction when necessary. For instance as the triangles reach the sharp curve under the neck between the front legs, they are tilted away from the vertical so that they can cover the shape more easily. The same is true with the tiles laid across the back: these are tilted towards the horizontal where they meet the curve of the belly.

7 Finishing

When the dog is covered all over and the adhesive has cured, grout your sculpture. This is best achieved by rubbing the grout into the joints with your hands (protected by latex gloves). The excess grout should be sponged off immediately and the surface given a final clean with a dry cloth. If your creature will reside outside most of the time, consider using grout containing stain inhibitors or sealing your grout to protect it from staining.

House Number

A mosaic house or office address number makes a unique personal statement. This project, by Bonnie Fitzgerald, uses stained glass and vitreous glass tiles, both rated for exterior application, in conjunction with an appropriate substrate and adhesive. The design is whimsical and cheerful. When designing, remember that the numbers must be bold as they are the focal point. Even though there are many colours in the finished artwork, the colours were carefully designed and planned, making sure there was a high contrast between the numbers and the background. The colours that touched the numbers were also taken into consideration, rotating the flowers where necessary so that a strong contrast was made whenever possible. Glass rods were used for the centre of the tiniest flowers.

Materials

- Stained glass
- Vitreous glass tiles (used for border)
- Wedi board cut to the desired size
- Glass rods
- Hardware for hanging: washers, nut and bolt, D-rings

1 Preparing your substrate
The first step is to cut your substrate to size. Wedi board or a similar lightweight product is an excellent selection for exterior mosaic work as it is lightweight and easy to cut. If the mosaic will be fully exposed to the weather elements you must prepare the edges to prevent water from seeping into the foam centre. Wrap the edges with alkaline-resistant mesh, which does not rust. The mesh is slightly sticky, but you need to adhere it fully with a very thin layer of thin-set.

2 Scale your drawing
The numbers are the most important design element in this project. Using a word-processing program on your computer, select a font that fits your taste, and scale up to the desired size (see page 70–72). Using graphite paper, transfer the design to the substrate. Hold onto your pattern, as you will use it when you begin cutting and laying your tesserae.

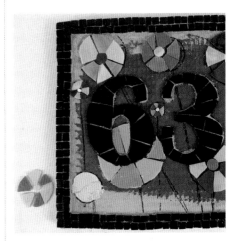

③ Prepare the hanging hardware
It is always a good idea to address the issue of hanging hardware before beginning your mosaic, and in this case it is essential. Wedi board and similar products have a unique hanging system: a special washer with small points is pushed into the surface of the substrate and secured with a flathead bolt. Here, we have added a D-ring to the rear, so a picture wire can be strung and the artwork will be hung like a picture.

④ Cut the numbers
First cut and dry-lay the middle number to do a quick visual check that the design elements are working and the viewer will easily be able to 'read' the numbers. Cut large, specific shapes for the numbers – 'opus sectile', see page 77 – from stained glass. To cut opus sectile, lay an angled piece of glass next to the previous tiles, mark the angle with a grease pencil, then cut using an appropriate tool.

⑤ Dry-lay the numbers
Use the pattern to dry-lay the numbers. When you are ready to begin adhering the numbers to the substrate, simply move the pieces over one by one.

⑥ Begin adhering
Begin adhering your numbers using thin-set mixed as per the manufacturer's directions; you can either backbutter larger pieces or spread some thin-set on the substrate with a palette knife and apply the tesserae on top, whichever method works best for you. Work neatly and clean out grout channels using a toothpick.

⑦ Glue the border
Next, cut black vitreous tiles into quarters for the border. Stick the border in place in order to confine the shape of the piece. Because of the tiny pieces, light will reflect off the border in unexpected and beautiful ways.

⑧ Adhere other elements
Begin working on the flowers and other elements. Like the numbers, cut the flowers in opus sectile. Cut the centre circles of the larger flowers from stained glass and use glass rods for the centres of the small flower centres. Set them in white (not grey) thin-set, as this will most enhance the colours of stained glass.

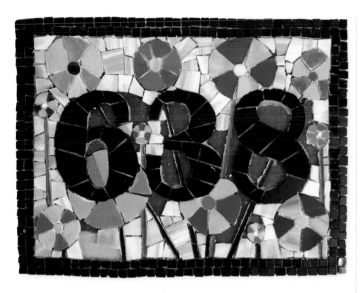

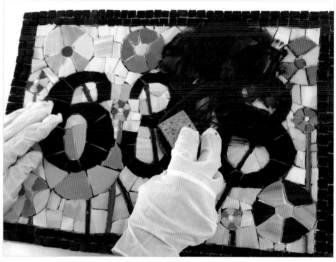

9 Finish the background

Once the main elements have been glued into place, begin dry-laying and fitting the background. It is especially helpful to have a pool of materials cut to work from and nipping and cutting only when need be. Allow to dry overnight.

10 Grout

It is a good idea to clean off any dry thin-set from the surface of the glass, otherwise this may interfere when you grout. There could be clumps of dried thin-set in your grout. Select a grout colour that unifies the numbers and is pleasing to all the colours. A great way to test grout in advance is to sprinkle dry powder onto your finished project. For this project a very dark grey is most appealing; pale grey would wash out the overall look. Stained glass cleans up especially well and polishes up beautifully.

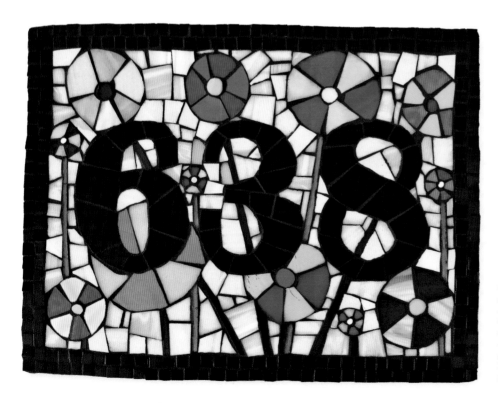

Stained glass provided a vast colour palette for this cheery house number plaque. The black numbers and border are in high contrast to the yellow background, making the most important information stand out and the piece feel framed. The stylised flowers make for a fun artwork that serves an important function.

Glossary

Adhesive
The various types of glue or cement-based products used to attach mosaic tesserae onto a substrate.

Andamento
The placement of tesserae in a flowing pattern to suggest movement and rhythm – the mosaic equivalent of a brushstroke.

Back buttering
Applying adhesive to the back of tesserae pieces.

Ceramic tiles
Ceramic tiles are made from a layer or layers of fired clay. Available in a wide range of textures and colours, they are a popular mosaic material.

Direct set
Mosaics with tesserae set into a bed of mortar and not grouted. This is most common when working with smalti and found object tesserae.

Direct method
The mosaic method by which tesserae are laid and affixed directly onto a final surface.

Dry-lay
The process of laying tesserae into a design without adhesive, for planning purposes.

Fabrication
The physical process of building the mosaic.

Fused glass
Glass made up of pieces, often with varied patterns and colours, that have been melted in a kiln.

Glass scorer
This scoring tool has a small carbide wheel at one end. The wheel is either dragged or pushed along the glass surface, breaking the surface tension. The glass is then snapped in two with a running plier.

Grout
A cement-based product mixed with water to produce a paste which fills the space (interstices) between tiles or tesserae. Used to both decorate and stabilise the work, grout has no adhesive properties.

Grout line
Also referred to as a grout joint, this is the space left between tiles or tesserae that is filled with grout.

Indirect method
Fabrication techniques where mosaic is developed off-site onto a temporary surface before being permanently fixed into place. Mesh method, face tape and reverse on brown paper are all indirect methods of mosaic making.

Interstices
The space between tesserae on a mosaic. This space may either be grouted or not depending on the desired design outcome and intended use.

Mastic
Premixed ceramic tile adhesive.

Millefiori
Literally meaning 'one thousand flowers' in Italian, this term refers to small tesserae created by the fusion of many glass rods arranged so that the cross section creates a floral or geometric pattern.

Mixed media
A combination of various distinct media in a single work.

Nippers
Plier-like hand tool used to cut, shape or 'nip' tile or glass. Rotary or wheel nippers have two carbide wheels used for glass and sometimes tile. Offset tile nippers are used to cut or shape tile only.

Opus
This is the Latin word for 'work'. It describes the design, andamento, placement of tesserae, or flow of tiles in mosaic work. The plural of opus is opera.

Opus circumactum
Laying of tesserae in a fanlike, circular pattern.

Opus musivum
Laying of tesserae to outline the main features of the design and continue to flow outwards, filling the entire background.

Opus palladianum
Laying of assorted shaped tesserae in a random, interlocking pattern. Also known as crazy paving.

Opus regulatum
Laying of tesserae in a straight, gridlike pattern.

Opus sectile
Each tessera is cut to form a complete shape in itself.

Opus tessellatum
Laying of tesserae in a straight line on one axis, but with broken yet parallel lines on a second axis, like bricklaying.

Opus vermiculatum
Laying of tesserae in wavy lines, in a wormlike fashion.

Polymer clay
A lightweight synthetic clay that can be modelled or pressed into moulds and is generally cured in a low fire oven.

Porcelain
A hard white clay fired to a high temperature. Properties include density, durability and low water absorption. Porcelain can be glazed or unglazed.

Running pliers
Hand tool used to snap or break a score line on a piece of glass.

Slake
The chemical reaction that occurs when water is introduced and mixed with dry thin-set mortar or grout.

Smalti
Tesserae formed from molten glass poured into patties, cooled and cut into individual pieces. Extremely light-reflective, smalti are available in a tremendous range of colours.

Squeegee
A tool for spreading grout. The squeegee has a rubber blade on one edge that helps force the grout into all the spaces.

Stained glass
Thin glass that has been coloured with the addition of metallic salts during its manufacture. It can be cut easily into desired shapes for mosaic. Iridescent stained glass has a metallic sheen, like oil on a glass surface.

Substrate
Any surface used as a base for a mosaic.

Tessera / Tesserae
The term dervives from the Greek word meaning 'four-sided'. It is the building block of mosaic design, also defined as the individual units that are used to make up a mosaic. The plural of tessera is tesserae.

Thin-set
A dry mix of portland cement, sand and sometimes latex additives used for bonding tesserae to a substrate. This adhesive is commonly required for use in exterior settings.

Vitreous glass
A uniform manufactured glass tile made in moulds from glass paste. These tiles have a smooth top, a rough, textured back and bevelled side edges.

Resources

Mosaic Art Organisations

British Association for Modern Mosaic (BAMM)
www.bamm.org.uk

Contemporary Mosaic Art (CMA)
www.mosaicsandceramics. ning.com

International Association of Contemporary Mosaicists (AIMC)
www.aimcinternational.org

German Organisation for Mosaic Art (DOMO)
www.domo-ev.de

Society of American Mosaic Artists (SAMA)
www.americanmosaics.org

Mosaic Association of Australia and New Zealand (MAANZ)
www.maanz.org

Mosaic Art Association in Japan (MAAJ)
www.maa-jp.com

Mosaic Association South Africa (MASA)
www.mosaicassociationsa. ning.com

Suppliers and Resources

United Kingdom

Mosaic Heaven
www.mosaicheaven.com
Phone: +44 (0) 1778 380989

Mosaic Supplies Ltd
www.mosaicsupplies.co.uk
Phone: +44 (0) 1299 828374

Mosaic to Fit
www.mosaictofit.co.uk
Phone: +44 (0) 7814 408 413

Mosaic Trader
www.mosaictraderuk.com
Phone: +44 (0) 1227 459350

Opus Mosaic
www.opusmosaic.co.uk
Phone: +44 (0) 1392 496393

The Mosaic Gallery
www.mosaicsonline.co.uk
Phone: +44 (0) 1424 211947

USA

D&L Art Glass Supply
www.dlstainedglass.com
Phone: (001) 800 525 0940

Delphi Glass
www.delphiglass.com
Phone: (001) 800 248 2048

Diamond Tech
www.diamondtechcrafts.com
Phone: (001) 800 937 9593

diMosaico
www.dimosaico.com
Phone: (001) 866 437 1985

Ed Hoy's Int'l
www.edhoy.com
Phone: (001) 800 323 5668

Glass Crafter's Stained Glass Supply
www.glasscrafters.com
Phone: (001) 800 422 4552

Institute of Mosaic Art
www.mosaicstudiosupply.com
Phone: (001) 510 898 1174

Maryland Mosaics
www.marylandmosaics.com
Phone: (001) 410 356 3555

Monster Mosaics
www.monstermosaics.com
Phone: (001) 800 388 2001

Mosaic Art Supply
www.mosaicartsupply.com
Phone: (001) 404 371 4070

Mosaic Basics
www.mosaicbasics.com
Phone: (001) 404 939 4892

Mosaics by Maria
www.mosaicsbymaria.com
Phone: (001) 828 312 0291

Mosaic Mercantile
www.mosaicmercantile.com
Phone: (001) 877 966 7242

MosaicSmalti
www.mosaicsmalti.com
Phone: (001) 508 432 5369

Murano Millefiori
www.muranomillefiori.com
Phone: (001) 201 934 9558

Piece Love and Smalti
www.pieceloveandsmalti.com
Phone: (001) 972 839 4160

Smalti.com
www.smalti.com
Phone: (001) 888 494 8736

Tiny Pieces
www.tinypiecesmosaics.com
Phone: (001) 773 832 9410

Warner Stained Glass
www.warnerstainedglass.com
Phone: (001) 800 523 4242

WitsEnd Mosaics
www.witsendmosaic.com
Phone: (001) 888 494 8736

Youghiogheny Glass
www.youghioghenyglass.com
Phone: (001) 724 628 3000

Canada

Fantasy in Glass
www.fantasyinglass.com
Phone: (001) 416 252 6868

Mosaic Art Source
www.mosaicartsource.com
Email: info@mosaicartsource. com

Mosaic Beach Studio
www.mosaicbeach.com
Phone: (001) 416 915 1627

Mosaïkashop
www.mosaikashop.com
Phone: (001) 514 582 7476

Continental Europe

Italy: Mosaici Donà Murano
www.mosaicidonamurano.com
Phone: +39 041 527 4561

Italy: Orsoni Smalti Veneziani
www.orsoni.com
Phone: +39 041 244 0002 3

Italy: Xinamarie Mosaici
www.xinamarie.com
Phone: +39 340 463 7731

Netherlands: The Craft Kit
www.thecraftkit.com
Phone: +31 297 344 668

Netherlands: Tiles and Tools
www.tilesandtools.eu
Phone: +31 622 775 868

Australia

Australian Stained
Glass Supplies
www.asgs.com.au
Phone: 02 9560 0880

Oz Mosaics
www.ozmosaics.com.au
Phone: (+617) 3847 4873

Smalti Australia
www.smaltiaustralia.com
Phone: 02 4739 3532

The Mosaic Art Store
www.themosaicstore.com.au
Phone: 1300 320 392

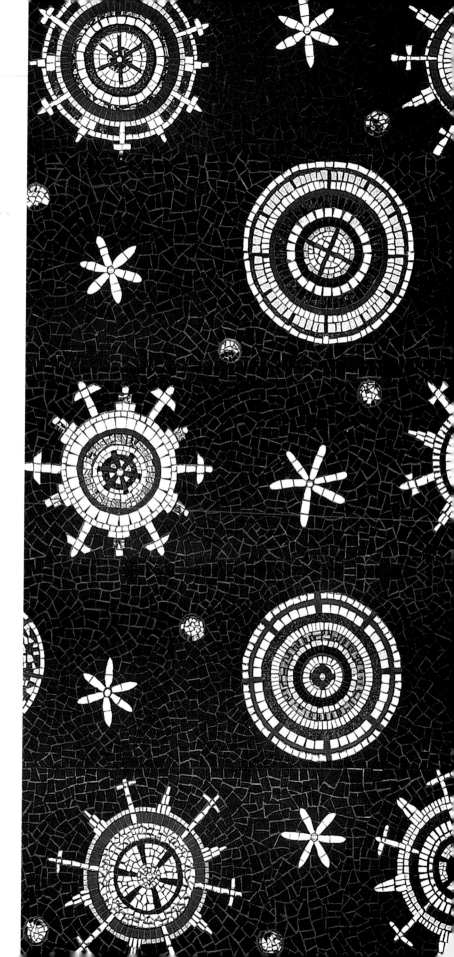

Index

Credits

None of this would be possible if not for the unconditional love and support of my partner Ken and our daughter Stephanie. Thank you.

Quarto would like to thank the following artists, agencies and manufacturers for supplying images for inclusion in this book:

- Aldo, Deb, www.pietredure design.com, pp.47cr, 101br, Photo (p.101): Bonnie Fitzgerald
- Allen, S.J., Shutterstock.com, p.13bc
- Bell, Kyra, p.77br
- Bessera, Jolino, www.jolino architecturalmosaics.com, pp.12t, 13br, 23r, 39tr, 49l
- Biggers, Linda, www.eggshell mosaicart.com, p.21b
- Bodycomb, Helen, www. helenbodycomb.com, p.1l
- Bosela, Cherie, www.cherie bosela.com, Photos by artist, pp.1 third from left, 53t, 89, 114br, 115t
- Brallier, Christine, www. cbmosaics.com, Photo: Mehosh Dziadzio, p.17b
- Brody, Mark, www.mark brodyart.com, pp.51, 81t, 106tl
- Brustad, Ilona, www.ilona brustad.com, p.57b
- Bryant, Carl and Sandra, www.showcasemosaics.com, pp.17t, 33, 55t, 60, 79tr/br
- Cheek, Martin, www.martin cheek.co.uk, pp.19t/b, 32bl
- Clark, Lisa, www.lisafields clark.com, pp.86–87
- Crocenzi, Susan, www. scmosaics.com, p.114t
- Crosby, Dianne, p.13t

- Damrom, Anita, www.anita damron.com, p.99tr
- Delyea, Bev, www.delyeaart. com, p.16b, 68b, 77t
- Deng, Songquan, Shutterstock.com, p.16t
- Dick Blick, p.118tr
- Dolson, Patty Van, www. shardsofreflection.com, pp.1 second from left, 2, 88
- Falvo, Michele, p.107tr
- Fisher, Cynthia, www.BIG BANGMOSAICS.com, p.48r
- Fitzgerald, Bonnie, www. bonniefitzgeraldart.com, pp.22t, 24t, 54, 56b, 59bl, br, 63, 66–67, 76, 81b, 83b, 92b, 94, 95, 103, 110, 150–152
- Goldman, Marley, p.48c
- Goode, Pam, www.pamela goodemosaics.com, Photo: Ashley Hayward, p.52l
- Goodwin, Elaine, www. elainemgoodwin.co.uk, pp.2, 135–137
- Groeneveld, Sandra M., www.kalideco.com, pp.18t, 77bl, 107c
- Hanansen, Yulia, www. mosaicsphere.com, p.50l
- Hunkin, Tessa, www.tessa hunkin.com, pp.138–141, 142–145, 146–149
- Isidore, Raymond, p.23t
- Javarman, Shutterstock.com, p.47tl
- Jones, Shug, www.tesserae mosaicstudio.com, p.15t/b
- King, Sonia, www.mosaic works.com, Photo by Artist, p.74
- Knickerbocker, Kelley, ©2013 www.rivenworksmosaics. com, p.25t
- Kruzich, Michael, http:// mkmosaics.com, pp.1r, 11, 109cl

- Leonard, Sandra, www. haciendamosaico.com, pp.107br, 109bl
- Lornet, Shutterstock.com, p.14t
- Maxson, Jessica, Photo: Kevin Maxon, p.35tr
- McKee, Julie, www.bigpicture mosaics.typepad.com, pp.76, 107bl/bc
- Messali, Brigitte, www.the mosaicbox.com, p.107tc
- Mika, Laurie, www.mikaarts. com, Photo: Colin Mika, p.22b
- Miles, Helen, www.helen milesmosaics.org, p.92tr
- Miller, Melissa, www.Melissas Motif.com, p.23bl
- Mirsky, Ali, www.alimirsky mosaics.com, pp.92tl, 109tl/tr
- Mueller, Christian, Shutterstock.com, p.13bl
- Perdomo, Estela, Photo Michel Zabé, p.97br
- Pokorny, Brenda, Beads & Pieces LLC, www.brenda pokorny.com, p.50r
- Rayberg, Gila, www.gila mosaics.com, Photo: Rachel Reed Dushoff, p.57t
- Sager, Rachel, www.rachel sagermosaics.com, p.49r
- Schubert, Joan, www.joan schubertart.com, p.104b
- Shapiro, Marian, www. dariandesign.com.au, Photo: Bruce Terry, pp.61, 100bl
- Shelkin, Carol, www.carol shelkinmosaics.com, p.55b
- Shor, Lin, www.linschorr.com, Photo: Ashley Hayward, p.52l
- Shtterstock.com, p.47tr
- Talkov, Carol, http:// caroltalkov.com, p.10
- Taylor, Andrea Shreve, www.taylormosaics.com, pp.20bl/r, 106

- The Tool & Gauge Company (UK) Limited T/A, www.diy tools.com, p.28b
- Towle, Madison, p.48l
- Tyszka, Ruth, www. ruthsglass.com, Photo: P.D. Rearick, p.59t

- Photography by Julie Dilling, p.81bc
- Photography by Bonnie Fitzgerald, pp.48l, 106, 107bl/bc/br
- Photography by Kenneth Fitzgerald, pp.14tl/cr, 21, 32–33 step-by-step shots, 35t/b, 38t, 40, 42, 72, 73, 94, 99, 100–101 step-by-step shots, 111t/c/b, 113tl/tr, 150–15292b, 95tr, 102, 110, 111
- Photography by Sam Leonard, Hacienda Mosaico, pp.95tr, 96

Some material in this book originally appeared in:
- *Classic Mosaic*, Elaine Goodwin
- *Modern Mosaic*, Tessa Hunkin
- *The Mosaic Artist's Technique Bible*, Teresa Mills

All step-by-step and other images are the copyright of Quarto Publishing plc. While every effort has been made to credit contributors, Quarto would like to apologise should there have been any omissions or errors – and would be pleased to make the appropriate correction for future editions of the book.